Tattoo Culture

Tattoo Culture

Theory and Contemporary Contexts

Lee Barron

ROWMAN &
LITTLEFIELD
————INTERNATIONAL
London • New York

Published by Rowman & Littlefield International Ltd.
Unit A, Whitacre Mews, 26-34 Stannary Street, London SE11 4AB
www.rowmaninternational.com

Rowman & Littlefield International Ltd. is an affiliate of Rowman & Littlefield
4501 Forbes Boulevard, Suite 200, Lanham, Maryland 20706, USA
With additional offices in Boulder, New York, Toronto (Canada), and Plymouth (UK)
www.rowman.com

British Library Cataloguing in Publication Data

A catalogue record for this book is available from the British Library

ISBN: HB 978-1-78348-826-1
 PB 978-1-78348-827-8

Library of Congress Cataloging-in-Publication Data Is Available

ISBN: 978-1-78348-826-1 (cloth : alk. paper)
ISBN: 978-1-78348-827-8 (pbk : alk. paper)
ISBN: 978-1-78348-828-5 (electronic)

™ The paper used in this publication meets the minimum requirements of American
National Standard for Information Sciences—Permanence of Paper for Printed Library
Materials, ANSI/NISO Z39.48-1992.

Printed in the United States of America

Contents

Introduction

Within our contemporary culture, it seems that tattoos are everywhere. This perception (and expression) ranges from the now-common sight of baristas in various coffee shop chains proudly displaying their full sleeves of tattoo art as they serve a Caramel Frappuccino and popular cultural icons such as David Beckham, Lewis Hamilton, Johnny Depp, Cara Delevingne or Ruby Rose routinely showcasing their heavily tattooed bodies within mainstream fashion advertising to a plethora of television shows devoted to the best and worst examples of the craft. More directly, tattoo studios are now a common fixture within urban spaces, and many tattoo artists themselves have risen to celebrity status, and through frequently tattooing celebrities. Consequently, tattooing is seemingly a ubiquitous presence within modern social life and culture. But it wasn't always like this. The cultural history of tattooing is one of changing norms, styles and, most dynamically, cultural opinions. From what was arguably a clandestine and strictly defined class-and-gender subcultural practice, tattooing has, in recent years, become a far more mainstream facet of cultural life. While tattooing has periodically vacillated between acceptance and censure, celebration and rejection, it now arguably exhibits an unmatched degree of cultural presence, as reflected by the number of high-profile celebrities, such as Tom Hardy, Angelina Jolie, Justin Bieber, Cara Delevingne and Ruby Rose (to name but a few), who regularly display their extensive tattoo collections, and the regular representation of tattoo artists and 'human canvases' who have appeared in numerous Reality TV series, such as *Miami Ink, Tattoo Nightmares, Ink Master, Tattoo Fixers*.

The reappraisal of tattooing was a notable factor in the celebration of Dr. Matt Taylor, the rocket scientist who was a key figure in the European Space Agency's landing of the probe, Philae on a comet in 2014, but who also sports extensive sleeve tattoos that were openly displayed in media coverage

of the event. As such, there is now a cultural and social landscape that sees the tattooed and tattooists as extensively mediated figures. But, this is not to forget the social actors we meet on a daily basis who display visible tattoo designs to the world, and the increased presence of tattoo studios within towns and cities. Hence, tattoos are arguably at their most pervasive. Whereas in the not-too-distant past tattoos were commonly culturally perceived to represent an outward sign of social nonconformity or even deviance, tattoos increasingly transcend class, gender and age boundaries and are now more culturally acceptable than they have ever been, having seemingly transcended their status as markings of deviance, criminality or rebelliousness. And yet, irrespective of such social visibility, the persistent link between tattooing and 'sensation seeking' and 'risk taking' individuals stubbornly remains (Haywood et al., 2012; Stirn, Hinz and Brähler, 2006). For example, in Viren Swami et al.'s 2015 study, 'Are tattooed adults really more aggressive and rebellious than those without tattoos', the perception of such a link is indeed discernible.

As Swami et al. state, a traditional view of tattoos is that they 'were associated with out-groups, such as bikers or prisoners, who were stereotyped as aggressive. Indeed, some scholars likened tattoos to an "exosketetal defence" … a symbol of physical strength and aggression' (2015, p. 149). A key rationale for such a linkage is that rebellion and social dissent have frequently been perceived as one of the key motivating factors inspiring individuals to acquire tattoo. And as such, Swami et al. sought to contemporaneously test this connection through the administration of a questionnaire delivered to 181 women and 197 men drawn from the general population of London. The questionnaire asked respondents to report if they had tattoos, how many, and where they were situated on the body, but these questions were buttressed with a further set (drawn from the pre-existing Aggression and Rebelliousness Questionnaires) that asked respondents to report upon feelings such as, 'Given enough provocation, I may hit another person'; 'I have trouble controlling my temper' and 'If you are asked particularly not to do something, do you feel the urge to do it?' From a sample of 378 respondents, ninety-seven reported that they had at least one tattoo, and although the overall aggression/rebelliousness levels between tattooed and non-tattooed respondents were small, nevertheless Swami et al. argue that the respondents with tattoos did register higher scores of aggression and rebelliousness and that 'tattoos can be employed as a communicative signifier of defiance or dissent'. Thus, they conclude that 'tattooing may offer some individuals a means of expressing their anger or aggression in a socially acceptable manner' (2015, p. 151).

Such findings, and the residual association of tattooing with attitudes of personal rebellion, are interesting with regards to current academic approaches to the practice of tattooing, but clearly do not fully reflect social actors' myriad

motivations for acquiring tattoos. As Miliann Kang and Katherine Jones argue in their article, 'Why do people get tattoos?', rather than simply being acquired as acts of defiance and sublimated aggression, many tattooed people regard their tattoos as expressions of distinctly unique aspects of themselves, and that tattoos have manifold inspirations that transcend mere provocation or membership of subcultural rebellious groups. As such,

> [t]he tattoo speaks to the ongoing, complex need for humans to express themselves through the appearance of their bodies. The tattooed body serves as a canvas to record the struggles between conformity and resistance, power and victimization, individualism and membership. (2007, p. 47)

Alternatively, tattoos may have no immediate signification beyond the desire for the skin to be marked by the tattooist's needle, as Christine Braunberger observes, 'One does not become immanently "knowable" by virtue of being tattooed. Tattoos can be as inexplicable to the selves who wear them as they are to their viewers. Skin cannot so easily speak for the self that inhabits it' (2000, p. 3). And yet, the issue of signification is a factor that dominates academic tattoo discourses and which has characterised the evolution of the culture away from what Michael Atkinson (2003a) dubbed the 'Rebel Era', the 1950s–1960s period in which social actors bearing tattoos were routinely perceived as communicating their nonconformist stances through visible inked designs. However, as Rocky Rakovic, editor-in-chief of *Inked* magazine argues, the traditional 'backstreet' and disreputable milieu of tattoo shops, and their 'artists' and clients, is what ultimately drew a new generation of creative artists to the profession who, attracted by the anti-corporate, alternative lifestyle of the profession, progressively moved the practice beyond the basic application of traced 'Flash' stencils, and introduced far more innovative tattooing designs and techniques. The result of this artistic development was the opportunity for those being tattooed to possess more unique and personalised tattoo designs that enabled tattoos to act as personal 'stories'. Consequently, argues Rakovic,

> [i]nk is that important to the wearer. The marks on their skin signify an important time in their life – even if someone just got a tattoo on a whim because they were 'young and crazy', that's an entry point into talking about what else they did when they were reckless. (2012, p. x)

Such tattoo stories and design signification lie at the heart of *Tattoo Culture: Theory and Contemporary Contexts'* critical approach to contemporary tattooing. Although the first half of the book will present cultural examinations and theoretical interrogations of tattoos and the concepts that can illuminate their personalised and communicative inspirations, the book will

also present numerous instances of the personalised stories that accompany tattoos, from the single image that signifies a passion for global travel, to the intricate and multifaceted inspirations that inform a body-suit. In this regard, the book builds upon the ethnographic tradition of authors such as Clinton R. Sanders, Margo DeMello, Michael Atkinson and Beverly Yeun Thompson, but within a distinctly British context. Furthermore, the book contextualises contemporary tattooing in relation to celebrity discourses and media expressions in addition to the distinctive fan culture that pervades the tattoo convention in relation to ethnographic data collected through interviews with artists and tattooed social actors to explore tattooing from personal and professional perspectives.

As such, given the experiential nature of this data, *Tattoo Culture: Theory and Contemporary Contexts* views it through the lens of phenomenological perspectives to richly investigate the ways in which tattoos influence personal conceptions and expressions of being, and how designs travel through time and continue (or do not) reflect that sense of being. Indeed, as Vince Hemingson states of the persistent enquiry that those who elect to wear a tattoo, '"What does it mean?" When you get a tattoo, rest assured that this is a question you will be asked many times, by your friends, your family and complete strangers at restaurants, bars and bus stops' (2009, p. 19). And to this list of those who asked this question, we can add the researcher within a university office, and while not all designs have a profound and symbolic meaning, most, as will be illustrated in chapter 4, do.

In terms of structure and content, *Tattoo Culture: Theory and Contemporary Contexts* is divided into two distinctive parts, with part 1 examining tattoo in the context of cultural and theoretical understandings of tattooing, while part 2 is dedicated to ethnographic approaches to social actors, tattoo artists and tattoo conventions. The first chapter sets out the foundation for the subsequent book and charts academic readings of tattoo culture and bodily practices related to the act of tattooing and discusses key academic readings of tattooing culture. Substantively, the chapter will be drawing upon the work of established commentators such as Michael Atkinson, Margo DeMello and Clinton R. Sanders and revisit the evolution of tattooing mapped out by these academics into the distinctive 'eras' that have characterised the development of tattooing culture, such as the 'Carnival' Era in which the heavily tattooed acted as exhibits and sources of public intrigue, the 'Rebel' Era whereby the wearing of tattoos was socially perceived to denote criminality or anti-authority stances (typified by prison culture tattoos and biker gangs, with tattoos serving as visible signs of social 'threat' – a factor that will be explored with reference to Cesare Lombroso's classic Positivistic sociology) and the later expressions such as the 'New Age' Era that saw class and gender boundaries become blurred with regards to the kinds of social actors who elected to be

tattooed. A significant factor (which will be explored and illustrated in later chapters) as to why tattooing began to transcend social barriers and move away from being seen as a sign of deviance or vulgarity was the increasing desire of social actors to express key aspects of their identities and to represent definitive 'statements of the self'. This period lead into the contemporary 'Tattoo Renaissance' in which, due to improvements in tattooing technology and increased creative skill levels of artists (no longer dependent upon predesigned 'Flash' art) social actors could request and receive bespoke and individually unique designs that has arguably progressed into a contemporary period of 'Individualist Populism', an 'era' in which tattoos simultaneously react to the increased visibility of tattoos within popular culture, but with an increased onus on tattoos reflecting aspects of the self, personal biographies, fandom or future professional trajectories.

Chapter 2 develops the theme of tattoo culture's contemporary expression and examines the various examples of tattooing on display within popular culture, through the example of celebrity culture. While celebrity culture has developed a cultural presence within major social institutions and social trends (from media through to economics, politics and even religion), a potent focus of interest within such culture is the social impact of celebrity bodily image. Arising from academic discussions of this debate, this chapter will focus upon celebrities who display extensive tattoos. Thus, a range of high-profile personalities possess extensive tattoo designs that are routinely displayed in media discourses. Similarly, within the world of popular music stars, while long associated with heavy metal rebelliousness (e.g. the extensively tattooed members of Mötley Crüe), tattooing has become a much more widespread practice across pop music with female and male artists such as Rihanna, Miley Cyrus, Demi Lovato, Lady Gaga, Justin Beiber, Ed Sheeran, Adam Levine or the appropriately named hip-hop star, Kid Ink. Furthermore, such a high degree of visibility is also evident within sport and adorning the bodies of high-profile athletes including Brittney Griner, Anastasia Davydova, Natasha Kai, LeBron James, Chantae McMillan, Mike Nickels, Chris Andersen, Zlatan Ibrahimović, Lewis Hamilton and perhaps most famously, David Beckham. Moreover, fashion models, as illustrated by Jourdan Dunn or Heather Kemesky, have taken tattoos onto the Fashion Week runways and into the pages of *Vogue*. Thus, with regards to these examples, although drawn from acting, modelling, music and sport, their tattoo designs have been extensively photographed and form a part of their public personas.

Having explored tattooing from a cultural perspective, chapter 3 synthesises theoretical and philosophical theories that will inform later ethnographically based chapters. In Bryan Turner's sociological analysis of tattooing, its anthropological roots consistently emphasise a highly symbolic function in that designs communicated very specific meanings of social, cultural

and individual significance. Although tattoos and tattooing have developed from social and spiritual practices to become in contemporary societies akin to 'consumer products', sociological readings and popular cultural expressions of the art of tattooing and, crucially, the decision to have a tattoo, have retained communicative and highly symbolic functions. Here, then, I will explore what can be called a new 'era' of the Semiotic/Existential tattoo culture given the degree to which tattoos frequently tell stories and signify key moments and developments in a life whereby many individuals map out rites of passage on their bodies, for others to read, but often for themselves that symbolically represents biographical moments: band insignia and lyrics, poetry, superstitions, private jokes, religious expression, corporate logos and inspirational codes. In effect, tattoos did and do speak to the world semiotically. Drawing upon the classical work of Roland Barthes, this chapter will link semiotics firmly with contemporary tattooing culture. Much classic work on tattooing draws upon postmodernist theory to explain the ways in which social actors 'take control' of constant change and social flux through inscribing permanent designs on their skin that 'freeze' their identities. However, the chapter will draw upon alternative theoretical ideas, and the chapter will reinforce semiotic analysis with the application of key elements of phenomenological theory principally derived from Martin Heidegger (with additional supporting references to the work of Edmund Husserl, Peter Berger and Thomas Luckmann, Henri Bergson, and Maurice Merleau-Ponty) that explores the degree to which tattoos alter an individual's sense of being, and how tattoos articulate relationships (positively and negatively) with the passing of time and changing perceptions of self. The central aspects of Heidegger will centre on his conception of being ('Dasein'), of Dasein's relationship with worldness, authenticity, the cultural influence of society in the form of the 'They-self', and Heidegger's work on art.

Part II commences with chapter 4, which begins to illuminate and critically apply the substantive issues, concepts and theories explored in chapters 1–3 in response to data gathered through ethnographic interviews with a number of tattooed social actors. The methodological underpinning of the chapter is the result of qualitative material collected through face-to-face semi-structured interviews (with respondents recruited through invitational posters) in the Newcastle area in the north-east of England. The chapter examines the decision-making process that social actors undertake when deciding to have a tattoo design, the genre to which their work belongs, how they select their studio/artist and, principally, the factors which inform and inspire their design choices. More substantively, the chapter relates data to the key theoretical issues discussed within chapter 3 to explore the phenomenological communicative functions that their designs may have, and how tattooing has affected

bodily perceptions of self and personal being, what being tattooed means to them individually.

Chapter 5 explores the professional context of tattoo culture from the perspective of artists and the cooperative nature and structure of the tattoo studio. Taking inspiration from the earlier ethnographic work of Clinton R. Sanders, this chapter is informed by ethnographic interview data gleaned from artists and studio managers and participant observation of the studio dynamic, how social actors become professional artists, their individualised work and art practices, and how they interact with clients in terms of negotiating requested designs. In relation to data obtained through ethnographic methods, the chapter applies Heidegger's usage of 'world' to articulate the specific Dasein of the artist. As such, the personal and professional development of the artist within the professional world of tattooing is critically considered in relation to this aspect of Heidegger's work.

However, this philosophical approach is augmented with reference to Howard Becker's sociological understanding of the 'art world'. As Becker argues, 'All artistic work, like all human activity, involves the joint activity of a number, often a large number, of people' (2008, p. 1), and this process, if only the cooperation between the artist and client (but there are a number of other agents within the studio, from manager to apprentices) captures the dynamic of the studio setting.

Chapter 6 continues to explore Becker's concept of the art world but in relation to Henry Jenkin's use of the idea in relation to fandom and fan conventions. In Jenkins' view, an art world involves networks of artistic production, distribution, consumption, circulation and the exhibition and forums for the sale of artworks. In this regard, argues Jenkins, fan conventions are not simply events in which fans can interact with fellow fans, but they also perform a key role in the distribution of knowledge about media productions and are one of the modes by which producers promote cultural products such as comic books, science fiction novels, new film and TV releases, or online/game releases (typified by events such as Comic Con). More importantly, Jenkins argues, conventions provide spaces in which producers have the opportunity to communicate directly with the consumers of their cultural products (with many fans externally signifying their connection with the culture through 'cosplay' – adopting the guise of popular cultural characters). Within the context of tattoo culture, the professional tattoo community engages extensively in conventions in which tattoo enthusiasts meet other enthusiasts, display their tattoo designs (engaging in conduct that is analogous to cosplay through exposing their tattoos in a way that they may not conventionally do in their everyday lives, but wearing clothing designed to maximise the visibility of their extensive tattoo work) and, most importantly, meet prominent international tattoo artists who undertake tattoo work within the convention in addition to advertising their work and studios.

Methodologically, the chapter is informed by participant observation data gathered by the author at tattoo conventions held in London, Edinburgh and Manchester.

The final conclusive chapter evaluates contemporary tattoo culture, the impact of celebrity and the phenomenological ideas expressed in earlier chapters. However, these ideas are linked to practices of tattoo removal. At one level, removal is frequently entirely aesthetic as it is motivated by the desire to remove poor quality work or ill-conceived concepts which are subsequently replaced with new designs that reflect current conceptions of being. For example, laser removal advertising within leading tattoo magazines frequently lead with the strapline 'Erase and Replace', illustrating the extent to which removal often does not signify an individual seeking to break away from tattoo culture, but rather affords the opportunity for social actors to acquire new designs. Reinforcing the discussion of this practice, the chapter will also discuss the rise in the artistic practice of designing and implementing 'cover-ups', by which social actors have unwanted designs concealed with new ones that are more artistically pleasing and/or communicate changes that have occurred within individual sensibilities.

Tattooing has changed radically in recent years, and *Tattoo Culture: Theory and Contemporary Contexts* evaluates key tattooing literature and studies, but sets this within a distinctive British context and is based upon a methodological approach that enables the theoretical underpinnings, from postmodernism and semiotics, to a more sustained use of phenomenological ideas, to find expression from the perspective of those who actively participate within contemporary tattoo culture. This is because, in addition to the voices of Roland Barthes, Ferdinand de Saussure, Maurice Merleau-Ponty, Henri Bergson and Martin Heidegger (not forgetting an array of academic tattoo commentators), the book gives judicious space for tattooed social actors who embrace tattooing to speak about their tattoos, to articulate their passion for the craft, and the inspirations (and mistakes) that have lead some of them to devote their professional lives to tattooing and others to have ink imprinted into their skins. But most importantly, the book explores what this ink means to them.

Part I

CULTURE AND THEORY

Chapter One

From Ötzi to Trash Polka

Reading Tattoos

Writing in the early 1970s on the 'mystery' surrounding the practice and culture of tattooing, Ronald Scutt and Christopher Gotch reasoned that tattooing constituted a social 'oddity', one that produced a range of social reactions 'from curiosity, through degrees of interest, amusement and envy, to downright contempt, pity or disgust' (1974, p. 13). In the decades following this appraisal, attitudes to tattooing have transformed and, certainly in the Western world, tattoos are now less of an oddity and have arguably attained an unprecedented level of social ubiquity and cultural visibility. This ranges from social actors encountered in everyday life, increasing numbers of tattoo studios in urban spaces, a marked increase in tattoo-themed Reality TV shows and images of extensively tattooed globally famous Hollywood superstars such as Angelina Jolie and Johnny Depp, to respectable professionals such as the European Space Agency 'rocket scientist', Dr. Matt Taylor, the project scientist responsible for the historic landing of the *Philae* probe on a comet. Moreover, an evocative contemporary expression of the cultural significance of tattooing is that of Amy Bleuel's Project Semicolon, a web-based initiative established in 2013 in tribute to her father who committed suicide and which serves as a movement offering hope to people experiencing depression, addiction, suicidal thoughts or self-harming behaviours. Potently, this ethos is symbolised by supporters across the world obtaining semicolon tattoo designs to symbolise hope and positive change because the 'semicolon is used when a sentence could have ended, but didn't' (Bolton, 2015, p. 1). Hence, from bodily ornamentation to political activism, the tattoo in the West has carved out a visible and pervasive cultural position, but it hasn't always been this way.

The social and cultural history of tattooing has witnessed the tattoo evolve through symbolic expression of community and personal status, an expression of self-mutilation, an exterior signifier of a deviant or criminal

3

personality, as an individualised symbol, as a major contemporary art form and a sign of gendered self-determination (Mascia-Lees and Sharpe, 1992; Favazza, 1996; Atkinson, 2003a; Adams, 2009; Thompson, 2015). As such, the story of tattoo culture is one that is a chronicle of a human bodily art form characterised by processes of ceaseless flux and transformation, from tattooing techniques to societal attitudes to individuals who wear tattoo designs. As Doralba Picerno observes, from the vantage point of the twenty-first century, tattoos are now seemingly culturally ubiquitous and have arguably attained a status of social acceptance that is unprecedented, and yet, she observes, one does not have to venture too far back to a time when 'tattooed people were regarded with distaste, suspicion, or downright contempt, associated as they were in the public consciousness with gang culture, crime and irresponsibility' (2011, p. 6). To illustrate, in his assessment of the practice of tattooing in the 1950s, Hugh Garner caustically concluded that

> [a]mong all the forms of mass masochism practiced by that frailty known as man, none is quite as silly as the acquiring of tattoos. This egocentric perversion has had its devotees since the dawn of time, and in inverted sequence, it has been a tribal custom, penal stigma, class craze, snobbish adornment, and finally a vulgar affectation. Among the Maoris and various Hindu sects it is still a mark of caste and beauty, but among most Western peoples, it is at best a juvenile indiscretion, and at worst a thing of shame and loathing to those of us who are tattooed. It can, and does, slow a person's social life to a crawl. (Cited in Vassileva and Hristakieva, 2007, p. 367)

Certainly, as academic-turned-tattooist Samuel Steward argues in his 'street corner' social history of tattooing, the classic cultural reaction has closely reflected Garner's view, whereby media representations classically stressed an unambiguous connection between the acquisition of tattoos and the engagement with criminal or 'derelict' behaviours. However, in assessing motivations behind tattooing, Steward found a myriad of reasons underlining the decision to be tattooed. Certainly, the desire for a tattoo as a marker of herd instinct and gang affiliation was a common element in Steward's studio, from distinctive gang-designed symbols to a more unfocused sense of nonconformity and rebellion in which tattoos reflected the stance of 'anti-social "rebels without a cause" or inarticulate revolt' (1990, p. 66). However, in Steward's experience, he found that motivations to have a tattoo design far exceeded statements of social subversion or anti-authority marginalised social positions. For instance, some clients sought tattoos in imitation of a tattooed figure from popular culture or sought to copy a design seen in everyday life, while others were tattooed in the pursuit of narcissistic enhancement, arguing that tattoos would render an already beautiful body even more aesthetically pleasing. Similarly, other customers wished

to wear tattoos simply to decorate their bodies and for the designs to serve as symbols of exhibitionism, underscored, in some instances, by a marked sense of possessiveness related to the permanence of the design whereby the client could claim 'it's mine; no one can take it away from me' (1990, p. 48). Certainly, later psychological research has also pointed to 'sensation seeking' and aesthetics as primary motivating factors in tattoo acquisition (Armstrong and McConnell, 1994; Stirn, Hinz and Brähler, 2006; Swarmi, 2011; Tiggermann and Hopkins, 2011). This latter category raises an especially significant relationship that some of Steward's clients had on examining their completed tattoo, and a particular emotional response at the conclusion of the tattooing process, which was to describe being tattooed as representing a distinctively existential act. This conception of tattooing stemmed from a client who was a university graduate familiar with the philosophy of Jean-Paul Sartre and Albert Camus, but it resonated beyond this particular philosophically informed individual. For Steward, although the majority of customers had no inkling of the nature of existentialism, nevertheless, their tattoo experience constituted an existential act, a deed carried out in a solitary fashion and which once done was ostensibly irrevocable. Accordingly, Steward reflected of a client's at the end of a session, 'I had many times seen them tense at the end of a tattoo, flex the muscles, look at the completed design, and mutter something like: "By God, it's there for always"' (1990, p. 59).

The idea of a tattoo altering a sense of self at the level of existential being will be further developed in chapter 3, but Steward's myriad motivations for obtaining tattoos, in addition to multifaceted societal reactions to the wearing of tattoos, depicts the nature of tattoos as being complex and often contradictory aspects of human culture. As such, tattoos are a permanent bodily adornment that can be desired simply as pure decoration, to visually signify specific group membership or wider social and cultural mores, or to symbolise deeply individualised values and attributes, ranging from religious and political affiliations to a fervent fandom of *Star Wars*, assorted *Marvel* and *DC* superheroes (but with recent spikes in tattooed depictions of *Deadpool* and Margot Robbie–likeness Harley Quinns), *Harry Potter*, or *Game of Thrones* (to indicate but a few). Moreover, wider social reactions to tattooing have periodically, and in some instances continually, vacillated between acceptance (and in some societies, insistence), toleration, or censure and rejection. Hence, Nikki Sullivan captures the dynamic nature of tattoo culture cogently when she states that 'in our culture, at least, the tattooed body is a spectacle that incites a plethora of responses, but rarely indifference' (2001, p. 1). Accordingly, as Jane Caplan contends, in the pantheon of irreversible body modification practices that have been practiced by human cultures, such as scarification, piercing, and branding, tattooing is arguably the oldest, and

it has been found to have been performed 'in virtually all parts of the world at some time' (2000, p. xi). Consequently, tattooing is a custom that spans the entirety of human culture itself.

TATTOOING THROUGH THE AGES

From a historical and anthropological perspective, A.W. Buckland dubbed tattoos as a near-universal 'painful mode of personal adornment' (1888, 319), and subsequent archaeological research has established that tattooing has always been a global practice and a truly ancient custom. Although, in the view of Charles Taliaferro and Mark Odden (2012), the development of tattooing is difficult to exactly trace given the multiplicity of human cultures that practiced it, from ancient Egypt, Greece, Africa and Siberia to Alaska, the Arctic, Latin America, China, India, Indonesia, the South Pacific, Japan and the Middle East.[1] However, tattooing cultures predate these societies, because archaeological data suggests that tattooing, the insertion of ink into the deep layers of human epidermis, was extensively practiced in the Stone and Bronze Ages. As Clinton R. Sanders argues in this regard, 'proof of the antiquity of the practice is derived from the mummified body of a priestess of Hathor (dated 2000 BC) that bears parallel line markings on the stomach, thought to have had medicinal or fertility functions' (2008, p. 9). As such, archaeologists have provided evidence of yet older tattooing, and actually identified the oldest known human being to bear tattoos, the man dubbed by scientists as Ötzi, the European 'Iceman' discovered beneath a glacier on the Austrian–Italian border. Dated to have been buried circa 3250 BCE, Ötzi's naturally mummified body (due to the extreme cold of the glacier) was found to have sixty-one tattoos designs positioned across his body and displacing (by some five hundred years) the Chinchorro mummy of Chile as the oldest recorded tattooed human. Moreover, it is argued that Ötzi's tattoos possessed distinctive symbolic functions. As such, within antiquity tattoo-ing distinctively and deliberately 'acted to negotiate relationships between individuals and their society, nature, and the spiritual realm' (Deter-Wolf et al. 2015, p. 19). Yet, while Ötzi currently retains the unique status of being the oldest known tattooed human, given the symbolic meanings and motivations of his bodily designs, he cannot be the first human to have been tattooed. As such, 'Ötzi's 61 marks represent physical actions performed on his body as part of established social or therapeutic practices that almost certainly existed within his culture well before his birth' (Deter-Wolf et al. 2015, p. 23). In this regard, tattooing is a practice rooted within the earliest manifestations of human culture, but also, crucially, it has been utilised as a means by which to visibly reflect personal symbolic meanings given that

most of the designs would have been obscured by clothing. (Scheinfeld, 2007, p. 362)

From a sociological perspective of the body, Bryan Turner (1991) argues that the 'premodern' body was a primary site for the display of a range of key cultural factors such as, social status, family position, tribal membership, age, gender and religion. The issue here was that early tribal societies physically marked out status differentials through scarification and the act of tattooing. Such marks signified key moments in an individual's life, particularly with regard to rites of passage between differing statuses (age being a prime example). With regard to tribal tattooing in the Pacific, this was, argues Juniper Ellis, not simply a bodily practice, but 'a distinct philosophy' because 'Pacific tattooing is created ritually in community, by community' (2012, p. 17). As such, early histories of tattooing fully explored this social function of the practice, for example, Wilfrid Dyson Hambly's anthropological *The History of Tattooing* (originally published in 1925), which traced the roots and cultural function of tattooing back to religious, magical and status-communicating practices and examined tattooing as a practice that was quintessentially a religious and magical practice, but also a literal marking of life stages, such as the tattooing of women in some cultures when they reached puberty as a visible preparation for matrimony (in ancient Egypt, women were the predominant recipients of tattoos in relation to fertility). With reference to the New Zealand Maori warrior Moko tattoo operations, Hambly argued that the designs of tattoos were not for ornamentation but functioned to signify specific meanings such as prowess in battle and to convey advancing levels of social status within tribal groups and as such, there was a 'wealth of meaning attached to the body marking process' (2009, p. 46). Moreover, the distinctive Maoris facial designs also possessed a post-death function as the patterns would be recognisable to their spirit guide, a spirit the Maoris believed would enable them to navigate their way to the next world following their death. Accordingly, numerous early cultures regarded the practice of tattooing as serving vital social and cultural tribal purposes, but also acting as protective symbolic totems and spiritual mechanisms against evil and misfortune to the extent that tattoos enabled 'people to remake themselves in their eyes and in the eyes of their god or gods' (Scheinfeld, 2007, p. 365).

Nevertheless, as Willowdean Chatterson Handy's (2008) anthropological research (published in 1922) on tattooing practices in the Marquesas established, being tattooed or non-tattooed did not always necessarily have a community-based symbolism. For example, that only the economically powerful Marquesas were tattooed as opposed to the tattoo-free fishermen was frequently read as a symbolic feature of the society in which tattoos deliberately articulated social distinction. However, following further research, the reality was somewhat more prosaic, because, as Chatterson Handy discovered, the

reason for the disparity in tattooing was more material than symbolic as the extent of tattooing was simply based upon the ability to be able to pay for the skills of an artist, and as the community's lowest class, fishermen were not tattooed simply because they could not afford tattoos. So, while the symbolic nature of tribal tattooing is an intrinsic aspect of tattoo history, economics in the form of the affordability of tattooing is also a factor, then, and now.

Moving on to early European cultures, tattooing was also highly evident and extensively practiced. For example, the Picts, the ancient tribal groups populating the British Isles (whose name derived from the iron tools used to create tattoo designs) adorned themselves in animal tattoo designs to inspire fear in their invading Roman enemies, and which were dubbed by the Romans as 'Stigmata Britonum' – the 'Mark of the Britons' (Alayon, 2004, p. 17), and the Pictii, or 'the painted ones' (Hemingson, 2009, p. 73). Significantly, in an evocative early example of the imitation motivation for tattoo inspiration, far from instilling fear in the Roman Legionnaires, it actually inspired many of them to adopt the tattooing practice themselves, until forbidden by the Emperor Constantine on the grounds that tattoos 'violated God's handiwork' (Sanders, 2008, p. 13). This antipathy between religious authority and tattooing continued for hundreds of years in early British history. As Hemingson illustrates, in the fourth century AD, Saint Basil the Great (St. Basil of Caesera) forbade Christians to wear both long hair and tattoos as it placed them in behavioural and spiritual proximity to the Satanic 'heathen' who marked themselves with 'thorns and needles'. For many tattoo commentators, the religious prohibition against tattooing in Europe has been routinely linked to a passage from Leviticus, in the Old Testament, that commanded followers that, 'You shall not make any cuttings in your flesh on account of the dead, or tattoo any marks upon you'. It has been argued that the rationale for this forbidding of tattooing was as a means by which the Jews could distinguish themselves and their monotheistic faith from alternative polytheistic belief systems and ethic cultures (Taliaferro and Odden, 2012, pp. 4–5). Yet such censure against tattooing would change as something of a Christian volte-face occurred in AD 787 when the Council of Northumberland issued an edict which stated that the Fathers of the Church drew a distinction between profane or sacrilegious tattoos and Christian-inspired tattoos. Indeed, it was contended that religiously inspired body art, unlike magically inspired tattooing, could actually serve to connect the wearer to the Christian faith. As the Church Fathers reasoned,

> [w]hen an individual undergoes the ordeal of tattooing for the sake of God, he is greatly praised. But one who submits himself to be tattooed for superstitious reasons in the manner of the heathen will derive no benefit therefrom. (2009, p. 74)

Nonetheless, as Kim Hewitt (1997) argues, the tide would again turn against tattooing from a Christian perspective, frequently in the form of the European colonial 'civilising' ventures that frequently sought to eradicate indigenous communal tattooing practices. For example, the Puritans in the North American New England colonies established links between tattooing and witchcraft, seeing tattoos as 'Devil's marks' and sure signs of satanic allegiances. Moreover, employing Old Testament prohibitions against marking the body, the Puritans also denounced Native American tattooing practices. And yet, tattooing within such societies, and the allure of indigenous tribal bodily designs, would remain remarkably tenacious. As Ellis argues, in Tahiti, through the express influence of Christian missionaries from the eighteenth century, tattooing was formally banned, but notwithstanding legal prohibition, tattooing continued as a clandestine practice, becoming a means by which ethnic sovereignty was maintained in the face of oppressive colonial values. Ironically, much tattooing took place on Sundays, during Christian church services (when the priests were otherwise engaged for proscribed periods of time), and more ironically, many priests ultimately obtained tribal tattoos, such as the missionary George Vason, who having failed to convert any Tongans to the ways of Christianity nevertheless acquired a full body-suit set of tattoo designs from a Tongan artist. Futhermore, as Maarten Hesselt van Dinter wryly observes, it was the very 'same ships that transported zealous missionaries to the South Pacific [which] brought tattooing back to Europe by way of tattooed sailors, written descriptions and illustrations of tattooed people, and decorated Oceanians who were exhibited as circus attractions' (2005, p. 13).

However, within such communities, in many instances tattooing defiance came at great risk and brutal reprisals for those who contravened the prohibitions were proposed in order to decisively stamp out the 'un-Christian' practice. For example, a letter published in 1836 in the *American Tract Society* recommended that the 'only way to prevent tattooing was at length to be, having the parts that were marked, disfigured by the skin being taken off, and foul blotches left where beautiful patterns had been pricked in' (Ellis, 2012, p. 23). Consequently, in the face of theological and legal prohibitions against indigenous body modification cultures (that effectively made tattooing a crime), clandestine tattooing became a committed and political self-determination, whereby the wearing of tattoos became 'a defiant proclamation of indigenous sovereignty over indigenous bodies – and, by extension, indigenous lands and worlds' (Ellis, 2012, p. 22). Furthermore, the creation and wearing of these tattoo designs would continue to act as expressions of cultural identity and cultural values. As John Utanga and Therese Mangos argue, the practice of tattooing in Tahiti (and wider Polynesian societies ultimately collectively known as the Cook Islands), was a ritual means by which to symbolise 'mana', a form

of inherent tribal authority, but also as a means of bodily beatification that visually combined to offer both spiritual protection and to communicate the tattooed person's identity. Yet, although virtually stamped out as a traditional cultural practice, the latter part of the twentieth century saw the establishment of the South Pacific Festival of the Arts, a venture dedicated to reviving traditional South Pacific art forms suppressed by European culture and values, including traditional tribal tattooing. As a result, artists such as Tetini Pekepo and Ben Nichols led to the rediscovery of the art to the extent that from the 1980s, and 1990s, and into the twenty-first century, 'Cook Islands patterns and motifs, for so long a source of social stigma, have become more prevalent as the art has been both "rediscovered and redefined"' (2006, p. 322). While Tahitian tattooing was extensively repressed by contact with European culture, it actually was a primary force in popularising tattooing in the wider world. As Margo DeMello states,

> [w]hile tattooing had been practiced, off and on, in Europe for centuries, it was not until the journeys of Captain James Cook and other eighteenth-century explorers that tattooing firmly entered European, and later, American culture. (2014a, p. 216)

Until Captain Cook and his crew reached Tahiti on their second voyage between 1772 and 1775, tattooing was actually called 'pricking' in the West, but seeing the practice performed extensively in the South Pacific 'Cook introduced the Tahitian word "ta-tu" meaning "to strike" or "to mark" and soon "tattoo" became the common term' (Sanders, 2008, p. 14). Such was the appeal and interest in Tahitian tattooing, a number of Captain Cook's sailors and officers obtained tattoos from Tahitian artists to permanently memorialise their voyage. In addition to the returning sailors displaying their tribal designs, Captain Cook brought back to England the heavily tattooed Tahitian, Omai, 'who was exhibited as an object of great curiosity to members of the British upper class (Sanders, 2008, p. 14), and which helped to inspire a European "tattoo rage" (although, as Lodder [in Kenny, 2017] points out, tattooing did occur in Britain prior to the eighteenth century, and within sailor traditions that did not reflect Pacific tattoo designs (Lodder, 2015), and so Cook did not 'discover' tattooing). But while the intensified desire to acquire tattoos, which spread into succeeding centuries, was most commonly manifest among sailors and the military, respectable legitimacy was temporarily bestowed upon the practice by the wearing of tattoos by numerous members of the aristocracy, such as Tsar Nicholas II of Russia and Kaiser Wilhelm of Germany. Indeed, rumour has it that the British tattoo artist, Alfred South reputedly tattooed a Bengal tiger locked in combat with a python on Queen Victoria (Mifflin, 2013) (although it is worth noting that contemporary 'august' figures such as The Crown Prince Frederik of Denmark and Canada's prime minister, Justin Trudeau both openly sport tattoo designs). Yet, this seemingly egalitarian appeal of tattooing soon faded and a distinctive class configuration of those individuals choosing to be tattooed became progressively associated

with vulgar and 'unsavoury types' who habitually frequented 'disreputable urban areas' (Sanders, 2008, p. 17).

TATTOOING AS A DEVIANT BODILY SIGN

As tattooing progressively became more culturally prevalent in the industrialised Western world, early sociological examinations of the practice decisively positioned it as an unambiguous signifier of social disreputability, deviance and/or criminality. In this regard, perhaps the most evocative exponent of this view was the nineteenth century early Italian criminologist, Cesare Lombroso within his book, *L'uomo Delinquente (Criminal Man)*, published in 1876. As one of the founders of what would emerge as the discipline of criminology, Lombroso was a proponent of Biological Positivism as he approached the explanation of crime from a distinctive anthropological and Darwinian perspective. Furthermore, Lombroso engaged in a specific methodology that sought to identify signs of 'physical stigmata' (McLaughlin and Muncie, 2013). Via the analysis of a number of 'criminal' craniums (studying 2,734 subjects), Lombroso concluded that individuals who commit crime have distinctive physical abnormalities including, ape-like lower faces, large jawbones, receding foreheads and small cranial capacities, but these skull shapes did not suggest 'the sublimity of the primate, but the lower level of the rodent or lemur' (Lombroso, 2006, p. 28). Accordingly, Lombroso concluded that criminals were essentially physically different from law-abiding individuals as they constituted atavistic or 'primitive' regressions back to previous pre-civilised states, and who were 'born with evil inclinations' (2006, p. 48). Consequently, Lombroso argued that criminals were biologically determined towards antisocial behaviour and acts of criminality. Moreover, in addition to their distinguishing bodily traits, Lombroso also cited tattooing as a further indicator of a criminogenic nature, observing that

> [o]ne of the most singular characteristics of primitive men and those who still live in a state of nature is the frequency with which they undergo tattooing. This operation, which has both its surgical and aesthetic aspects, derives its name from an Oceanic language. In Italy, the practice is known as *marca* [mark], *nzito segno* [sign], and *devozione* [devotion]. It occurs only among the lower classes – peasants, sailors, workers, shepherds, soldiers, and even more frequently among criminals. (2006, p. 58)

In Lombroso's view, although some tattoos specifically denoted identity in terms of membership of criminal groups (most notably the Italian Camorra criminal organisation) all of the tattoos worn by his criminal sample acted as *signs*, and more specifically, indicators of class. To illustrate this

conclusion, Lombroso argued that he had discovered a limited set of design categories of tattoos centred upon love, religion, war and profession, representing 'external signs of belief and passions predominant among working-class men' (Lombroso, 2006). With regard to tattoo designs, Lombroso contended that sexually obscene tattoos, especially those applied to pubic regions, indicated not merely antisocial shamelessness, but clear evidence of 'abnormal' tolerance of pain, given the sensitivity of the sexual organs, concluding that even 'savages avoid tattooing those areas' (2006, p. 59). As is patently evident from such quotes, Lombroso unambiguously linked tattooing to 'inferior' non-Western tribal cultures, and consequently to wear tattoos was a visible marker of a lack of civilisation and a desire to regress to a 'primitive' state. Hence, in explaining the desire to be tattooed, Lombroso reasoned that

> [a]mong Europeans, the most important reason for tattooing is atavism and that other form of atavism called traditionalism, both of which characterise primitive men and men living in a state of nature. There is not a single primitive tribe that does not use tattooing. It is only natural that a custom widespread among savages and prehistoric peoples would reappear among certain lower-class groups. (2006, pp. 61–62)

However, Lombroso did acknowledge that forgers and swindlers were of the most intelligent rank of criminal, a status indicated by the fact that they were rarely tattooed because they know that 'the marks of the tattooer, once recognised and noted by the police, furnish afterwards an easy means of identification' (Tighe, 1877, p. 774). Not surprisingly, Lombroso's work has long been the subject of extensive criticism and rejection within the discipline of criminology as a motivational explanation for criminal behaviours. These critiques range from the weak statistical basis of his empirical approach, the recognition of environmental and social influences upon criminal behaviour and motivations, to later genetic theory that has categorically invalidated the idea of criminal 'throwbacks'. Furthermore, his inclusion of tattooing as a sign of inherent criminality is also viewed as a major weakness of this thesis because tattooing is 'the result of cultural fashions which have tended to have been concentrated in the lower classes' (Taylor, Walton and Young, 1973, p. 42). The increasingly complex issue of class and tattooing in the late nineteenth century also presented issues that even stymied Lombroso himself. As stated earlier, the 'tattoo craze', or 'tattoo fad' of the late nineteenth century included a number of royal figures (including Edward VII, tattooed in Jerusalem, and his son, George V, tattooed during a tour of Japan), but it also extended to a large number of Society women. As Jordanna Bailkin states,

Lombroso was greatly disturbed by this British craze, which he saw as a dangerous anomaly within civilized Europe. By 1895, Lombroso was offering long diatribes against British aristocratic women, who appeared to spoil many of his criminological claims. His response was to broaden his arguments. The aristocratic tattoo was proof that all women were fundamentally at odds with modernity: 'it is very much', he said, 'like returning to the trials by god of the middle ages'. (2005, p. 48)

However, in addition to an incongruous manifestation of upper-class atavism, Lombroso also found fashion to be a culpable cause in its ceaseless creation of 'ephemeral crazes' and its frivolous nature, both of which had 'caused many complaints against the most beautiful half of the human race'! (Lombroso, 2006). Yet, regardless of the now well-established rejections of Lombroso's approach, the association of tattooing with 'deviance' and disreputability would become a perennial feature of tattooing culture and social reactions and attitudes towards it. On the one hand, the biological positivism proposed by Lombroso continued to be developed, from the 'science' of phrenology, the belief that argued that the shape and size of the skull was linked with the nature of the brain within it, to physiologically based works of criminology developed by theorists such as Charles Goring and William Sheldon in the early twentieth century (White and Haines, 2008). While on the other hand, the intimate association between deviance and tattooing also persisted. A notable example of this tradition was Lombroso's French contemporary, Alexandre Lacassagne, who approached the study of crime from an ethnological and medico-legal standpoint, and who attempted to devise schematic maps that also strived to establish a visible and causal link between tattoos and criminality to the extent that the number of tattoos worn and even the artistic quality of the designs could be argued to indicate the nature of criminal offences committed by the wearer. Furthermore, distinctive patterns of tattoo designs could also potentially 'indicate a particular convict's crime' (Ellis, 2012, p. 14).

As tattooing became more culturally prevalent in late nineteenth and early twentieth century Europe and America, a class-dynamic decisively emerged as to the individuals who got tattooed, and why they did it. As tattooing professionally proliferated, it became, argues Taliaferro and Odden (2012), intimately connected with specific modes of masculinity. In addition to the spiritual and communal functions of tribal tattooing, the ceremonial aspects of the tattooing procedure were physically onerous. For example, the Polynesian tradition consisted of the tapping method, by which a comb or rake (fashioned from sharp animal teeth) was attached to a stick, dipped in ink and then tapped into the skin by a mallet (DeMello, 2014b). Consequently, tapping was a practice predicated on the principle of the endurance of bodily pain,

especially with regards to male recipients of the art. As such, when tattooing became widely embraced in the Western world this aspect of masculinity in close connection with tattooing was also, arguably, revitalised. For example, throughout the nineteenth century and into the twentieth, tattooing became prevalent among the navy and a key element was that sailors 'endured the pain of the tattooing process as a contemporary way of asserting their masculinity over their peers. It soon became a competition for dominance, as no sailor could be perceived as weak' (Taliaferro and Odden, 2012, p. 5). Moreover, the 'machismo' of tattooing also became evident within the army of the Victorian era in Europe, but it also translated into a distinctive class signifier because when military personnel left the armed forces and became civilians, their tattoos 'became known as working class jewelry' (Taliaferro and Odden, 2012, p. 5). This conflation of the physical pain of tattooing and the class-based perception of those wearing them would be evocatively captured in a further work that continued the association between deviance and tattooing in the twentieth century, namely that of Albert Parry's classic book, *Tattoo: Secrets of a Strange Art*, published in 1933.

In explaining the development and growing popularity of tattooing in early twentieth century America, Parry unapologetically popularised the ideas of Lombroso and his view that people living in modern and 'civilised' countries engaged in tattooing as a means by which to atavistically revert to a primitive mode of behaviour. But while Parry acknowledged that this did not necessarily translate into criminal behaviour or a criminal nature, as Lombroso contended, nevertheless, the desire to be tattooed *did* confirm atavism. However, Parry also introduced a number of quasi-Freudian ideas to explain the inspiration for individuals to acquire indelible and permanent bodily designs. As such, on the first page of *Tattoo*, Parry rhetorically asks,

[w]hy do people get tattooed? Very seldom are the tattooed aware of the true motives responsible for their visits to the tattooers. Some say: 'So that they'll know me if I'm killed or struck unconscious'. Others refer to the impulse to imitation of their friends; or because they wish 'to look swell'. Many claim that they get tattooed 'just to kill time'. These reasons are evident rationalizations. The true motives lie deeper. (2006, p. 1)

In the view of Parry, the impulse for tattooing, and indeed the drive to perform tattooing, was psychologically explainable. On the one hand, the upperclass tattoo fad amongst members of the royal, aristocratic or business classes represented, in a Lombrosian fashion, an attempt to 'borrow the primitive strength of the lower class' (2006, p. 92), while on the other hand, tattooing was equally explainable in relation to sexual instincts, and, crucially, the repression of these urges. As such, to explain the dramatic popularity of

tattooing in late nineteenth and early twentieth centuries, for male-dominated isolated professions, such as those of the sailor, soldier or frontier miner, acquiring tattoos acted as a distinctive masochistic substitution undertaken to compensate for the lack of women in such locales. Furthermore, the masochistic element of tattooing, the fervent desire to experience the pain of the tattooing process, was simultaneously blended with a potent 'guilt complex', or, more specifically, a 'martyr complex' in which in the future individuals would commonly absolve themselves from responsibility regarding their tattoo designs, blaming alcoholic instances, 'wild impulses', the influence of military environments or the persuasive machinations of 'wicked' peers.

At a more explicit psychological level, Parry identified a distinctly Freudian dimension that even extended to familial reactions to tattoos, that evoked the Oedipal complex, the formative moment in a child's life in which the 'Law of the Father' disrupts the previously 'dyadic' child–mother relationship and making the child aware of sexual difference (Eagleton, 1989). In tattooing terms, this takes the form of Oedipal fears, what Freud (1991) stressed was a regular and important factor in all children's mental life deriving from Sophocles' tale, explaining resentment of the father, which manifested themselves, argued Parry, in the often violent reactions (both verbal and physical) that fathers expressed on the discovery of their sons' 'defiant' tattooed skin. The reasons for the strong reactions went beyond simply critical reactions to their children 'marring' their skin, or contravening religious family tradition, but, curiously, Parry opined that the fathers experienced an attack of their own repressed fears of the homosexual and intimate nature of the tattooing procedure in relation to the relationship that their sons had with their tattooists while being tattooed. Indeed, yet another psychologically repressive aspect of tattooing was central to the act of tattooing, an action that Parry argued contained repressed homo-erotic feelings on the part of the tattooist. As such, Parry argued that in the course of their work, 'certain American tattooers ... betray their homosexual cravings by the way they hold the young boys' arms and legs while tattooing them – not by the double finger pressure customary in tattooing but by the more intimate full grasp of their hands' (2006, p. 36).

Hence, the early readings of tattooing invariably read tattooing as an aberrant art, but one that, whether the impetus sprang from the biological or the psychological, were united in stressing the desire for tattoos as a search to reconnect with the 'primitive', as Parry evocatively describes the practice's cultural proliferation, and class orientation:

> The art of the folk-masses of America: the sailors, the soldiers, the day-labourers, the farm-hands, the cowboys, the miners, the loggers, the hoboes ... The tattoo-medium caters to their feeling for primitive pathos and simple sentimentality. (2006, p. 39)

TATTOO CULTURES

While Parry's work has been criticised for being speculative rather than empirically based in its conflation of tattooing with sexual deviance and sadomasochism (Thompson, 2015) and is now (like Lombroso) regarded as an interesting 'curio' in the social analysis of tattooing, the idea of the practice as a 'folk-art' is a compelling one, and throughout the late nineteenth century, twentieth century and into the twenty-first century, tattooing has developed and evolved into a series of distinctive cultures, and differing societal reactions to both the practice of tattooing and the social actors who elect to be tattooed. With regard to providing categorisation of tattooing, Michael Atkinson, in his book, *Tattooed: The Sociogenesis of a Body Art* (2003a), produced a defining work built upon the argument that the history of tattooing can subdivided into a distinctive genealogical series, or rather, a sequence of distinctive 'Eras' in which tattooing became a significant and highly visible Western cultural practice. Beginning with the 'Colonist/Pioneer' Era (from the 1790s to the 1870s) that were typified by Captain Cook's voyages to, and encounters with, South Pacific tattooing practices, the next substantive eras is what Atkinson refers to as the Circus, or more specifically, the Carnival Era (covering broadly the period between the 1880s–1920s). The Carnival Era represented a dynamic period that witnessed both the popularisation of tattooing as a source of public entertainment, but also its perception as a 'form of social deviance' (2003a, 36). As sailors bearing numerous tattoos returned from their voyages, they sought work in carnivals that promoted them as 'wild men', and which initiated widespread public interest in viewing heavily tattooed bodies. Within this context, the tattooed body quickly became a source of entertainment, and a highly commercialised 'exhibit'.

In addition to Freudian-inspired theorising, Parry's work also contains strong historical content, and conveys the Circus Era in a compelling fashion. While unable to resist the urge to convey the audiences' atavistic dreams and desires in paying to witness the heavily tattooed bodies within the circus-setting (and the copying of such bodies to both reconnect with primitivism and to experience the 'erotic pleasure' of the tattooing 'ordeal'), Parry's work also deftly captures the economic impetus that lay behind the introduction of the tattooed body within the circus setting. The most famous employer of what became dubbed the 'human picture galleries' was P.T. Barnum, founder of the Barnum & Bailey Circus, and his most influential 'galleries' were James F. O'Connell, extensively tattooed in the Pacific as a castaway who then professionally 'presented himself as a text published by Pacific tattoo artists' (Ellis, 2012, p. 21), and Georg 'Georgius' Constantine, whose legend advertised that he had obtained his 388 tattoo designs in Burma as an agonising form of punishment. Barnum displayed Constantine throughout

North America and Europe to great effect, not only financially, but also with regard to the way that Constantine inspired figures such as the future artist, Charlie Wagner to not only obtain tattoos himself, but to learn the craft of tattooing, and the degree to which Constantine inspired other circuses to seek out 'human canvas-backs' (Parry, 2006, p. 63). Significantly, the search for alternative heavily tattooed individuals to act as circus attractions initiated distinctive gender factors into tattooing culture in this early period as women became increasingly visible on the circus and carnival stages.

Extensively tattooed women rapidly entered into the circus environment and quickly, with the exception of Constantine, became stronger attractions than male counterparts. At one level, argues Atkinson, this was because, in addition to directly and dramatically challenging the normative cultural connotations between tattooing and masculinity, the addition of female bodies, that were extensively revealed to show the extent of their bodily artwork, provided an extra dimension of eroticism as the shows served the dual purpose of tattooed bodily spectacle in addition to providing a form of 'soft pornography'. Moreover, in addition to the erotic, tattooed women invariably offered exotic tales to explain their tattooed skin. Consequently, the 'Tattooed Girl' habitually came 'with a yarn about her having been captured by the Indians and tattooed when she was a little girl' (Parry, 2006, p. 64). However, the audience-grabbing tales charting the origin of tattoo designs would also be evocative of what Edward W. Said dubbed of nineteenth century Western discourses as the 'imaginative demonology of "the mysterious Orient"' (1995, p. 26). Consequently, two prominent tattooed women, May Brooks and Annie Howard were born in Pennsylvania, but found themselves shipwrecked in the Pacific Ocean and saved from death by 'savages' who subsequently 'tattooed them until every inch of their bodies, except their faces, hands, and feet, were covered by wondrous scenes and figures' (2006, p. 65). While such tales were enticing to prospective audiences, the reality was more prosaic as Brooks and Howard had received their tattoos from the very American artists, Martin Hildebrandt, Samuel F. O'Reilly, Steve Lee and Frank Howard (Annie Howard's brother).

Yet, while the introduction of female tattooed bodies was all part of the audience-grabbing (and profit-generating) 'huckster' ethos of the circus, the introduction of tattooed women did signify a distinctive gender shift in the practice of tattooing. In addition to Lombroso, writing in 1908 on the link between 'ornament and crime', the Austrian architect, Adolf Loos criticised the rise in turn-of-the-century 'fashionable tattooing' and was especially critical of women acquiring tattoos as, in his view, it did not constitute merely females adopting an overly masculine bodily practice, but, rather, the tattooed female constituted a distinctive aesthetic category which signalled atavistic behaviours because, as Loos stated, 'in the final analysis women's ornament goes back to the savage, it has erotic significance' (in Botz-Bornstein, 2012, p. 57).

In the view of Margot Mifflin, in her book *Bodies of Subversion*, the presence of heavily tattooed women within the circus environment did have great significance, but not in the negative sense that Loos implied as it represented far more than just exotic or erotic spectacle. As Mifflin states of the significance of tattooing within this context,

> [n]o form of skin modification is as layered with meaning as tattooing, especially for women. Tattooed women of the 19th and early 20th centuries flouted Victorian ideals of feminine purity and decorum, gradually peeling them away like so many starched undergarments. (2013, p. 4)

Many tattooed women would feature on circus stages in this era, such as Irene 'La Belle' Woodward, Betty Broadbent, Serpentina, Pictura, Lady Viola and Nora Hildebrandt. Moreover, these tattooed performers occupied a paradoxical gendered status. As Christine Braunberger observes, on the one hand, many women provided an extra dimension of male-audience-member titillation through not only bodily exposure, but also through their lurid tattooing tales that effectively 'consisted of tattoo rape' (2000, p. 7), while on the other, the financial rewards that performing in the circuses provided granted tattooed women a level of economic independence and opportunities for international travel that would be otherwise difficult, if not impossible, to obtain in alternative employment at the time. However, the Carnival Era was not to last because, as Parry states, the proliferation of tattooed performers, both male and female, would sound the death knell for the tattooed era as the increased number eroded the exotic and rare 'freak' attraction of such bodies, although Barnum did attempt to keep audience interest alive with the addition of ever more lurid and sensational tattoo acts such as, tattooed dwarves, tattooed wrestlers, tattooed knife-throwers and even heavily tattooed daredevil motorcycle riders.

As the carnival attraction of the tattooed waned, tattooing as a practice significantly developed, and tattoo artists and tattoo parlours were increasingly established in numerous American cities, with a clientele drawn predominantly from the military and the working class, to ultimately signify what Atkinson dubs the Working-Class Era (spanning the 1920s to the 1950s). Furthermore, the nascent body modification industry had a distinctly illicit nature, as the early tattoo parlours were located 'down dirty alleys, in pool halls, and generally spread across areas of cities characterised by poverty and crime and representing a 'social club for those existing on the margins of society' (2003a, p. 36). The standard form of design offered consisted of 'Flash' art, tattoo designs displayed on the walls of parlours that were chosen by clients and would typically consist of military insignia, names, hearts and banners, cartoon characters, skulls and daggers, eagles, snakes and flags. Yet, these designs were seldom random and devoid of meaning. As Parry argues,

many Flash designs carried distinctive symbolic meanings. For example, serpents represent symbols of wisdom and eternity, tiger motifs signify strength, while roses symbolise love and constancy. But, the wider social 'reading' of such motifs etched in skin was dominated by its association with the disreputable strata of society. And this connection would endure throughout the next phase of tattooing culture: The Rebel Era (spanning from 1950 to 1970).

The Rebel Era, developing in the immediate post-World War II period, saw both the proliferation of tattooing as a Western cultural practice and its degeneration in terms of widespread social reactions. In part, this was because many individuals elected to wear tattoos as deliberate badges of defiance against social conventions, to 'advertise their collective discontent with society', and as such, tattooing became popular 'among members of the social underbelly – 'deviant' groups (Atkinson, 2003a, p. 38), cementing the tenacious association between tattooing as a practice that signifies 'danger and transgression' (Rojek, 2007, p. 79). Arguably, then, youth cultures and particularly motorcycle gangs in the 1950s and 1960s used tattoos in keenly semiotic ways, in a process of symbolic transmission and social reception. Consequently, North American motorcycle gangs adopted tattooing as a deliberate signifying practice and their 'highly visible tattoos were an encoded language of rebellion' (2003a, p. 40); and their symbolic 'messages' were 'decoded', argues Atkinson, by wider social groups as visible indicators of the wearer's 'predisposition to crime' (2003a, p. 41).

Although Lombroso's positivism had been long relegated in terms of its validity, the essence of his ideas, that tattoos, and the choice to have them, were an outward sign of criminality, was reinforced by individuals who acquired them because of their power to symbolise rebellion and social nonconformity. While having tattoos manifestly are not signs of innate criminality, they were culturally read as belonging to individuals associated with the 'criminal and outlaw spheres' (Lombroso, 2006). In this regard, tattoos served as distinctive subcultural signs, a factor that contemporary commentators argue they still perform. For instance, Kamaludeen Mohamed Nasir's study of Muslim Malay youth gangs in modern Singapore draws reference to the ways in tattoos express core aspects of classic youth subcultures theories, from their search for a sense of collective symbolic identity (however short-lived or illusory), resistance to overarching hegemonic social forces and dominant cultures, or the semiotic appropriation of artefacts and trends within prevailing fashion systems (Brake, 1980; Hebdige, 1979). More significantly, the study also identifies distinctive and globalised manifestations of these classic principles. In Mohamed Nasir's sociological assessment, the weak and fragmented traditional social bonds within many contemporary urban spaces means that the formation of gangs represents the creation of alternative forms of coherent social networks, especially for young people who may be

marginalised from conventional social values and organisations, and where tattoos can play a vital role in this particular global context. This is because

> [w]hile tattooing has always been a feature of gang membership, it is even more significant as an aspect of social membership in the ambiguous cultural context of a multiracial society like Singapore. Fundamentally, tattooing among the Malay youth (who are predominantly Muslims) has a transgressive quality since Islam specifically condemns tattooing and bodily ornamentation. (2016, p. 952)

Although subject to censure within the Malay Muslim Singaporean community (which constitutes roughly 13.4 per cent of Singapore's population), tattoos serve as symbolic modes of establishing group solidarity within the Chinese-based ethnic demography of Singapore. As such, with reference to the 369 gang (and via ethnographic interviews and observation), Mohamed Nasir argues that many Malay members, in addition to wearing tattoos as a form of gang identification, deliberately opt for tattoos designs that are non-Muslim Chinese symbols, images and script on their bodies, and so consequently 'tattooing, which is so often cited as a sign of social dislocation, serves as a prosocial activity among gang members' (2016, p. 955). Furthermore, youth tattooing is all the more prevalent in this regard given the fact that unlike within Western societies, the tattooing industry in Singapore is unregulated by the state, and as such has experienced growing numbers of young people acquiring tattoos (Mohamed Nasir, 2015).

The use of tattoos as a means by which to establish an alternative 'subcultural' community redolent of Atkinson's Rebel Era was/is also flagged within studies of the use of tattooing in regard to prison cultures that significantly developed during the 1950s and 1960s, in which tattoos acted as 'identity symbols' within penal institutions. While much of the research surrounding the practice of tattooing examines the medical risks of Hepatitis C (HCV) and HIV infections due to unhygienic tattooing tools and needle sharing (Awofeso, 2002; Hellard, Aitken and Hocking, 2007; Abiona, 2010; Sia and Levy, 2015), the cultural factors have also been documented. For instance, DeMello articulates the ways in which tattoos play a vital role in the construction and maintenance of exact social boundaries. As such, the images chosen traditionally were the 'loca', a design which communicated the name of the convict's home neighbourhood, serving 'as a reminder of the community to which the displaced convict belongs' (1993, p. 11). Here, then, tattooing arguably forms an individualised defence against what Erving Goffman dubbed the 'mortification of self' processes redolent of the total institution, the stripping away of the primary 'adult' constituents of identity in terms of self-determination, personal independence and freedom of action. This is so

because incarceration within a total institution imposes both the removal of physical possessions and the 'loss of identity equipment' (1991, p. 30).

Tattooing, argues DeMello, subsequently acts as a means of creating an alternative common culture within a prison setting that has removed artefacts of cultural individuality, either as a collective 'convict' community or as members of distinctive ethnic or gang-related subcultures, enabling them to produce autonomous meanings within their 'institutionally mortified' lives in the form of fixing meanings and memories and cultural images on their bodies (Thompson, 2015). Developing this theme, Laura Manuel and Paul D. Retzlaff (2002) have argued that, while the motivations for acquiring tattoos within a prison setting can be entirely mundane, representing reactions to boredom and prison-created ennui, the symbolic factor has endured. For example, the sporting of the lagramas design (the tattooed tear drop that can signify either the length of time served, or, more ominously, the number of people that have been killed by the wearer) can give tattoos a role in acting as both a form of 'exoskeletal defense' and as communication affiliation with a specific prison-based subculture, and which can also act as a defensive mechanism against physical attacks (2002, p. 529). As such, tattooing within this period displayed a tattooing culture that possessed symbolic characteristics and functions.

The link between penal punishment, incarceration and tattooing is a long-standing one. For example, while the Han dynasty in ancient China used tattooing as a mode of punishment, it also became a practice that became a judicial practice in Japan (DeMello, 2014a). As Sanders (2008) explains, the initial period of Japanese tattooing spanned from the fifth century BC to AD fifth century but it was revived in the thirteenth century as a method for permanently marking criminals with tattooed symbols that denoted the type and location of the crime they had committed. Moreover, subsequent developments in Japanese tattooing art would constantly be the subject of state censure. However, the technique of Irezumi, centred upon the tattooing of highly ornate designs of heroic and mythic figures that covered large sections of the body, would burgeon in Japan until it's banning in the mid-nineteenth century by the Emperor Meiji who regarded it as immoral, but also as a potential signifier of barbarism to Western visitors. In this fashion, Irezumi would become an underground practice (legally prohibited until 1948) and the one most contemporaneously associated with the Japanese organised crime group, the Yakuza. Moreover, Japanese tattooing has contemporaneously displayed the instability of attitudes towards the practice of tattooing, as it is a form that has consistently negotiated a fine line between censure and social acceptance. As an artistic form, the traditional Japanese style is revered as one of the most respected expressions of the craft from the perspective of both the

artist and the recipient of such tattoos. As Takahiro and Katie M. Kitamura argue in their book, *Bushido: Legacies of the Japanese Tattoo,*

> [t]he Japanese tattoo is … one that requires years of commitment and severe discipline; a Japanese tattoo is not something one can complete on a drunken night on the town, but requires the repeated endurance of severe pain in the form of an extended series of appointments and sessions that can last as long as ten years. (2001, p. 7)

Yet, irrespective of the centuries-old traditional craft and artistry that typifies Japanese tattooing, the practice has habitually been characterised by one of discretion given its semi-legitimate status in relation to the practices of organised criminal gangculture, and the wearing of tattoos is still deemed an impediment to employment, and a source of censure in public leisure spaces such as gyms and swimming pools. Consequently, tattooists have worked in a 'grey zone' of not being formerly recognised as professionals, but not having their practice legally prohibited. But, this has changed as tattoo studios have been the subject of police raids, with artists being fined substantial sums in relation to a 2001 issued legal notification that included a reference to tattooing being an illegal activity if performed without the possession of a medical license. Although predominantly ignored by authorities, the caveat is increasingly being enforced, leading to the closure of many studios in major cities such as Osaka and Tokyo and the cancellation of major Japanese tattooing conventions. Hence, as the social and cultural disreputability of being tattooed in Japan has dramatically increased, many artists have emigrated or abandoned the practice, as it is deemed socially unacceptable. As one prominent artist, Gakkin, states of the perception of tattooing in modern Japan

> [m]any Japanese citizens are still showing unpleasant feelings towards tattoos. They like tattooed football players and rock stars, but at the same time don't want to share a swimming pool with someone who looks like them. (Travellin' Mick, 2016, p. 75)

A significant factor that emerges from appraisals of the 'Rebel Era' of tattooing is the primacy of subcultural symbolism that surrounds it, that tattoos, regardless of quality, signify some kind of communicative meaning, or at least represent a mode of communicative identification, be it signs of gang membership or a form of visual prison argot (a theme that will be returned to in chapter 3). This is significant because the 'signalling' ethos becomes central to subsequent developments within tattooing, and an attitude that transcends the subcultural in the period that Atkinson calls the 'Tattoo Renaissance', or 'The New Age Era', identifiable from the early 1970s. This was the beginning of a period in which, as Susan Benson states, tattoos came to be recognised

as 'statements of the self' and no longer the result of 'drunken impulse or forcible subjection', but 'chosen after much deliberation' and representing declarations of 'me-ness' (2000, pp. 244–245). This period marked a decisive shift away from the association of tattooing with social stigma or disreputable and/or 'criminal' classes, and into one of the embrace of tattooing as a means of self-expression. A driving force in the rise of the 'Tattoo Renaissance' was improvements in tattoo machine technology and a greater array of ink pigments, greater levels of sanitation, practitioners from art school backgrounds (such as Don Ed Hardy), and increased levels of professionalism within tattoo studios (consultations and appointments rather than drop-ins), all of which facilitated greater opportunities for 'clients' to acquire customised tattoo work in lieu of stencilled Flash art; designs explicitly tailored for the person to be tattooed that were distinctive, if not unique. Consequently, from the 1970s onwards, tattoos progressively became ' "chic products," "personal ornaments," "cosmic jewellery" and pigments of imagination – not gaudy kitsch souvenirs' (Wroblewski, 2004, p. 21). Tattooing, therefore, became more personalised, and the motivations linked to self-expression and discernible transformations in class and gendered attitudes to tattooing developed as women and the middle classes became increasingly interested in tattoo culture and increasingly having tattoos applied. Furthermore, alongside the emergence of new, socially diverse audiences, there were increasingly 'globalised' tattoo styles being made available such as, Japanese, New Zealand, South Pacific and African, in addition to a resurgence of interest in American Traditional – the style synonymous with the early twentieth century 'Bowery slum' tattoo parlours.

As DeMello argues within her cultural history of American tattoo communities, she identifies a range of motivations by those who have elected to have tattoo designs that have consciously communicative functions and significances. As such, the impetus for being tattooed includes group affiliation, commemoration of a significant life event, dissatisfaction with wider society, but also, from the 1980s and into the 1990s, the reinterpretation of tattoos as an ill-considered sign of a lack of discipline and bodily foresight (due to their permanence) to artistic and expressive 'signs'. This was in part, argues DeMello, related to issues as politically disparate as the development of feminism and women's spirituality, ecology groups and New Age and self-help movements. Consequently, 'Tattooing began, for the first time, to be connected with emerging issues like self-actualization, social and personal transformation, ecological awareness and spiritual growth' (2000, p. 143).

At one level, the tattooing process itself was interpreted as a 'spiritual' act, expressed in terms of Christian symbols, and so on, or distinctive tribal designs drawn from non-Western religions and ethnic traditions. In this regard, the tattooing of religious/tribal motifs act as sources or inspiration, or as symbolic mechanisms with which individuals mark or confront personal life issues. At its

extreme, adherents of the tribal styles have, in conjunction with other techniques of body modification (piercings, scarification, branding) utilised tattooing as part of a symbolic rejection of the dominant mores of Western culture. As part of a movement that Vale and Juno (2010) dubbed the 'Modern Primitives', they critique a society that is held to be 'alienating, repressive, and technocratic and that lacks ritual, myth, or symbol' (2000, p. 175). But in a less extreme form, the embrace and use of tattoos as a mode by which to use symbols also became increasingly associated with personal 'storytelling' within wider, mainstream adherents of tattooing, and marked by the social 'taboo' of tattooing diminishing as the traditional class nature of tattooing gave way to growing middle-class enthusiasm for the art and practice (Pitts, 2003). A key issue within the 'Tattoo Renaissance' has been the extent to which individuals have mapped out on their bodies specific designs that represented values, events or memories that were exclusive to their lives and created via customised, only-for-them work. Such tattoos enable social actors to 'speak' through symbols and use them as 'an "expression" of the self and for "self-realization"' (Benson, 2000, p. 250). In essence, such personalised communicative practices that draw upon the raw materials of popular culture to adorn aficionados of that culture epitomise the era of tattooing Atkinson calls 'The Supermarket Era' that covered the latter 1990s and the early 2000s. This era is characterised as a consumer market in which clients shop around for the best artists (who charge market-dictated fees) in a field that is (as opposed to the classic Flash tradition) driven by the principles of freedom of expression and self-exploration, and in which tattoo culture is a heterogeneous practice underscored by the provision of highly personalised designs. As one artist interviewed by Atkinson stated of his artistic ability and approach to clients, 'If you can think it up, I can do it' (2003a, p. 47).

THE ERA OF INKED INDIVIDUALISM

A key element of perceptions of the development in tattooing culture throughout the twenty-first century has been the distinctive artistic quality that has emerged. As Lola Mars states, 'Tattoos are art; and an art form at the peak of groundbreaking innovation at that … Simple outlines and a limited palette have exploded into watercolours, photorealism, and pen-and-ink works of art' (2015, p. 5). Consequently, the principles of custom-work, superior levels of tattooist talent (if affordable, of course), and the primacy of tattoos acquired to display personal appraisals of self is such that the current era within Western cultures may arguably be dubbed the Era of Individualist Populism. The seemingly contradictory quality of the nature of the term is accurate as the motivations for tattooing are frequently driven by the desire to mark the body with an expression of the individualised self, while being part of a bodily

process that has arguably attained its highest degree of social and cultural visibility and apparent social acceptance.

In analysing contemporary tattoo culture, Kyle Fruh and Emily Thomas draw attention to the proximity between design choices and personal identity to explain the degree to which people 'regularly use tattoos to externalise some aspect of their inner lives, or as a way of marking or remembering significant events in their histories' (2012, p. 83). Employing tattoos as part of a personal strategy to construct a narrative of self has frequently been related to distinctive postmodern social and cultural configurations that reflects Jean-François Lyotard's (1986) rejection of metanarratives of truth to be replaced by multiple (and potentially conflicting) discourses of knowledge. The resultant 'postmodern condition' that arose from these shifts was one in which a number of cultural configurations 'take shape, persist for a duration, and then disintegrate' (Lash, 1990, p. 4). At the level of the individual, the nature of the postmodern condition has been read as one that is predicated upon an accelerated speed of living and communication that actively influences the identities of social actors so that identity becomes more and more unstable and fragile, to the ultimate extent that identity can be experienced as being nothing more than 'a game that one plays' whereby 'one can easily shift from one identity to another' (Kellner, 1992, p. 153). Perhaps it is no coincidence that it was in the 1980s, the period which represents postmodernism's 'high watermark', that the 'Tattoo Renaissance' evolved into the 'Supermarket Era', as tattoos arguably became a means by which to resist identity instability and attain a modicum of fixity of self-image.

So, the increasing vogue of tattooing across diverse class and gender lines from the 1980s onwards has been interpreted as a means by which individuals attempted to secure a sense of stable identity in a potentially bewildering, fluid postmodern world through the permanence of tattooed symbols and signs (Sweetman, 1999). Moreover, argue Fruh and Thomas, this philosophy which has continued in the twenty-first century and is a dominant trope of contemporary tattoo motivation because they are a potent means by which an aspect of identity, from the deeply personal and significant (a memorial or relationship statement) to the playful and irreverent (images of Pokémon – a highly common tattoo choice, or personal/family jokes or nicknames), can be secured to symbolically unite a person's past, present and future self. Consequently, in the face of hyper-accelerated societies predicated upon social instability and ceaseless change, Fruh and Thomas stress the degree to which tattoos can play a decisive anchoring effect to counter such a cultural maelstrom:

> As years and miles add up, it becomes easy to feel adrift in your own life. A couple of anchors can keep you in touch with where you have been, commit you to being somewhere you want to be, and provide a fixed points by reference to

which to chart new voyages. This is the chief contribution tattoos can make to narrative personal identity, and one way of explaining how inking it can make you feel at home in your own skin. (2012, p. 91)

Hence, the attempt to communicate some aspect of the self, if only to the self, remains a powerful motif within the reading of tattoo cultures, and the quest for personalised expressions is one that has become culturally evident in recent years in relation to the likes of Reality TV. Furthermore, given continual technological and artistic advancements made within the tattooing industry in recent years, there are seemingly few limits to what can be rendered as an image on a person's skin.

The relationship between identity, tattooing and self/being will be explored in more philosophical detail in chapter 3, however, the increase in the number of people acquiring tattoos, the populist component of the modern era, is not simply one emerging from personal choice, but one that also reflects both representations of tattooing practice within popular culture, and tattooed imagery within that same culture. At one level, tattooing has seen individuals become part of distinctive tattoo 'communities' given that there are now a myriad of distinctive tattooing styles and artistic specialisms, including, Realism, Black and Grey, Portraiture, Biomechanical, Dotwork, Geometric, Traditional and Neo-Traditional, Japanese and Neo-Japanese, New School, Stick and Poke and Trash Polka. Moreover, while the individual meaning of and rationale for a tattoo design is a key factor, nevertheless trends in tattooing are now seeing many individuals wearing exactly the same designs, to the extent that specific styles are becoming distinctive trends, and sometimes short-lived trends, such as, stars, arrows, pocket watches, mountains, dots, arm bands, and mandalas – all of which may be problematic given that a fashionable trend that is permanent is a problematic aspect of contemporary tattooing culture. But, the role of fashion, Reality TV and increasingly (and significantly), celebrity, as both representative of tattooing currency and inspiration to be tattooed, has become a substantial factor of modern tattooing. As such, perhaps a more accurate adjective for the latest 'era' is that of the Individualist Popular Media Era, as tattooing is now such a perpetual cultural presence.

NOTE

1. Tattooing is both historically and contemporaneously a global phenomenon and as such this chapter encompasses the extensive global histories of tattooing. Readers wishing to gain an expansive international historical perspective on the development of tattooing should refer to Anna Felicity Friedman (2015) *The World Atlas of Tattoo*. London: Quintessence and Maarten Hesselt van Dinter (2005) *The World of Tattoo: An Illustrated History*. Amsterdam: KIT.

Celebrity Skin

Tattoos and Popular Culture

While, as the previous chapter explored, tattooing has evolved in a number of ways to become a key aspect in many individuals' technologies of self and self-expression, popular culture has also played a key role in communicating images of tattoos and tattooed bodies. As Ina Saltz states of the 'normalisation' of tattooing, a key influence is 'unquestionably the new cultural aristocracy: film stars, the kings and queens of rock, sports heroes, celebrities and artists of every persuasion. The tattoo world has now become the ultimate in chic' (2006, p. 13). As such, this chapter will explore some of the key popular cultural expressions of tattooing, from novels and films to Reality TV and celebrity, illustrating the range and nature of a contemporary tattoo culture that expresses individualist expression with populist inspiration and, in some instances, can inspire the direct emulation of cultural trends and personalities.

TATTOOING IN PRINT AND ON SCREEN

In terms of cultural expression, tattooing has a long history within literature that spans a diverse range of genres, from the romance of Carl Van Vechten's *The Tattooed Countess* (1987 – first published in 1924), to Ray Bradbury's fantasy/science fiction collection, *The Illustrated Man* (1972), in which tattoo designs mysteriously act as a framing device to introduce a portmanteau of fantastic stories. Within a more classical context, arguably one of the first major characters to exhibit tattooing was Herman Melville's Queequeg, Ismael's harpooner companion aboard the Pequod, as the crew in Captain Ahab's quest to kill the legendary white whale, Moby Dick. Although they form a firm bond of friendship, Ismael's initial reaction to Queequeg is one of fear, not least of which results from the harpooner's extensively tattooed

skin, as Ismael decries on first seeing him: 'Such a face! It was of a dark, purplish, yellow color, here and there stuck over with large, blackish looking squares' (2003, p. 23).

Writing of the cultural history of tattoos, Mascia-Lees and Sharpe point to the ways in which tattooing, an ancient art of 'bodily mutilation', views the body as a 'surface or ground onto which patterns of significance can be inscribed' (1992, p. 147) and identify further literary expressions of tattooing which exemplify this approach. For instance, they cite Tanizaki Junishiro's short story, *The Tattooer*, based upon both the exquisite art of tattooing and also the masochist qualities frequently attributed to it. In terms of narrative, *The Tattooer* tells the story of the tattoo artist, Seikichi, whose high level of skill is motivated by a specific form of desire: 'His pleasure lay in the agony men felt as he drove his needles into them, torturing their swollen, blood-red flesh; and the louder they groaned, the keener was Seikichi's strange delight'. (Junishiro, 1991, p. 162) However, the essence of the tale centres upon Seikichi's yearning to tattoo a woman in order to reveal her 'real beauty'. On identifying his ideal 'princess', Seikichi drugs her, and tattoos an immense black widow spider on her back, and the result is an image of horror, an effect reinforced by the forcible nature of the tattooing process: 'Slowly she began to recover her sense. With each shuddering breath, the spider's legs stirred as if they were alive'. (1991, p. 168) And yet, the final moment of the story establishes the beautiful nature and power of the art

'Let me see your tattoo once more', Seikichi begged. Silently the girl nodded and slipped the kimono off her shoulders. Just then her resplendently tattooed back caught a ray of sunlight and the spider was wreathed in flames. (1991, p. 169)

In other instances, literary evocations of tattooing have similarly fused the beauty of tattooing with obsession, such as the crazed Japanese artist, Ishy, in John Burdett's crime novel, *Bangkok Tattoo* (2006), who murders his own clients in order to gruesomely 'reclaim' his now financially valuable artwork through the removal of their tattooed skin. However, the artistry of tattooing has also been potently evoked within novels such as Sarah Hall's *The Electric Michelangelo* (2004), which charts the apprenticeship of Cy Parks to Eliot Riley, in the years shortly following the First World War. A key aspect of the narrative is the focus upon the artistry of tattooing, and the novel evocatively captures the essence of the Circus/Carnival Era when, having emigrated to America, Cy sets up a studio in Coney Island and meets Grace, who requests that her body is covered in tattooed eye designs so she can act as the carnival attraction, 'The Lady of Many Eyes'. Similarly, John Irving's novel, *Until I Find You* (2006) sets the character of Jack Burns and his search for his

heavily tattooed father, William, against the backdrop of 1970s European tattoo cultures, as Jack moves from country to country with his tattoo artist mother, Alice, who works as a guest artist in various European tattoo studios in addition to providing tattoos to clients in the varied hotel rooms she and Jack inhabit. While centrally a narrative detailing the effects of a fractured family, the novel provides a recurrent and highly detailed insight into the beginning of the 'Tattoo Renaissance' cultural scene and the craft of the tattoo artist.

Taking a further historical perspective, Jill Ciment's *The Tattoo Artist* (2005) explores the nature of tribal tattooing as both a source of art and punishment, emphasising the beauty and violence of both tattooing and Western arrogance and cultural incursion. Based upon the characters of artist, Sara Ehrenreich, and her husband, Philip, who, prior to the Second World War, voyage to the island of Ta'un'uu to collect tribal masks for an industrialist art collector, they establish contact with the island elder, maker of masks and tattooer, Ismael. However, they are later mistakenly held responsible for the death of Ismael's granddaughter, and as a punishment, they are forcibly tattooed by him in the island custom, with both given extensive facial designs against their will. Although the designs are initially reacted to with horror, Sara begins to tattoo both herself and Philip with her own designs, telling their own stories, a process that continues for the decades that Sara remains on the island, and until every inch of her body is covered with designs. Consequently, *The Tattoo Artist* conveys the symbolic and communicative nature of tribal tattooing with a wider consideration of the self-signifying potential tattooing possesses within contemporary culture, as Sara reflectively states of her art: 'My tattoos, like all the tattoos of my island, are a pictorial narrative, an illustrated personal history, though not necessarily a chronological one' (2005, p. 4).

However, it was arguably Stieg Larsson's crime novel, *The Girl with the Dragon Tattoo* that established 'the first famously inked literary heroine' (Mifflin, 2013, p. 101) in the form of Lisbeth Salander, a highly gifted computer hacker, who, with her various piercings and extensive tattoos (on her neck, arms and ankle) is visually characterised by the large dragon tattoo that she wears on her left shoulder. Indeed, in addition to her proudly displayed bodily ink, Salander also utilises tattooing as a tool for revenge, inking the 'confession': 'I AM A SADISTIC PIG. A PERVERT, AND A RAPIST' into Bjurman's (Salander's court-appointed guardian) stomach as a permanent punishment for his crime of raping her. However, newer tattooed heroines have also emerged within popular fiction, such as Beatrice 'Tris' Prior, the central protagonist in Veronica Roth's YA (Young Adult) science fiction novel, *Divergent*, who, in the course of her training to serve within the Dauntless faction, acquires a number of tattoos, including the Dauntless faction seal as an expression of 'tribal' communal fidelity. However, the novel (the first in a

series of four) also features her broody military trainer, Four, whose back is entirely covered with a design that combines the five factional symbols of the future dystopic society: Dauntless, Abnegation, Candor, Erudite and Amity.

In addition to the film adaptations of *The Girl with the Dragon Tattoo* and the *Divergent* series, tattoos and tattooing has also found potent visual expression within film and television across a variety of genres. For example, the thriller *Tattoo* (Bob Brooks, 1981) tells the story of a tattoo artist who is commissioned by an advertising firm to design fake tattoos onto the bodies of fashion models, but who then kidnaps one of the women and forcibly tattoos her chest, shoulders and back. But unlike the acceptance of the design expressed within Junishiro's *The Tattooer*, the reaction of his 'muse' is one of horror, bodily violation, and ultimate violent and murderous retribution due to her 'experiencing the tattoo as worse than death' (Mascia-Lees and Sharpe, 1992, p. 152). Moving centrally into horror, the film *Tattoo* (Robert Schwentke, 2002) concerns a serial killer story about a killer who murders people with tattoos and skins them for their designs, while the New Zealand-set *The Tattooist* (Peter Burger, 2007) combines traditional island tattoo traditions with a supernatural ghost revenge theme. Alternatively, *Memento* (Christopher Nolan, 2000) sees the employment of tattoos as a distinctive signifying mechanism used by an amnesiac (whose memory keeps periodically 'wiping clean') to attempt to map out clues to both his identity and as a means of solving a murder, while *Eastern Promises* (David Cronenberg, 2007) explores the highly nuanced semiotic significance of tattoos worn by members of the Russian mafia. Popular television, too, has also weaved signifying tattooing into narratives, for example, crimes series such as *Prison Break* (2005–2009), the Tom Hardy-starring series, *Taboo* (2017–), and the action drama, *Blindspot* (2015–), another tale of an amnesic who awakens to find her entire body covered in mysterious tattoo designs, the significance of which she has no memory of receiving nor any understanding of what the images signify. Finally, within the third series of the serial killer drama, *Hannibal* (2013–2015), the murderer, Francis Dollarhyde's William Blake-inspired Red Dragon back-piece tattoo design frequently becomes an animated character in its own right, as he imagines it coiling and moving across his body.

However, in addition to televisual dramas that feature tattooing, television has significantly increased coverage of tattooing and tattooists in a series of Reality TV shows that are centrally based upon the subject of tattoos, and, as such, have proven to be a potent source within the modern popularisation of tattoo culture. As Guy Aitchison, an influential tattoo artist famed for his biomechanical style has stated: 'There's been a lot of talk lately about the tattoo Reality TV craze and the impact that it has had on the profession. One major effect is that it has created a bridge for the average person to visualise themselves actually getting inked' (Thorne, 2012, p. 6). Certainly, from 2005 there

has been a significant surge in tattoo-themed Reality TV shows, from series which chart the work of artists and interactions with their clients, such as, *Miami Ink* (2005–2008), *LA Ink* (2007–2011), *London Ink* (2007–2008), *NY Ink* (2011–2013), *Tattoos After Dark* (2014–), *Bondi Ink Tattoo Crew* (2015–) and *Tattoo Girls* (2016–). In addition, Reality TV formats also focus upon 'tattoo disasters', charting the work of artists who repair clients' poor work, or provide high-quality cover-ups, such as, *Tattoo Nightmares* (2012–), *Tattoo Rescue* (2013–), *Bad Ink* (2013–), *Bodyshockers* (2015–) and *Tattoo Fixers* (2015–). Although the professional American tattoo community were initially critical of the *Miami Ink* format due to the fears of a negative reaction to the televisual revelation of the nature of tattooing's 'secret society' (Von D, 2009), the effect of such shows has been to significantly popularise tattooing, because, as Rakovic states, they 'took the tattoo shop experience and beamed it into the homes of soccer moms in Ohio. The nuclear family that would have never dared peek into the window of a tattoo parlor could safely play a fly on the wall thanks to reality television. Not only did they like what they saw, they wanted in – they wanted ink' (2012, p. xi).

The genre ultimately dubbed 'Reality TV', rose to prominence through the 2000s, particularly in the wake of the success of the interactive game-show series, *Big Brother*. For many commentators, the intrinsic appeal and distinctiveness of Reality TV is that it specifically involves '*real people*', individuals who have been 'plucked from obscurity and turned into stars, not because of any special talent, but just because they seem personable' (Cummings et.al., 2002, p. xii). In this regard, Reality TV is a televisual genre that has been argued to be 'located in border territories, between information and entertainment, documentary and drama' (Hill, 2005, p. 2). In the course of the development of the Reality TV genre, it has added variants such as the chronicles of individuals who lead glamourous and wealth-created fantasy lives (*The Real Wives* series or *Keeping Up With the Kardashians*), and those which focus upon individuals with 'interesting jobs' such as, bounty hunters, pawnbrokers, storage bin bidders, deep sea fishermen, repossession agents and tattoo artists. Certainly, tattoo-themed shows have been hugely success-ful, as Carmen, Guitar and Dillon (2012) note, when first broadcast, *LA Ink* garnered the highest-rated series premiere in the TLC network's history in the 18–34 viewer demographic, and variants on the *Miami Ink* model have continued to be produced and broadcast.

For example, *Ink Master* (2012–), hosted by former Red Hot Chili Peppers and Jane's Addiction guitarist, Dave Navarro (who sports an extensive array of tattoo designs), represents a significant Reality TV hybrid as it combines the tattooing craft-focus of the likes of *Miami Ink* and *LA Ink* with a distinc-tive game show format in that a number of tattoo artists live within a large studio setting and compete on a series of tattooing challenges (using 'human

canvas' volunteers) to ultimately determine who will be crowned the Ink Master, the awarding of which brings a $100,000 cash prize and a profile feature within *Inked* magazine. As with *Big Brother*, an artist is evicted from the show on a weekly basis, and similarly a significant focus of the series involves the various human conflicts that arise between the artists and the assorted strategies and 'gameplay' that they employ in order to outperform their rivals and gain the coveted title of Ink Master. As such, *Ink Master* deftly expresses a key characteristic of Reality TV that sees 'characters vices into virtues' (Cashmore, 2006, p. 189) in order to maximise entertainment values. Furthermore, the series has now produced a spin-off, *Ink Master: Redemption* (2016–), in which artists are reunited with human canvases who received critically derided designs in order to 'atone' and provide an aesthetically satisfying tattoo. *Ink Master* demonstrates the extreme aspect of the series as one human canvas is voted to have the 'worst tattoo' of each episode, a factor that they cannot remedy given the permanence of the work (indeed, at least one canvas has appeared on *Tattoo Nightmares* to have a poor design covered up with a new and superior tattoo), and, importantly, reiterates the lastingness of tattoos to remind those who are drawn to tattooing via Reality TV of the risks of engaging in a 'fad you can't toss away' (Kosut, 2006, p. 1040).

However, tattoo-themed Reality TV shows provide a distinctive trait that explains both their appeal, and the ways in which they have contributed to the prevalence of tattooing within contemporary culture. As Louise Woodstock argues, shows such as *Miami Ink* contained a unique therapeutic quality in the stories that form the heart of their narratives, and continued in the other versions which have followed. As such, tattoo-themed Reality TV shows have emerged as a premier source of therapeutically motivated narratives of the self, a factor that reflects the symbolically expressive 'me-ness' that wider tattooing culture is argued to be characterised and influenced by. As Woodstock explains,

> [e]ach interaction between tattoo artists and client becomes an opportunity to tell a story about transforming significant life experiences into affirmations of individual identity and familial loyalty. At the heart of this exchange sits the tattoo itself, saturated with symbolism. Time and time again, both artists and clients endow tattoos with transformative power and consider them expressive marks of both inner self and the social bonds that unite the self and loved ones. Tattoo artists facilitate the attribution of meaning to tattoos. As they work, the tattoo artists almost unfailingly ask their clients to explain why they are getting the tattoo, and by doing so, they invite their clients to tell stories of healing and transformation. (2014, p. 781)

With regard to *Bondi Ink Tattoo Crew*, this ethos dominates the narrative. While the series follows a similar format to Miami, LA, London and NY

Ink, and is built around the premise of the tattoo artist, Mike Diamond, being brought into manage the Bondi Ink studio in Australia, in addition to the 'dramatic' artist conflicts and other business/personality-focused crises, the client testimonies based upon health issues and bereavement are extensive and extended within the series. Moreover, many reflect what Woodstock identifies as a central thematic trope, the memorialising tattoo, designs which are applied in order for an individual to commemorate a person who has died and which can represent a method of grieving or honouring a lost loved one, friend or comrade (Hemingson, 2009). As such, tattoo-themed Reality TV shows demonstrate the ways in which tattooing represents a mode of personalised and individualised symbolic communication through tattoos, a means by which tattoos are not statements of communal belonging, but bold and determined statements of self that can serve as 'visual, personal moral guideposts, reminding the individual of what matters most' (Woodstock, 2014, p. 793). In this regard, the extensive focus upon tattoos as modes of self-expression demonstrates the role in which tattoo-based Reality TV shows have played in the popularisation and 'normalisation' of tattooing in the twenty-first century, however, they have also reflected a further dimension of Reality TV, and one that also explains the intensification of tattoo visibility within contemporary popular culture.

A compelling consequence of Reality TV show has been their ability to 'celebritise' a number of its participants who were previously 'ordinary people' prior to their appearance on television (Holmes, 2004; Biressi and Nunn, 2005; Turner, 2014). In this regard, Graeme Turner (2006) devised the term 'the demotic turn', a concept devised to explain the increasing visibility of ordinary people who are able to transform themselves into media content through platforms such as Reality TV and become notable media personalities by dint of simply appearing on television. Consequently, participants in Reality TV shows as disparate as *Big Brother*, *Made in Chelsea*, *Jersey Shore* or *Geordie Shore* have become significant celebrity figures, and tattoo-based shows have similarly contributed to this process. As such, a number of professional artists, such as, Ami James, Chris Núñez, Oliver Peck, Kat Von D and Megan Massacre, have become distinctive celebrity figures, with a level of fame that has consolidated their professional status within the industry, but also provided a level of celebrity that transcends this vocational arena. However, it is worth noting that while the Reality-TV route to celebrity is frequently derided, representing what Chris Rojek dubs the 'celetoid' – the individual who achieves short-lived fame in the form of 'lottery winners, one-hit wonders, stalkers, whistle-blowers, sports arena streakers, have-a-go heroes, mistresses of public figures' (2001, p. 21) – the tattooist celebrities' fame is built upon years of craft development and talent. Prominent media-based tattooists, such as Megan Massacre (who appeared

in *NY Ink*), who has her own studio in New York, Grit N Glory, are featured in guest artist spots in other studios and appear at tattoo conventions across the world. Therefore, the celebrity status directly works with, and enhances, the tattooing career, raising the artists' profile within the industry and making a tattoo from the likes of Kat Von D, Ami James or Tommy Montroya all the more desirable to clients.

Alternatively, there are also a number of tattoo artists who have become culturally prominent not due to their participation in Reality TV, but due to their intimate and routine proximity to celebrity culture itself via their role as tattooists *of* celebrities. Such artists include Mark Mahoney, who tattooed Tupac Shakur and Hollywood star Johnny Depp; Jon Boy, who has tattooed Kendall Jenner; Keith "Bang Bang" McCurdy, whose work adorns the bodies of Rihanna, Rita Ora and Justin Bieber; Dr. Woo, who has tattooed David Beckham, Brad Pitt, Ellie Goulding, Cara Delevingne, Miley Cyrus, Drake and Chloe Grace Moretz; and Nikko Hurtado, who has worked with Cheryl Cole and Tess Holliday. As a classically trained violinist, fashion buyer and designer, Dr. Woo represents a potent illustration of the increasing merging of the worlds of tattooing, fashion and celebrity, all of which is contributing to the contemporary normalisation of tattooing as a bodily practice whose taboo status is now marginalised. As Dr. Woo reflects on the previous status of tattoos as emblems of nonconformity and barriers to respectable employment, 'We called those job stoppers … But nowadays, if you don't have a tattoo, people think you're square' (in Ferrier, 2014, p. 2). Moreover, celebrity has played a significant role in this transformative attitude.

CELEBRITY INK

In the view of the tattooist, Henk Schiffmacher, tattooing was always classically a dichotomous culture, represented at one end of the spectrum by the 'lower social classes' of the sailors, criminals and soldiers, and at the other by the 'eccentrics of high society', the wealthy and aristocratic, the artistic and the bohemian intellectuals. And this spirit is evident within contemporary tattoo culture, with celebrity as its source. As Schiffmacher states, contrary to popular prejudices, at the turn of the twentieth century,

> [i]t was the elite who had tattoos [and] the elite of today are no different: film stars, the kings and queens of rock 'n roll and many artists have tattoos. They are models to be emulated, the vehicles of culture, they determine the trends. Through their image and their behaviour they influence the life, art, fashion, morals, democracy, emancipation, and thinking of whole societies. (2005, p. 19)

The 'power' of celebrity within contemporary global cultures is a factor that has now been extensively examined and documented within 'celebrity studies', extending from issues of economic power (the prevalence of celebrities within advertising and brand endorsements) to political influence (political advocacy and even political office). It is argued, then, that the cultural primacy of celebrity is based upon its 'capacity to attract attention, generating some 'surplus value' or benefit derived from the fact of being well known (highly visible) in itself in at least one public arena' (van Krieken, 2012, p. 10). Consequently, celebrity is now an endemic aspect of contemporary global popular culture, and a social category whose influence is extensive across a range of key social and individual parameters. As Sean Redmond states of the multifaceted influence of this culture,

> [c]elebrity matters because it exists centrally to the way we communicate and are understood to communicate with one another in the modern world. Celebrity culture involves the transmission of power relations, is connected to identity formation and notions of shared belonging; and it circulates in commercial revenue streams and in an international context where celebrated people are seen not to be bound by national borders or geographical prisms. (2014, p. 3)

Such is the level of influence that this culture has produced, Cooper Lawrence evocatively argues that we now live within the era of the 'celebritocracy' in which psychological conditions dubbed 'celebrity worship' have now become recognised, expressing itself from the ways in which individuals react to celebrities as sources of entertainment or as attitudinal or bodily 'role models', to more extreme degrees of obsessive celebrity fixation (Maltby and Giles, 2008). In the words of Todd Gitlin, such celebrity devotion reflects a social category that is 'slightly larger than life, slightly smaller than divinity' (2003, p. 147). Given such public reactions to celebrity, Lawrence posits the view that 'we worship celebrities and aspire to their lifestyle, who better to influence our decisions; who better to tell us what to buy, who we need to be' (2009, p. 108), and this extends to them acting as tattooed role models.

Reflecting upon the cyclical nature of tattoo culture's respectability throughout its history, Catherine Grognard identifies the influence of celebrity as a key element within the 'renaissance' of tattooing, and its acquisition of fashionable status, a prestige confirmed by stars such as Sean Connery, Gérard Depardieu and Cher becoming constituents of the early wave of celebrity members of what she calls the tattooed 'brotherhood' (1994, p. 25). Moreover, as this tattoo resurgence progressed, so too has the prevalence of tattooing within celebrity culture. While tattoos have long been part of the rebellious nature of popular music, especially that of heavy metal, from long-established musicians such as, Ozzy Osbourne, Nikki Sixx and Tommy Lee from Mötley Crüe, Metallica's James Hetfield, Slayer guitarist Kerry

King, Marilyn Manson, Rob Zombie and Blink-182's Travis Barker, to more contemporary stars, such as Trivium's Matt Heafy, Steel Panther's Stix Zadinia and Simon Neil of Biffy Clyro (to cite but a few). Moreover, such extensive tattooing within heavy metal culture is also mirrored by the genre's fan base as tattooing is also an endemic aspect of the heavy metal fandom, acting as 'a special mark of loyalty to the metal subculture' (Weinstein, 2000, p. 129). Similarly, hip-hop music is also characterised by extensive tattooing as illustrated by artists as diverse as Tupac Shakur, 50 Cent, Eminem, Lil Wayne, Tyga, Wiz Khalifa, Ty Dolla Sign, Iggy Azalea and the appropriately named Kid Ink. Also of interest in this regard is the South African hip-hop band, Die Antwoord, fronted by the tattooed rapper/vocalists Ninja and Yolandi Visser. Tattoos form a central component of the band's distinctive 'Zef' ideology, which derives from a slang term used in the 1960s to describe South African working class white culture, and this ethos is visually denoted by Ninja's extensive array of hand-poked designs that consciously evoke Apartheid-era anti-authority prison tattoos.

Yet, while tattooing plays a distinctive subcultural function within musical forms such as heavy metal and hip-hop, tattooing has progressively become a common motif within mainstream pop music, as evidenced by the tattooed bodies of performers such as, Rihanna, Katy Perry, Beyoncé, Miley Cyrus, Justin Timberlake, Demi Lovato, Lady Gaga, Justin Bieber, P!nk, Cheryl Cole, Nicki Minaj, Harry Styles, Ed Sheeran, Rita Ora, Chris Brown, Adam Levine, Zayn Malik, Selena Gomez, Adele and Lana Del Rey. Moreover, this form of tattoo populism can be similarly identified in the roster of extensively tattooed Hollywood stars, ranging from Johnny Depp, Angelina Jolie, Brad Pitt and Colin Farrell, to Megan Fox, Zoe Saldana, Tom Hardy, Lea Michele and Lena Dunham, to Dwayne 'The Rock' Johnson, Jared Leto, Ryan Gosling, Jemima Kirke and Scarlett Johansson.

For Mary Kosut (2006), the increasing pervasiveness of tattooing within celebrity culture represents both the mainstreaming of tattooing, and its com-modification, but also serves as a further indication of the ways in which celebrity bodies represent objects of imitation. Celebrity influence with regard to body image is a perennial theme within the analysis of celebrity cul-ture (Maltby et al., 2005; Willinge, Touyz and Charles 2006; Nelson, 2012), and it has been complemented by an extensive body modification industry that offers consumers technologies and techniques of bodily modification and transformation in the form of cosmetic surgeons, personal trainers and tattooists (Shilling, 2008). This is a point that Hamish Pringle develops with explicit reference to celebrity culture and the position that celebrities hold as visual role models, stressing the extent to which individuals undertake cosmetic surgeries driven by a desire to emulate specific celebrity attrib-utes, such as breast implants, lip plumping, liposuction, Botox and buttock

implants. Hence, with regard to body image, celebrity's influence is potent, as Pringle states with regard to celebrities offering lifestyle and fashion advice

> [i]ncreasingly, they are telling us how to modify our appearance, not just by means of cosmetics, clothing and other accessories, but by use of medical treatments and cosmetic surgeries. The fact that such a significant number of people are actually going through with this, often using celebrity features as a reference point for their surgeon is indicative of the powerful influence that stars can have. (2004, p. 46)

Kosut applies such imitative behaviour in relation to celebrity to the embrace of tattooing, too, with its potential for fans to acquire designs simply because a favoured celebrity has them. As she declares, 'If the musicians we idolise and sometimes seek to emulate (at least in appearance) have tattoos on their bodies, why not get one ourselves?' (2006, p. 1039). Not surprisingly, this does occur, and not simply in the form of acquiring tattoos as a generic homage to a particular celebrity (e.g. portraits of their faces,), but actually directly copying specific celebrity designs. For example, the pop singer, Cheryl Cole, whose extensive collection of tattoos (such as a much derided Nikko Hurtado-created set of roses on her buttocks) includes a distinctive hand design that was the subject of extensive 'copycat' fan emulation. Similarly, fans have copied Louis Tomlinson' black heart and stag design as a statement of their fandom, while others have mimicked Jon Bon Jovi's Superman logo and Angelina Jolie's distinctive tiger back tattoo design. At one level, these emulative behaviours stress the power of celebrity influence regarding bodily comportment and desirability, while undercutting the uniqueness, or 'meness' associated with contemporary readings of tattooing. This has occurred to such an extent that celebrities themselves have bemoaned the popularity of the practice, such as the actress, Dame Helen Mirren, who, in relation to her acquiring her tattoo, the image of two interlocking Vs tattooed on her left hand decades ago, stated,

> [i]t was a very, very long time ago, when only sailors and Hell's Angels were tattooed, honestly, and prisoners. And I decided to get a tattoo because it was the most shocking thing I could think of doing [and] now I'm utterly disgusted and shocked because it's become completely mainstream, which is unacceptable to me. (cited in Goldhill, 2014, p. 2)

Yet, it is seemingly too late because, as David McComb avers, tattooing is now the epitome of fashion and the tattooed bodies of Lady Gaga and Beyoncé have served as 'the catalyst for millions to go under the needle' (2015, p. 271), and even the actress, Dame Judi Dench, acquired her first tattoo, the words 'carpe diem' at the age of eighty-one.

FASHIONABLE TATTOOED BODIES

The tattooed celebrity body now has also become a distinctive media 'text', whereby their designs are visualised in detail, the designs discussed and any meanings inherent within the tattoos revealed. For example, the actress and film director, Angelina Jolie's extensive tattoos are a routine feature within celebrity magazines and tabloid newspapers, ranging from the designs that she has had removed or had covered up (such as the Asian dragon tattoo that bore the name of her actor ex-husband, Billy Bob Thornton and the Japanese symbol for death that was replaced with a positive Khmer tattoo design dedicated to her Cambodian adopted son, Maddox). As such, Jolie's tattoos have become part of her fashionable bodily image which, given their East Asian, Thai and Cambodian Buddhist symbols and mantras, consciously communicate Jolie's long-rooted connections with these locations through the adoption of her child, and the extensive personal charity work and in her UN High Commissioner for Refugees role. With regard to her own self-reflexive attitude to her tattoos, many of which are dedicated to her family, she has described them as representing 'a totem pole of my history' and a series of permanent images which have been collected 'in counterpoint to a career in which she is constantly assuming other people's identities' (Mifflin, 2013, p. 132).

In this regard, tattoos have become a central component of the 'celebrity body' and how that body is fashionably represented, demonstrating the extent to which tattooing is now a significant aspect of bodily self-presentation, a factor indicating that a decisive change with regard to celebrity body performance and social and cultural influence has occurred. However, bodily transformation is an ubiquitous aspect of fashion, and tattooing has now become an evermore visible sign within the contemporary fashion industry. As Jennifer Craik (1994) argues, the function of fashion is that it serves as a 'mask' that individuals use to effectively disguise themselves. According to this view, the ways in which people use dress represents a series of 'technical devices' which go beyond simply adorning the body, but actually can and do express a precise relationship that exists between an individual's body and the society within which she or he lives. To explain this process, Craik draws upon the work of the sociologist, Pierre Bourdieu, and specifically his concept of habitus (as articulated within his text, *Distinction*). What Bourdieu means by habitus is a set of very specialised techniques and knowledge that individuals acquire from their given culture which then enables them to move through their lives effectively. An essential feature of habitus is that these techniques appear to be unconscious or 'common sense' notions of appropriate 'techniques and modes of self-presentation' (1994, p. 4).

Although the concept of habitus is frequently connected to the concept and expression of social class, habitus has also been related to gendered practice to explain the ways in which gender is culturally replicated and communicated through fashion styles. The importance for celebrity culture here is that people look to particular cultural 'role models' to guide them and to prescribe the acceptable and 'unacceptable' modes of clothing the body. A key example of a fashion role model, argues Craik, is the fashion model, a figure that has historically proven to be intrinsic to changing ideas about gender representation and changing definitions of femininity, but a female figure that is fundamentally associated with the need for bodily discipline that underlines Western conceptions of beauty and the appropriate maintenance of the body. This is because a central element of modelling is the requirement to meet exact bodily specifications, but these change over time. Moreover, the model has represented a key focus for the transmission of social and cultural perceptions of bodily habitus, and they have long served as figures of public inspiration/aspiration. Hence, bodies deemed to be 'perfect' have ranged from the androgyny of Twiggy, the athletic 'hard body' look of 1980s-era 'super-model', to the 'waif' image of Kate Moss and the controversial 'Size 0' trend within the 2000s. However, there are a number of images within the contemporary fashion industry and alongside the more progressive 'Plus Size' look, there is an increasing vogue for the tattooed model body, whereby tattooing has become incorporated into the high fashion system, representing 'a form of "dress" that provides both a badge of identity and a personal signature: an exotic statement within a fashion system' (Craik,1994, p. 25).

TATTOOED FASHIONISTAS: CARA DELEVINGNE AND RUBY ROSE

While models such as Niki Taylor and Kate Moss displayed the acceptance of 'perfect' bodies displaying subtle tattoos (with Moss bearing designs created by the artist Lucian Freud), a new generation of runway stars have pushed the boundaries to actively demonstrate the ways in which tattoos and high fashion are now commonplace, and none as extensively or as successfully as the British model and actress Cara Delevingne. Having modelled for fashion houses and brands such as Chanel, Mulberry, Dolce & Gabbana, Jason Wu, Burberry and Rimmel, Delevingne has also dramatically placed the tattoo at the heart of iconic fashion, and demonstrated that having tattoos is no impediment to fashion industry success at the highest level. Whilst 'new wave' fashion figures such as Kendall Jenner have opted for minimalist designs, Delevingne sports some twenty tattoos, ranging from her mother's name on her bicep, the slogan 'Made in England' on the sole of her left foot,

a diamond design in her right ear, and an image of a lion face on her index finger, with the latter design featuring prominently in one of her endorsement advertising images for the luxury watch brand, TAG Heuer.

As such, within the contemporary fashion industry tattooing has now become a prevalent practice as illustrated by runway models such as Chanel Iman, Aline Weber, Omahyra MotaFreja Beha Erichsen, Casey Legler and Jourdan Dunn. Moreover, heavily tattooed male models have also become sought-after figures, as evidenced by the primacy and success of Mikkel Jensen, Bradley Soileau, Miles Langford, Rick 'Zombie Boy' Genest, Ash Stymest and Stephen James. On the designer side, Jean-Paul Gaultier has used tattooed models to front advertising campaigns, while the American designer Marc Jacobs sports an extensive and eclectic array of tattoos (which include a doughnut, the movie poster for *Poltergeist*, an M&M's character, and SpongeBob SquarePants). Hence, as McComb states of the presence and influence of tattooing within the contemporary industry, 'tattoos are as much a part of Western fashion as the latest Versace dress or Jimmy Choo heels, and more and more young people are flocking to tattoo studios as soon as they turn eighteen to get extensive coverage' (2015, p. 223). But of course, fashion now seamlessly intersects with celebrity culture, adding to the array of famous tattooed bodies routinely displayed within media discourses.

As Pamela Church Gibson (2012) argues, the global fame achieved by models such as Twiggy, Jean Shrimpton, Cindy Crawford, Naomi Campbell, Kate Moss and Gisele Bündchen ensured that they became celebrity super-stars with a level of renown that transcended fashion, as has Cara Delevingne. Through starring roles in films such as *Paper Towns* (Jake Schreier, 2015), *Suicide Squad* (David Ayer, 2016) and *Valerian and the City of a Thousand Planets* (Luc Besson, 2017) she has moved firmly into celebrity culture and represents a key exemplar of celebrity bodily habitus (that also includes extensively mediated possessors of desirable bodies, such as Kim Kardashian, Taylor Swift, Jennifer Lawrence and Beyoncé), but with an added emphasis upon the 'chic' status of the tattooed celebrity body. Moreover, this crosso-ver is becoming more common as new fashion 'icons' now effortlessly exist simultaneously across fashion/celebrity/media channels, representing bodily images that are visually defined by tattoos, such as the model/DJ/television presenter/actress, Ruby Rose.

Born in Australia in 1986, Ruby Rose began her professional career as a VJ for MTV prior to becoming a major fashion figure appearing in a num-ber of high-profile fashion magazines such as *Vogue*, *InStyle*, *Nylon* and *Cosmopolitan*. With regard to image, Rose has been dubbed an 'androgy-nous Angelina Jolie' (Teitel, 2015, p. 1), referring to her penchant for short hairstyles, and, most pertinently, her extensive collection of tattoos, designs (of which she has approximately sixty) that have become central to her

fashionable 'habitus'. Rose is especially significant in the way in which her off-and-on-screen image is blended within her fashion and acting work, for instance within her 2014 short film, *Break Free*, in which she visually deconstructs conventional representations of femininity. Within *Break Free*, Rose enters the frame in a dress, with makeup and long, blonde, hair, but then proceeds to cut the hair into her trademark short style and wash her body in a bathtub, an action that gradually removes the body makeup she is wearing to reveal her extensive tattoo collection. The film then ends with her donning gender neutral clothing, highlighting the fluidity of gendered identity and gender image expectations. Furthermore, as an actress she played a notable part in the female prison-set comedy drama, *Orange Is The New Black* (2013–) in the role of inmate, Stella Carlin. A significant aspect of the character are Stella's tattoos, which are of course, Rose's, and her entire array of artwork is revealed in one shower scene, keenly combining the ethos of prison tattooing (many of the inmate characters are tattooed) while also displaying Rose's own distinctive bodily image – a key aspect of her fandom and her fashion status. In this regard, Rose both portrays a fictional character and, via her tattoo work, effectively plays herself, as the narrative knowingly incorporates her iconic fashion look in terms of her tattoos, hairstyle and distinctive makeup. Indeed, it is significant that it is Stella who gives the series' middle-class and affluent lead, Piper Chapman (Taylor Schilling), her first tattoo, further completing her gradual acceptance of her prison-based reality and as a personal reaction against its controlling culture. Furthermore, Rose's tattooed bodily habitus is also central to her fashion work, which has included acting as the face for the Maybelline and Urban Decay cosmetics brands, and for the Ralph Lauren fashion house. With regard to her role as spokesmodel for Urban Decay, Rose aligns her highly distinctive look and 'signature tattoos' with the ethos of the fashion brand with regard to the extent that it 'believes in supporting individuality and personal self-expression – two values I hold very dear – because everyone deserves the freedom to explore their personality and discover their true selves' (Sharkey, 2016, p. 2). And such is the impact of Rose that fashion journalists have declared that her highly distinctive tattooed image is so striking that she is a leading figure in actively changing the face of modern gendered beauty (Pavia, 2016).

Consequently, Ruby Rose demonstrates the ways in which the tattooed female body has become a significant figure within fashion and celebrity culture. And she is not alone, as evidenced by the tattooed model, Amina Blue, and her prominent role as one of the faces of Kanye West's Yeezy fashion shows (and who represents West's fashion 'muse'). As such, within modern fashion, tattooing is big business. Consequently, while fashion periodicals such as *Tatler* and *Vanity Fair* showcased fashionable female tattoo designs at the turn of the twentieth century (Bailkin, 2005), it is arguably in recent years

that it has hit its zenith. As such, tattooing is at the heart of celebrity and fashion culture, and it represents both the voguish status of permanent body art, its effects on the perception of the tattoo industry, and, significantly, who gets tattooed. For example, in their tattoo-based fashion feature within *InStyle*, Hannah Rochell and Chloe MacDonnell state of the 'chic' status of tattooing

> [e]ven the non-inked among you will have noticed that it's in no way taboo to get a tattoo anymore, particularly if you're female. In fact, a recent poll in the US found that 47 per cent of women aged 18-35 have tattoos, compared with 25 per cent of men. These days, the experience of getting a tattoo is more like going to a swish hair salon than a grubby, old-fashioned parlour. At "Bang Bang" in New York – favoured by everyone from Rihanna to Rita Ora and Justin Bieber – the chic concrete interior and pink-collared Chihuahua dashing around do wonders to relax the variety of people waiting for an appointment. (2016, p. 24)

GENDER AND VISIBLE INK

While stressing the seemingly ubiquitous cultural presence of tattooing, and its apparent routine presence within celebrity-related media discourses, the issue of a gender change with regard to tattooing is a significant one, and celebrity plays a part here, too. As Dominique Holmes argues within her book, *The Painted Lady: The Art of Tattooing the Female Body*, the increase in women acquiring tattoos is an important gender development. As she states of women with tattoos,

> [t]he archaic opinion of the tattooed woman as a freak or a misfit is on its way out. In the twenty-first century, the tattooed woman is a successful business owner, a fashion icon, an actress, a lawyer, a musician, an artist, an editor, a teacher, an executive, a mother, and she wears her tattoos with pride. Her tattoos are a statement of her individuality, her femininity and her complete confidence in who she is and what she represents. (2013, p. 7)

Citing female celebrities as diverse as Amy Winehouse, Princess Stephanie of Monaco, P!nk, Rihanna, Scarlett Johansson and Sandra Bullock, Holmes states that 'the tattooed female surrounds us, making it a completely natural phenomenon in today's society – with tattoos as likely to appear on an award-winning public supermodel as on your next-door neighbour' (2013, p. 12). Yet, this was not always the case. As Botz-Bornstein observes, with an especial reference to the opinions of Adolf Loos who designated female tattooing as a sign of 'primitivism', for much of its history in the West, tattooing was perceived to represent a distinctly masculine bodily practice underscored by the cultural view that there was 'nothing ladylike about

being tattooed' (2012, p. 55). In the view of Beverly Yeun Thompson, female tattooing was habitually regarded as an unfeminine 'deviant' bodily practice (related to alternative projects such as female bodybuilding), however, while visible tattoos on women can still yield social censure in relation to perceptions of 'self-mutilation' or deliberately rendering the female body as 'ugly'(especially with regard to heavily tattooed women, and those who eschew wearing 'femininely cute' small designs in favour of bold and 'revolting' images of monsters, aliens or demons). In this regard, by acquiring extensive tattoo collections, women have the potential to renegotiate traditional gender bodily norms and to redefine the 'masculine' tattooed body and recast it as 'beautiful'.

In this view, tattoos represent a means by which women can reclaim their bodies and communicate an enhanced sense of self-assurance as the 'visual content of their tattoos are often symbolic of important issues within women's lives' (Thompson, 2015, p. 52). While the increasing number of women who are being tattooed is connected to the distinctive transformations within tattooing culture that was discussed in chapter 1, the prominence of tattooed female celebrities is an important factor in this increased level of visible ink. For example, Thompson cites the now-famous example of the singer Janis Joplin getting a Florentine wrist bracelet tattoo from the artist Lyle Tuttle (who would also tattoo the singers Joan Baez and Cher) in 1970, an act that saw her dubbed the 'first tattooed celebrity' (Vidan, 2015). But while her tattooing perfectly suited Joplin's rock star image and lifestyle, nevertheless, it was still a bold example of a visible female tattoo within popular culture (and it did inspire many female fans to acquire the exact same design). Contemporaneously, Mifflin cites the influence of tattooed female celebrities such as Kat von D, Angelina Jolie, Margaret Cho, Susan Sarandon and fictional icons such as Lisbeth Salander as major factors that have contributed to tattooing dramatically widening its class, age and gender demographics in order to transcend its long-established subcultural limits. However, within her litany of tattooed figures of renown, Mifflin also cites the American female soccer player, Natasha Kai in relation to her extensive Polynesian tattoo designs, many of which visibly signify her Hawaiian roots, and sport has increasingly represented a further celebrity arena that displays extensive tattooing.

THE TATTOOED SPORTS CELEBRITY

In addition to Natasha Kai, a number of sports stars have attained media attention for their tattoo designs as well as their sporting prowess, for example, the basketball players, Brittney Griner and LeBron James, the heptathlete,

Chantae McMillan, the synchronised swimmer, Anastasia Davydova, the NFL's Colin Kaepernick, the MMA fighter, Ronda Rousey, swimmer, Sinead Russell and handball player, Jessica Quintino. Within football/soccer, tattoos are a common sight, and the former Manchester United and England star, David Beckham has long received media attention for both his football skills and his ever-growing tattoo collection. Writing in his autobiography, *Beckham: My World* of his then-sparse designs, he acknowledged the addictive, but symbolic nature of tattooing, stating, 'Maybe I want more because I'm so fond of the ones I've actually got. Although it hurts to have them done, it's worth it because they are there forever and so are the feelings behind them' (Beckham, 2000, p. 31). Since then, Beckham has obtained considerably more tattoos, to the extent that much of his body is now swathed in designs, a factor (and the meanings inspiring each design) that is routinely the focus of news features, and which is featured prominently in his brand work with companies such as Haig Club and H&M. Similarly, the Formula 1 driver Lewis Hamilton has acquired an extensive collection of tattoo designs that are also mediated extensively and which have become synonymous with his public image, and personal identity. As such, sports celebrities' tattoos are not merely reported upon, but are self-reflexively commented upon as they are viewed as key components of self. As Hamilton states of the significance of his designs,

> I love my ink … They all have a meaning. I'm very strong in my faith, so I wanted to have some religious images. I've got Pieta, a Michelangelo sculpture of Mary holding Jesus after he came off the cross, on my shoulder. A sacred heart on my arm. Musical notes, because I love music. The compass on my chest is there because church is my compass. (Godden, 2015, p. 3)

Although sports stars have long been considered as eminent globally iconic figures (from Babe Ruth to George Best and Muhammad Ali), it is only relatively recently that they have become part of mainstream celebrity culture due to increased media coverage of sporting figures and the progressively commercial development of sport in relation to corporate sponsorship, individual image management and brand endorsement initiatives (Cashmore, 2002; Smart, 2005). Given the extent to which sports stars *are* prominent within contemporary celebrity culture, their images and bodies are the focus of extensive media focus, as Betsy Emmons and Andrew C. Billings illustrate,

> [p]rofessional athletes have reached a level of media exposure on par with traditional Hollywood actors and have the fan bases to prove it; many professional athletes are viewed through the same cultural lens as other media celebrities, as role models, creators of trends, and marketable corporate icons. (2015, p. 66)

In view of the centrality of the body within sport, and representations of bodies, tattooing has become a growing visual presence within sport, with tattoos frequently representing personalised identity issues. For example, Emmons and Billings also cite Natasha Kai as an example of a sports star whose extensive tattoos on her arms and legs are routinely revealed in the course of her sporting performance to the extent that her tattoos have become a prominent facet of her public persona. Kai's designs explicitly represent her personal identity politics in relation to her Hawaiian heritage, however, other sports stars have employed tattooing to make wider political statements, such as the boxer, Mike Tyson. Tyson's Maori-style facial tattoo is especially significant as it represents an example of a bodily placement that is challenging (given the continued censure of facial tattoos, a placement point that was not liberalised as the result of any tattoo 'renaissance'). However, in explaining the motivation for acquiring the bold design, Tyson reasoned that the placement was politically deliberate and was motivated by his claim that 'he was against the Western capitalist society and that he was tired of conforming to what he thought the world expected him to be' (2015, p. 79). Similarly, while possessing a number of permanent tattoo designs, the Swedish footballer Zlatan Ibrahimović employed the aesthetics of tattooing to make a stark political point when, on scoring a goal against Caen in 2015, he removed his shirt to dramatically reveal fifteen removable tattoos consisting of the names of real people who were suffering from hunger in the world in order to raise public awareness of their individual plight, and the wider global realities of hunger.

However, the popularity and visual frequency of tattooing within the sporting world has raised interesting issues with regards to the copyright ownership of tattoo designs, especially when they are prominently featured within media discourses, such as within advertising and brand endorsement campaigns. Tattoos have become more prominent within advertising in recent years and are important visual cues for products due to the fact that tattoos 'are often associated with uniqueness and therefore are considered unforgettable' (Bjerrisgaard, Kjeldgaard and Bengtsson, 2013, p. 233). But, there are also risks of copyright infringement if specific designs are prominently featured within such campaigns. To illustrate, Christopher A. Harkins cites the case of the basketball player, Rasheed Wallace, who had an Egyptian-themed tattoo placed on his upper right arm. The design was tattooed by the artist Matthew Reed, who took initial suggestions from Wallace and developed the final design, a king, queen and three children with a stylised sun as the background image. With no licensing agreement in place, Reed accepted that the image would be extensively mediated when Wallace played in televised NBA games, but he took exception when Wallace featured in a Nike advertisement, with the tattoo playing a prominent role in the visual presentation. As a result, Reed applied for copyright to the design and alleged copyright

infringement against Nike and the agency that produced the advertisement, Weiden & Kennedy. As such, the case represented a 'warning to companies and advertising agencies that feature celebrities (sporting tattoos and body art) in advertisements on television, billboards, and the Internet' (2006, p. 318) to the extent that it is advised that those on the cusp of fame bearing tattoos should establish a joint work contract that transfers the ownership of the design to the wearer.

A TATTOOED (POP) CULTURAL LANDSCAPE

The prevalence of tattooing within popular culture is a potent and convincing signifier that tattooing has now decisively transcended its subcultural status, indeed, even 'high culture' now possesses tattooed stars, such as the Ukrainian ballet dancer, Sergei Polunin, whose dance talent and fame is matched by his enthusiasm for tattoos (to the extent that he co-owns a London-based tattoo studio). As such, from literature, film and television tattooing has had a long-standing cultural traditional presence, but popular culture and celebrity have dramatically elevated this conspicuousness. Furthermore, the dissemination of tattooed celebrities and tattooing trends has been extensively extended through the development of social media–based tattoo sites, such as *Tattoodo*, which showcases tattoo artists, genres, images of tattoo designs, in addition to features on celebrity tattoos, from profiles to 'breaking news' reports on new designs acquired by particular celebrities (e.g. Maroon 5 singer, Adam Levine's mermaid back tattoo) and extensive features of scantily clad 'tattooed babes'. This latter aspect raises interesting debates concerning gender and tattooing, especially when related to the wider context of the tattoo magazine industry. As Thompson argues, the industry was established with the establishment of *Tattoo Magazine*, in 1984, which spawned the publication of magazines such as, *Tattoo, Inked, Tattoo Society, Savage, Flash, Skin Art, Rise, Skin and Ink, Total Tattoo, Skin Deep* and *Tattoo Energy*, all of which feature articles on tattoo artists and present portfolios of work, commentary upon industry developments, and coverage of prominent tattoo conventions. However, a common denominator that unites the tattoo magazine industry is the cover image style that each magazine employs. As Thompson states,

> [o]verwhelmingly, women are featured on the cover of the magazines as scantily clad sex objects, with the focus on their bodies and large breasts even more than on their tattoo art. Often, women appear without shirts, covering their breasts with their hands, even when they do not have visible ink on their torsos. The magazines uphold traditional gender stereotypes: men are active, serious tattooists, while women are sexual decoration – even when they are presented in

articles as tattooists themselves. The presentation of men and women artists is vastly different, with the women often unclothed in ways that men are never represented. (2015, p. 148)

On the one hand, then, magazine and social-media-based tattoo media are regularly representing heavily tattooed women, to the extent that there is now a distinctive genre of tattoo modelling and fashion, but on the other hand, the sexualised nature of the imagery is, as Thompson argues, problematic. Indeed, the magazine industry has recognised this and debated it. For instance, the UK magazine, *Total Tattoo* produced a feature entitled, 'Magazine Cover Models: Sexy or Sexist?' which explored the issue of over-sexualised images, in addition to a wider sexism within the tattoo industry in relation to the pressures female artists face in terms of entering into the industry, work environments and equality of pay. What is interesting about the article is that a distinctive economic rationale plays a role in addition to any dominant cultural mores, as the concluding editorial commentary reveals: 'We'd love to feature a man on the cover of Total Tattoo now and then, but we know from past experience that it's a risky thing to do. Sales fall dramatically when a magazine that usually has a women on its cover opts for a man instead' (in Brown, 2015a, p. 80). A similar debate also surrounds the *Suicide Girls* movement, an online 'community' that exclusively features and promotes heavily tattooed and pierced women. Ostensibly produced to present a celebratory form of alternative beauty in accordance with a strategy that combines unconventional bodily female representations, and aligned with a distinctive political gendered ideological outlook, Wendy Lynne Lee argues that the *Suicide Girls* have been interpreted in very contradictory ways. At one level, the site has been read as highly politicised radical feminist reaction to hegemonic Western female beauty standards, a project that does not merely use tattooed women as an aesthetic platform of differentiation, but instead sees the act of tattooing as representing 'a radical form of feminist self-identification' (2012, p. 155). However, the alternative view is one that aligns the *Suicide Girls* project to the same criticisms levelled at mainstream tattoo magazines, in that rather than representing a feminist reaction to the sexualisation of women, the site and its content reflects a male-centred pornographic site in which tattooing is no more than a novel marketing gimmick.

Tattooing, then, now has a widespread and multifaceted presence within contemporary popular culture, in which trends, representations and controversies are visibly discernible. Accordingly, tattooing has arguably never been so popular, whether visible on the magazine shelf, the social media landscape (many of Ruby Rose's tattoo images are posted by her on her personal Instagram site), in cosmetics brand campaigns, fashion runways and the ceaseless and ever-changing cultural force that is celebrity. As Church

Gibson (2012) observes in relation to the historic relationship between celebrities and the public, they have long been promoted as fashion and bodily role models, and so tattoos have now decisively been added to this 'mimetic' influence. Of course, this has its negatives. As Daniel Miori pithily observes, the dilemma surrounding fashion and tattooing is that 'fashion and beauty are both temporary, tattoos are not' (2012, p. 202). So, on the one hand, the populism and potential shallowness of tattooing may indeed have utterly stripped the practice of any alternative 'rebelliousness' it traditionally had (as Dame Helen Mirren decries), but one the other, the significance of tattooing remains unchanged.

Whether the motivation to get a design is propelled by a custom piece that is unique to the individual or admiration for David Beckham's famous angel back tattoo, the permanence is a vital factor – regardless of inspiration or vogue of tattooing. The act of acquiring a tattoo is individual and transformative, whether visually, or in terms of a testament to personal identity. In Grognard's view (as discussed earlier in the chapter), celebrities played an important role in the apparent renaissance period of tattoo culture and they continue to do so in terms of establishing a wider perception (and acceptance) of tattooing, but it is still not the 'norm', and this is important, as Grognard explains, a tattoo is an expression of transformative will and a means of expression. In consequence, whether the chosen design is a heartfelt memorial to a deceased loved one, an aesthetic bodily enhancement, a joke, or a permanent sign of fidelity to Justin Bieber, the tattoo transforms the body, and in theorising tattooing it must be explored in direct relation to concepts of self, identity, time, symbolic communication and being. In this regard, the tattoo enables the body to act as an 'ornamental interface', an 'artistic object' that becomes open to interpretation (and still expressions of censure and disapproval), factors that will be explored in relation to sociological and philosophical ideas in the next chapter because, regardless of its apparent cultural ubiquity, Grognard makes a salient and provocative charge, that the tattoo, in the relationship between the individual and the artist, between the skin and the needle, is a fundamentally unique object, rendering the body as a challenging 'moving fresco'. Hence, the tattoo is, 'Born out of pain, it bursts out of a tear in the skin, takes shape and expands to the rhythm of the punctures. It is a creative but cruel delight, an object of desire or fear' (1994, p. 131).

Perhaps in the age of Reality TV-themed tattoo shows and tattooed media luminaries, the suspicion traditionally associated with tattooing has markedly decreased, but the fascination remains, and the desire to speak through the skin, continues. Consequently, while the populism of contemporary tattoo culture cannot be underestimated, the individual desire to transform the body and communicate symbolically through tattoos (from the sublime to

the ridiculous in terms of art and conceptual choice) is potent. Thus, from Queequeg to Lisbeth Salander, Kat Von D and Megan Massacre, Ruby Rose and Angelina Jolie, to David Beckham or US soccer star, Tim Howard, tattooing has an unprecedented visual cultural status that now increasingly transcends class, age, ethnicity and gender, and which has played (and continues to play) a major role in 'normalizing' tattoos. As such, while tattooed celebrity culture has, as McComb (2015) describes it, rendered tattooing as a 'mainstream obsession' devoid of its earlier edgy or alternative traditional cultural incarnation, the act and significance of tattooing in such public mediums and with regard to such public, if not iconic, individuals, does not detract from the fundamental nature of tattooing, which (aside from access to the 'aristocracy' of tattoo artists and cost of designs) is, in essence, the same whether the recipient is Rihanna or any 'everyday' social actor. Moreover, this derives from a distinctive and significant characteristic of the bodily practice: that tattoos 'make a contribution to an identity-constituting narrative' (Fruh and Thomas, 2012, p. 90).

This is all the more significant given Patricia MacCormack's argument that, irrespective of the tattoo within fashion and consumer culture, tattoos still face conservative reactions because tattooed 'persons are still defined as tattooed persons, we are still compelled to "cover up"'. (2006, p. 79). Tattoos, then, decisively mark a person's body and make a declaration (even if the motivating sentiment fades and the image becomes a source of regret or embarrassment) of the individual's sense of being in relation to time, factors which require further examination to fully explore how, in Margo DeMello's evocative phrase, tattoos ultimately represent 'Scars that speak'. Hence, as Hesselt van Dinter states of the 'existential' nature of tattoos, each one that a social actor acquires 'reflects a part of the soul; their permanence creates an illusion of eternal youth. [And so it] is no wonder that tattooing is especially popular with today's media and sport's celebrities' (2005, p. 20). Tattoos, then, fix aspects of self to enable the individual to map out some component of their sense of self, their conception of being, and although tattoos may be ill-conceived and poorly (if not tastelessly) rendered, or can be exquisitely crafted works of art that are deeply imbued with personal symbolism, tattoos display a sense of self on (or rather, *in*) the skin.

Chapter Three

Theorising Ink

Tattooing as Semiotic Communication and Phenomenological Expression

While the previous two chapters have examined the development and expression of tattooing in addition to popular representations of that culture, this chapter explores key theoretical approaches to understanding tattooing as a social signifying practice. In this regard, the chapter will revisit approaches which stress the nature of tattooing as a quintessentially postmodern behaviour, an action that is stirred by a desire to establish fixity in a world marked by constant social, cultural, economic and identity transformations. However, the chapter will posit alternative theoretical approaches that place the act of tattooing in the context of visual communication and self-signification, but also in terms of bodily transformation with regards to the passing of time and an individual's sense of 'Being'. In this context, tattoos form a crucial role within identity communication in which the skin is utilised as a storytelling organ. As such, moving away from postmodern approaches, I will explore the relevance of semiotics and phenomenology as ways by which to critically examine the role of tattoos as communicative signs and as bodily inscriptions that transform an individual's sense of being and relationships with time and personal biographical history.

INKED RESISTANCE: TATTOOS AND POSTMODERN IDENTITY

Within Mindy Fenske's analysis of tattoos in American visual culture, she utilises the postmodern work of Gilles Deleuze and Félix Guattari, in relation to their concept of 'striated spaces', to describe the nature of social and natural spaces that can either be carefully patterned and predictable, but also subject to processes of disturbance or 'mutation'. In this regard,

Fenske argues that this process can also be observed in relation to tattoo-ing, whereby 'striated space can be thought as the final version of the tattoo rendered upon the skin of the client. It is a frozen and structured image per-manently inscribed. The tattoo image is, in these terms, a territory' (2007b, p. 27). Furthermore, given that the tattoo is engraved into living skin, the image is subtly amorphous because the skin, given that it is the interface between the body and the external world, acquires cuts, wrinkles, scrapes and changes in texture and pigmentation as the skin ages. Crucially, how-ever, the tattooed image still retains its integrity, rendering the tattoo as a 'moving aesthetic territory where the territorializing practices of meaning making occur' (2007, p. 29). This idea of tattoos bearing a relation to mean-ing is a significant one in further theorisations of tattooing that reflect post-modernist modes of thought.

For example, applying the postmodernist ideas of theorists such as Michel Foucault, Emmanuel Levinas and Jean-François Lyotard, Nikki Sullivan, within her book, *Tattooed Bodies*, stresses the ways in which ear-lier analyses of tattooing foregrounded the psychological and criminal devi-ance of the practice, whereby tattoos communicated clear diagnostic signs of criminality or psychopathy. As such, within the 1960s, psychological and criminological studies of tattooing still harboured that Lombroso-like sentiment that tattoos held a 'predictive' power relating to antisocial and abnormal and criminal behaviours. But it wasn't just 1960s commentary that criticised tattooing and stressed its alternative nature. For example, some feminist-inspired studies read tattooing as an act of destructive self-mutilation (Sullivan, 2009), while medically based commentators warned of both the blood-borne health risks of an activity related to 'risk-taking' adolescents and the resultant labelling censure they faced from 'respectable' adults who perceived tattoos to be motifs declaiming deviant behaviour, and which would act as demonstrable impediments to later employment (Mercer and Davies, 1991; Armstrong and Pace Murphy, 1997). However, Sullivan stresses alternative studies that offered a counter-view, and which pointed to the ways in which tattooing could be viewed as an expression of iden-tity and part of an active process of self-definition, whereby tattooing was interpreted as 'the desire to decorate the public outside of our private inside' (Sullivan, 2009, p. 40). From a postmodern perspective, such 'decoration' serves as the grounds for interpretation by other social actors. For example, from Levinas' perspective, argues Sullivan, a person's sense of 'I' is derived from contact with other social actors, and is in a continuous process of 'becoming' because of this dynamic, a factor made all the more significant in relation to the tattooed body as its 'inner nature' is made manifest on the surface of the skin because as 'social texts they appear to demand to be read' (2001, p. 183). As Fenske points out, this process of bodily/identity reading

is a fundamental component of Reality TV representations of tattooing, in which the 'tattoo stories' focus 'on the individual's choice to represent some event, person, emotion, or aspect of their identity through a specific design they have chosen to have inscribed on their body' (2007b, p. 19), stressing a personal commitment to permanently (or semi-permanently, at least) preserving a facet of personal identity.

Paul Sweetman places this idea firmly within a postmodern context through the linkages with the perception that tattooing is a mainstream practice and a common component of contemporary fashion. As such, tattoos, like clothing, have been read as an artefact within the free-floating 'carnival of signs' whereby tattoos are just products that enable individuals to communicate aspects of self to the world. In this regard, tattoos have been read as being akin to fashion accessories such as jewellery, whereby they can be seen to serve as objects of decoration. To explore this perception, Sweetman conducted a series of ethnographic interviews with lightly and heavily tattooed social actors, and subsequently found responses that reflected this fashionable 'surface' function of tattoos, whereby tattooing was a central part of an individual's personal fashion system. As one respondent stated, 'it's nice choosing your outfit depending on whether you want to show off your tattoo or whatever, and, I dunno … I just think it's kind of like an extra accessory kind of thing' (1999, p. 56). However, such an approach to tattooing did not fully explain the key motivating factors in acquiring designs because most respondent considered their tattoos to be images that contained significance. Moreover, the decision to plan and be tattooed was inspired by feelings of attaining bodily originality, factors that were underpinned by the full realisation that the design would be permanent, and were acquired as part of making a personal 'statement' and, crucially, that being tattooed is a physically painful bodily process. For example, the primacy of pain within tattooing was also noted in Atkinson's (2003b) ethnographic study of the punk-inspired Straightedge subculture (based upon a rejection of 'physical excesses' such as drinking alcohol, taking drugs and smoking) found that, in addition to tattoos forever signifying fidelity to the Straightedge culture, the pain of tattooing was consciously experienced as a 'Spartan' component of the culture's attitude to body modification.

Reflecting Sullivan and Fenske's commentary, Sweetman found that individuals elected to be tattooed as an expression of the self because they carefully decided upon images that expressed their own personalised interests or their own individual biographies, with many opting for custom tattoo designs to guarantee that no one else would bear the same image. Significantly, respondents spoke of their tattoos playing an active role within what they considered to be 'self-creation', with designs acting as permanent reminders of key events and fixing memories in a permanent fashion. In essence, tattoos represented

a means by which individuals could tell stories about their lives through their tattoos. Therefore, as Sweetman concluded,

> [i]n this sense, becoming tattooed might be argued to commit the tattooee to a particular narrative, and at least one interviewee described his own tattoos as a permanent 'diary' that 'no one can take off you'. Others suggested that their tattoos could tell a story, with one heavily tattooed interviewee, for instance, suggesting that once he was completely tattooed, the realistic parts of [his] body suit [would] tell some kind of story about [his] view of the world. (1999, p. 69)

Consequently, tattoos represent more than addendums to fashion accessories, but possess the potential to map out key aspects of a personal biography, whereby tattooing becomes a strategic part of an individual's 'body project'. This sense of visual fixity of self is significant in relation to postmodern styles of thought, in which tattoos 'anchor' a sense of self due to their permanence, and so withstand the flux of constant social and cultural change and communicate personal stories. As Atkinson notes in his ethnographic work exploring Canadian tattoo culture, tattoos can act as distinctive signifiers of life trajectories, as one respondent, Rachel, explained

> I think tattooing really is probably one of the best ways to define yourself in ways that you can control. Things happen to you in your life and a lot of them are beyond your ability to change, and you just have to accept what you have been dealt with and go from there. My tattoos are like stickers you put on a suitcase when you travel around the world, they are *souvenirs* of everything happening to me in my life. (2003a, p. 189)

In a similar style, other respondents spoke of their tattoos acting as a means of emotional liberation, whereby emotions could be expressed through the tattoos worn on the body, whether in places subject to constant public view, or hidden images whose 'semi-seclusion indicates how special the symbol is for the enthusiast' (2003a, p. 233), echoing Sanders' appraisal of tattoos as representing 'highly symbolic objects' (2008, p. 149). In this regard, Atkinson's and Sanders' reference to tattoos acting as signifiers and symbols suggests the relevance of a distinctively semiotic approach to tattooing given the ability of tattoo designs to act as revelatory and communicative symbols that can be read by the wearer and the wider world.

SPEAKING THROUGH SIGNS:
THE SEMIOTICS OF TATTOOING

As articulated by Roland Barthes within his classic 1957 text, *Mythologies*, cultures transmit various messages or 'myths' that convey meaning. In

some instances these can include instances of oral speech, but they are not confined to such communication. Rather, mythic messages are diffused and supported through a range of mediums such as, photography, cinema, journalism, and sport publicity materials. Therefore, cultures 'speak' through mythic messages, and the focus of what Barthes dubs 'semiology' is based upon the operation of reading or deciphering these myths. Within his analysis of myths and the ways in which they work to communicate meanings, Barthes analysed cultural examples as diverse as a photography of the actress Greta Garbo, magazine covers, toys, soap powders, the science fiction of Jules Verne, striptease, steak and chips and wrestling. With regard to the example of steak, Barthes refers to the ways in which specific foods have come to signify specific qualities and cultural values. In the case of steak, although a food that consists of bovine meat, the significance of this transcends the biological nature of eating steak to sate hunger and provide the body with energy. Although it evidently achieves this, the eating of steak, argues Barthes, represents distinctive cultural meanings, too: strength and power. As such, objects acquire wider significations, a factor that underpins the advertising industry in its drive to associate empowering emotions and desires with the consumption of material goods.

Barthes' most famous example of mythology in action is that of the cover of the French magazine, *Paris-Match* that depicts a black soldier in a French uniform saluting. Here, myth is argued to operate in a distinctly ideological way as the magazine serves to reinforce ways in which the French colonial empire displays no discriminatory practices, and demonstrates the enthusiasm the 'colonized' have for their 'so-called oppressors' (Barthes, 1993, p. 116). In terms of explaining the science of semiology, Barthes argues that there is a *signifier*, the image of the black solider saluting, and a *signified*, the mixing of Frenchness and militariness. Signification comes with the fusion of these two components. However, these concepts were initially conceptualised by the 'originator' of semiotics: Ferdinand de Saussure (1857–1913).

Ferdinand de Saussure's text, *A Course in General Linguistics*, published in 1916, formed the foundation of semiotics, and his approach would become so influential that he would become known as the 'twentieth-century-father of the science of signs' and in which he would call 'semiology' (from the Greek semeion, meaning 'sign'). Semiology was intended to be a systematic means by which to explain what constitutes signs. Signs are drawn from the system of language that exists within a society (what de Saussure called 'langue', meaning language, in opposition to 'parole', meaning speech), and all signs are derived from the system of language. Most famously, de Saussure's theory of the sign is reducible to the way in which all signs adjoin a form

and a concept, what he famously dubbed a signifier and a signified. As de Saussure explains,

> [a] linguistic sign is not a link between a thing and a name, but between a concept and a sound pattern. The sound pattern is not actually a sound; for a sound is something physical. A sound pattern is the hearer's psychological impression of a sound, as given to him by the evidence of his senses. This sound pattern may be called a 'material' element only in that it is the representation of our sensory impressions. The sound pattern may thus be distinguished from the other element associated with it in a linguistic sign. This other element is generally of a more abstract kind: the concept. (2008, p. 66)

What de Saussure means is that the signifier creates in the mind of a listener a distinctive mentally registered image, be it a cat, a tree or whatever. Nonetheless, although this all sounds straightforward and we can routinely recognise this process, de Saussure claimed that the relation between a signifier and the signified, the word and the mental concept that it creates, is entirely arbitrary. Accordingly, there is no natural link between the word and the concept, meaning that there is no intrinsic reason why the word 'tree' should create the image of a tree, it is simply a name that was given to the woody plant at some point and which became fixed and culturally recognised, but there is no essential link between the word, either when spoken or written, that intrinsically bears any relation to trees. This is so because the meaning of signs is derived from their relations of difference, whereby words and concepts get their meaning in the ways they differ from other words and concepts. Consequently, the relations of difference between signifier and signified fix meaning and a linguistic system is a series of differences of sound combined with a series of differences of ideas. As such, any sign is what all the others are not and so, for example, night is in a binary opposition to day.

The key issue is the way in which sounds can signify and inspire mental images and explain how meanings are culturally communicated. And it is this foundation provided by Saussure that paved the way for an approach to cultural understanding that would become known as semiotics, and which would enable semiological readings of signs to go beyond just the verbal. Furthermore, Barthes stressed the crucial role played by the reader of signs, a factor further developed within the approach of Umberto Eco, and his classic text, *A Theory of Semiotics*. For Eco, although Saussure did not define the signified clearly, seeing it as a fusion of a mental image, concept and psychological reality, de Saussure's work did emphasise the nature of the signified as the mental activity of an individual receiving a signifier; and this is crucial. As Eco states of de Saussure's essential

insight, a 'sign is implicitly regarded as a communicative device taking place between two human beings intentionally aiming to communicate or express something' (1976, pp. 14–15). Furthermore, words can be substituted for signs of various kinds that can be read as expressing the same meaning. Therefore, in defining the role and function of semiotics, Eco argues that semiotics is concerned with everything that can be *taken* as a sign, and a sign is anything that can be seen as meaningfully substituting for something else.

Although separated by decades, de Saussure, Barthes and Eco are united in their emphasis upon the ways in which objects within cultures can 'speak' and be substituted by alternative objects or symbols that are then read by other social actors. But, the idea of communicating via symbols that substitute for distinctive ideas or words is one that we can readily discern within contemporary culture, from art, cinema, advertising, to graphic design, theatre and graffiti. Nonetheless, there is also the developed and expression of symbolism within tattoo culture, past and present, that offers itself as a potent means with which to see such semiotic communication in action as many classic tattoo designs are clearly linked with symbolic meanings. For instance, the timeless image of the rose has been read as a symbol of love, but also purity and chastity, while a rose with thorns symbolises that 'beauty does not come without sacrifice, and that caution must be exercised lest the prick of the thorns draws blood. Love is not without risk' (Hemingson, 2009, p. 97). Similarly, the classic tattoo motif of the anchor 'has come to be associated with security and safety – a depiction of feeling grounded and tied to a steady foundation' (Holmes, 2013, p. 43), while within the American sailor tradition the tattoo design of a pig or a pig's head tattooed on the instep was acquired because it symbolised 'a sure charm against the sailor's drowning' (Parry, 2006, p. 134).

As tattoo culture has changed radically in the last few decades in relation to the rise in the acquisition of custom tattoo work, the central motivation and function of many tattoos is to communicate distinctive meanings that may be understandable only to the wearer of the tattoo, but which can be read (in numerous ways) by wider society. This ethos is conveyed by MacCormack, who stresses that tattoos explicitly 'create a new surface of the body as text' and consequently enhances the way in which 'skin is encountered as legible' (2006, pp. 57 and 59). As such, whereas tattoos can be expressly political in nature, or purely acquired due to their aesthetic appeal, they are imbued with meanings, as DeMello similarly states, 'except when worn in private areas, tattoos are meant to be read by others' (2000, p. 137). In terms of clear examples of such a semiotic nature of tattooing, we can return to the issue of tattooing within total

institutions to identify clear examples of distinctive and deliberate semiotic systems of tattooing that are strategically designed to be, as DeMello contends, read by distinct others.

As discussed in chapter 1, it was initially within American prisons in the 1960s that tattooing was perceived to have taken on a clear semiotic significance and function, whereby tattooing took the form of a system 'of "communicative encryptions" to denote gang affiliation within prisons or one's feelings of capture and confinement' (Atkinson, 2003a, p. 40). However, a significant body of work has been devoted to the status and function of tattooing within the Russian prison system, during the Soviet era, and beyond the fall of the Communist regime, that reveals a rich culture of conscious semiotic communication expressed through tattoo designs. As Jérôme Pierrat (2014) states, tattooing has become a widespread bodily practice within contemporary Russia, however, for decades tattoos were synonymous with the 'Zone', the slang term for the Russian/Soviet prison system. In this context, as Abby M. Schrader argues, tattoos served as a visual form of the criminal's 'calling card' designed to reclaim authority over the incarcerated body based upon a visual system that was beyond the authorities' understanding and ability to interpret the designs, many of which contained contradictory images. For example, 'tattoos of churches bearing numerous cupolas signify the number of times an individual was incarcerated rather than Orthodox belief' (2000, p. 190).

In Danzig Baldaev, Sergei Vasiliev and Alexei Pluser-Sarno's extensive pictorial analysis of Russian prisoners bearing tattoos, they mapped out a rich and complex system of 'prison folklore': an argot that symbolically communicates a range of information, from dates and places of birth, to the crimes committed. While the historic Japanese penal system inscribed such information, within the Russian prison system prisoners used tattoos to tell their own stories. As the researchers state of the tattooed bodies of convicted thieves, their bodies are 'a linguistic object', and as such, the tattoos within this culture represent a 'unique language of symbols and the rules for "reading" them are transmitted via oral tradition' (2009, p. 27). A crucial factor in this regard is that the tattoos act as a secret or 'esoteric' idiom that encodes precise information that cannot be interpreted by 'uninitiated outsides'. Consequently, tattoo designs that may seem common and meaningless (a devil, a burning candle, a snake, a cat) are instead symbols that are imbued with precise social and often political significance. For example, snakes represent fate; a cat symbolises agility and the thief's luck, while a skull motif frequently alludes to an individual's status as a thief; anti-communist symbols (Lenin depicted with horns) are not intrinsically representative of specific political grievances, but frequently expresses a rejection of state power and symbols of resistance against the forces of authority. More precisely, a thief's tattooed body represents a 'full-dress

uniform' in that it is adorned with regalia, and distinctive badges of rank and status distinction according to the number of tattooed military designs, rings, crosses on chains, bracelets and star-shaped badges and crowns. Read in a semiotic manner,

> [t]hese tattoos embody a thief's complete 'service record', his entire biography. They detail all of his achievements and failures, his promotions and demotions, his 'secondments' to jail and his 'transfers' to different types of 'work'. A thief's tattoos are his 'passport', 'case file', 'awards record', 'diplomas' and 'epitaphs'. In other words, his full set of official bureaucratic documents. Therefore, in the world of thieves a man with no tattoos has no social status whatsoever. (2009, p. 27)

Hence, via these intricate collections of tattoo designs (which merely appear as a random jumble of images to those who are not instructed in the symbolic world of the culture) represent a 'voice' that speaks of personal history, thoughts, feelings, memories and, sometimes, regret. Accordingly, tattoos, within this context, represent a 'chronicle of a life' and the men who bear them are 'tattoo texts' whose bodies form, what Baldaev, Vasiliev and Pluser-Sarno dub 'a kind of thieves' mass media' (2009, p. 29). Furthermore, these bodily tattoo 'texts' accord perfectly with Barthes' conception of semiotic signs in that a single body can constitute an array of differing communicative signs from the verbal (written language), to the 'representational, allegorical and symbolic' (2009, p. 31). Consequently, Baldaev, Vasiliev and Pluser-Sarno's research represents a highly innovative, complex and subcultural example of the practice of tattooing used to communicate secret/coded meanings. As such, it represents a potent example of tattooing as an avowedly semiotic phenomenon whereby each symbol is deliberate and, if the code is known, readable by others, however, it is not merely within prison systems that such motivation and function is manifest.

Within a wider cultural context, Angela Orend and Patricia Gagné's ethnographic interviews with individuals who have elected to have corporate brand logo tattoos (such as Harley-Davidson, Nike, Adidas, Ford, Budweiser, Volkswagen, Lego and Apple) a distinctive semiotic function was also palpable from their respondents. Thus, interviewees expressed the opinion that tattoos should communicate specific meanings related to the wearer, as one respondent stated of the signification of tattoo designs: 'It's like you send out signals of what you're into' (2009, p. 501). The rationale for sporting corporate brands ranged from brand loyalty; identifying with the products and establishing 'communities' with other aficionados of the brands; creatively identifying with a brand (as one Lego fan stated); to 'oppositional' stances as evidenced by the respondent who wore the IBM logo, not as a celebration

of the classic computer company, but as a representation of ' "resistance" to corporate America' (2009, p. 506). The tattooing of corporate brands and logos, therefore, acts in a distinctive, and multidimensional manner, but all united by the individual desire to communicate something via brand symbols. As Orend and Gagné state,

> [a]ll of our respondents used corporate logos to convey meaning about themselves, their communities, or their lifestyles. Although most had reservations about why others get tattoos, all believed they were exercising personal autonomy and agency and that their tattoos represented something intrinsically real about themselves, their communities, and their lifestyles. (2009, p. 509)

Yet, any sense of intention and stability with regard to semiotic communication is problematic in terms of how signs are formed and used, but is especially contentious in relation to tattoos by dint of their permanence. With regard to the tribal and prison cultures referred to in chapter 1, within these micro-social settings the use of symbolic markers that signify rites-of-passage or warrior statues are understood within a small-scale interpretive community. Similarly, the tattooed symbolic substitutes for written language evident within certain prison cultures represent a distinctive argot that is shared by a specific group. In this regard, tattoos operate as semiotic devices that render entire bodies as readable texts, or what Sullivan dubs 'social texts' to the extent that 'it is possible to read the tattoo as a picture that tells stories' (2001, p. 183), even if the precise meanings are abstract to the viewer.

A semiotic approach to tattooing is a valid theoretical one as it is also clear that many tattooed people consciously seek to communicate, or at least, symbolically inscribe meanings through specific signals that act as communicative signs. However, the interpretive ambiguity that Sullivan raises can be problematic when read from a postmodernist perspective, underpinned by an approach to knowledge and texts that is based upon the polysemic nature of interpretation. In John Fiske's (1990) view, polysemy is a process whereby texts (television, art, film, etc.) can be decoded in different ways by audiences as texts are not 'monolithic', but alternatively contain a number of possible meanings and therefore allow for a range of interpretations that may be very different from that intended by the producer. Within such as postmodernist approach, then, there is no essential truth and that meanings are marked by plurality, and arguably the most significant figure in this tradition in this regard was Jacques Derrida. It was Derrida who famously established the concept of deconstruction, a complex method of close reading that demonstrated that texts cannot sustain definitive meanings. As Derrida states within *Of Grammatology* (1997), deconstruction means the displacement and dismantling of meaning and the rejection of the supposition that any text can ever be universal. Although

the concepts of polysemy and deconstruction are now classic examples of social and cultural theory, they are especially significant when applied to tattoos as they are expressly worn to be timeless and stable; and yet they are subject to extensive social, cultural and individual polysemic and deconstructive readings that circumnavigate the wearer's intent with the choice of a design. For example, one of Atkinson's interviewees, 'Doug', sported swastika symbols as a political gesture of cultural and symbolic reclaiming. However, as Doug stated,

> I know when most people see the swastikas I have tattooed on my arms, they immediately think I'm a Nazi. They don't get that it's one of the oldest symbols used by men, and I'm trying to steal it back as a meaningful cultural symbol. I hate all that white power bullshit, but I am not stupid enough to believe that I don't look like that to people on the street. (2003a, p. 229)

However, while tattoos as signs run the risk of being read in a mode that is not cognizant with the wearer's intention (and a sign such as the swastikas is one that is immune to deconstruction and frozen in its association with Nazism), tattooing is still arguably underpinned by a desire to transform the body, or at least to attempt at using the body through giving it expressions of uniqueness related to self-expression and identity differentiation (Tiggemann and Golder, 2006; Tiggemann and Hopkins, 2011). As such, whether communicating a deeply personal aspect of biography, signifying fandom of the Marvel superhero, *Deadpool*, or simply wearing a tattoo as a random peer-influenced joke, the tattoo changes the body and makes a statement about it that transforms it in relation to temporal processes. In this sense, tattoos can be argued to represent Peter Berger and Thomas Luckmann's analysis of how social actors make sense of everyday reality as it is shared with other social actors within a distinctive intersubjective world. The most salient aspect of this state and set of social relationships is that humans cannot exist meaningfully in everyday life without incessant interaction and communication with others. As a result, the interactions of social actors' ' "here and now" continuously impinge on each other as long as the face-to-face situation continues. Accordingly, there is a continuous interchange of ... expressivity ...' (1991, p. 43). Through facial expressions, for example, interacting social actors respectively project their subjectivity through a range of verbal and non-verbal communicative 'symptoms'. The goal is for human expressivity to result in a condition of 'objectivation', a product of human activity that is understandable as part of the common world. As such, gaining access to another social actor's subjectivity is achieved (or at least attempted) through the reaction to the other's production of signs, whereby a 'sign may be distinguished from other objectivations by its explicit intension to serve as an index of subjective meanings' (1991, p. 50). Fundamentally, then, signs are collected within a

number of communicative systems that include gesticulatory signs, bodily movements and language, the latter of which is both symbolic and constructs symbols which facilitate meaningful communication. Consequently, Berger and Thomas Luckmann argue that

> [i]n this manner, symbolism and symbolic language become essential constituents of the reality of everyday life and of the common-sense apprehension of this reality. I live in a world of signs *and* symbols every day. (1991, p. 55)

In terms of this analysis, social actors operate within a 'symbolic universe' that enables the production of meaning and the communication of individual biographies, and, given the self-constructive quality and semiotic richness of tattooing discussed earlier, tattoos can be added to Berger and Thomas Luckmann's itinerary of communicative systems as they operate as part of the signs and symbols that social actors use to express meaning in everyday culture. Moreover, the phenomenological ethos that underpins Berger and Thomas Luckmann's work offers a distinctive means by which the semiotic function of tattoos can be deepened with regards to the ways in which tattoos alter bodies in terms of transforming a social actor's sense of 'Being', and how this sense of 'Being' negotiates time in relation to symbols and statements of self that are inscribed into the skin.

TATTOOING AS PHENOMENOLOGICAL EXPRESSION AND COMMUNICATION

In providing an overview of the nature of phenomenology, Michel Henry argues that its object is based upon the objective of showing, unveiling, uncovering, manifesting and revealing, and upon the premise that what 'is intelligible, comprehensive, and capable of being grasped by us is what we can see, in a clear view' (2015, p. 90). To define the approach further, referring to the work of phenomenology's key founding thinker, Edmund Husserl, it is a body of thought that is a form of interrogation, but an 'interrogation not of facts and things but of meaning' (Welton, 1977, p. 54). From Husserl's perspective, phenomenology is a theory developed to understand the nature of 'essential Being' and to comprehend the essence of such an object 'in terms of its "bodily" selfhood' (1969, p. 55). Subsequently, at the root of the phenomenological approach is the 'centrality of the living body as the primary phenomenon to a historical-social understanding of intersubjectivity rooted in bodily experience' (Ferguson, 2006, p. 92). To begin to substantively explore the nature of this approach, within *Being and Nothingness*, Jean-Paul Sartre stressed that a person's sense of being has one caught in a perpetual present because the 'past is no longer ... since it has melted away into nothingness.

Memory – exists in the present – an imprint at present stamped on a group of cerebral cells' (2003, p. 131). In Sartre's view, everything is constantly present, and present as an impression on the body. Moreover, he also stresses that an individual cannot 'have' a past in the same way in which an individual possesses a physical artefact, such as an automobile. Consequently, the past cannot be possessed by the individual existing in the present, but the past can haunt the present. In this sense, individuals represent a form of temporal synthesis of the past and present, with the body playing a crucial role in making the 'present' world meaningful in relation to the past and the future. This is achieved with reference to the classic human distinction between the soul and body, whereby 'the soul utilizes the tool which is the body' (2003, p. 344). In this sense, the various other individuals a person encounters equally use their bodies in this fashion because, argues Sartre, 'the other's body is meaningful' (2003, p. 368).

The semantics of Sartre's analysis of being stress key aspects of the communicative function and potential of tattoos as part of a process by which the 'soul' can use the flesh to articulate meaning to the self and map out and carry the past in the present. For instance, Sartre speaks of grief as an abstract emotion, one that lacks concrete existence, but tattoos frequently symbolically fix a feeling of grief, and can act as a therapeutic agent in coping with, and negotiating grief. While the memento mori has been part of funerary monuments in the form of skulls, hourglasses or scythes from at least the Renaissance era, the tattoo has become part of this engraving, sculptural and artistic tradition whereby tattoo designs serve as constant celebratory or honorary bodily reminders of a lost loved one, and act as an inscribed memorial of the past that is constantly with the mourner (Hemingson, 2009), stressing the primacy of the present to remind the wearer 'of the fleeting nature of life' (Curl, 1980, p. 3). Sartre's idea of the 'soul' utilising the body to give meaning is an especially evocative one with regard to philosophically examining the tattoo because, as Pitts (2003) stresses, tattoos are a mode of bodily modification that are literally inscribed 'in the flesh'.

This idea is also present in the phenomenological work of Henri Bergson, who described the 'universe' as a space saturated with images in which our memory ensures that images of the past survive with us in our present lives, meaning that social actors constantly live with the persistence of the past. Consequently, argues Bergson,

> [w]henever we are trying to recover a recollection, to call up some period of our history, we become conscious of an act sui generis ['of its own kind'] by which we detach ourselves from the present in order to replace ourselves, first, in the past in general, then, in a certain region of the past – a work of adjustment, something like the focusing of a camera. (cited in Pearson and Ansell, 2002, p. 151)

In Bergson's view, the present is a state that simultaneously has one foot in the past and another in the future, but this temporary condition is mitigated by the physical because a person's sense of the present consists in the consciousness that they have of their bodies, but in a very distinctive way. As Bergson states,

> [m]y actual sensations occupy definite portions of the surface of my body; pure memory, on the other hand, interests no part of my body ... Of my past, that alone becomes image ... Memory actualized in an image differs then, profoundly from pure memory. The image is a present state, and its sole shame in the past is the memory from which it arose. (cited in Pearson and Ansell, 2002, pp. 156–157)

As with Sartre, the issue of the past in relation to the present, and the primacy of images and bodies evoked by Bergson, point to clear ways in which the ethos and conceptual nature of these phenomenological approaches can provide a significant theoretical prism by which to critically assess contemporary tattoo culture. This is because the issue of a memory being 'actualized in an image' *is* a meaningful factor within philosophical assessments of tattoos which have increasingly been read as distinctive and 'effective sites for self-affirmation, identity creation, and agentic reverie' (Stein, 2011, p. 128). The primacy of the 'living body' and meaning revelation is a factor critically assessed by Fruh and Thomas as a conscious means by which individuals use tattoos to express on their skin a symbol of their inner lives or to signify a consequential episode in their life histories. And whether the image represents a profound or superficial aspect of biography, the tattoo is transformative because once inscribed it becomes a part of the body and the self, fixing a memory or an emotion that can constantly be, in a Bergsonian fashion, recalled on viewing the tattoo.

Subsequently, even tattoo designs that become the subject of personal regret can become renegotiated into acceptable 'bodily mistakes' and not subjected to removal or covering processes because, regardless of the redundancy of the image, the memories of the past self that the tattoo conjures possesses significance and acts as a conduit to the past in relation to the present identity. In this sense, tattoos represent a unique technique of body modification, and one that is distinctively phenomenological, whereby an image (whether Flash-based or custom-designed) serves as an anchor point within an individual's life history and can serve as a literal evocative version of the temporal memory state that Sartre and Bergson articulate as 'they at once carry something of the past into the present and project it into future' (Fruh and Thomas, 2012, p. 92). However, the relationship between phenomenology and tattooing can be deepened when

the nature of tattooing is more fully considered with regard to its status as a bodily art form, as illustrated by Rachel C. Falkenstern's analysis of tattoos in relation to notions of the self, time and the permanence of tattoo designs.

In Falkenstern's view, the 'immutability' of tattoos remains a key factor in explaining why, irrespective of the ostensible 'mainstreaming' of the practice, many people still would not acquire one. However, as an art form, the tattoo is somewhat unique because, although explicitly designed to be permanent, this lastingness is tied to the temporality of the person who wears it. In this way, the person and the tattoo exist in an inimitable relationship whereby 'just as the tattoo is integrated into the person's body, so too is the bearer a part of the work – if you take the person away, there is no tattoo' (2012, p. 98). To further explore this relationship, Falkenstern employs the work of the phenomenological philosopher Maurice Merleau-Ponty, and his understanding that an individual's embodied subjective experience cannot be limited to either the mind or the body. Instead, Merleau-Ponty stresses that the connection between mind and body is not that of two differing constituents that are connected, but that we are our bodies, and that the body and self are not two discrete entities that work on the other but, alternatively, the body and the self are integrated together into one unified system. Hence, a body without a mind is no longer the being that it was when they are interconnected. Similarly, the 'external world' is not evident to individuals simply through their perception of it, rather, individuals are in the world and the world is in the individual. In this regard, individuals come into being, they develop, and they continuously interact with their milieus as distinctive and embodied beings because 'the world shapes us and we shape the world' (2012, p. 99). In this regard, as Merleau-Ponty argues within *Phenomenology of Perception*, phenomenology is the study of essences, of perception and of consciousness within 'lived' space, 'lived' time and the 'lived' world. It is the world that responsible for the founding of being, and the body 'is the very movement of expression, it projects significations on the outside by giving them a place' (2014, p. 147). This is because the body is not merely a physical object, but a signifying being, one that 'shows' and 'speaks' to the extent that the body cannot be compared to a physical object but 'rather to the work of art' (2014, p. 147).

Applying Merleau-Ponty to tattooing, the body can and does incorporate and communicate expression through inscribed art, and, as Falkenstern argues, points to the ways in which they can represent an object that is both distinct and a part of an individual. This is because the tattoo is not an object that rests *on* the body, but is a part of the body, whereby the art work and the body are integrated and unified, and remain so in a process of bodily symbiosis to

the extent that as the body changes over time, so does the tattooed image. Consequently, Falkenstern states, in a phenomenological fashion,

[n]ot only does the body express, and is expressive of, emotions, attitudes, and ideas, but also our emotions, attitudes, and ideas are affected by the body. Being tattooed has changed not only how the world views me but also, interelatedly, my perspective of the world and my perspective of my self. (2012, pp. 99–100)

As Merleau-Ponty elucidates on the individual's relationship with time and the past, he argues that we 'believe that our past, for ourselves, reduces to the explicit memories that we can contemplate. We cut our existence off from the past itself, and we only allow our existence to seize upon the present traces of this past' (2014, p. 413). Reflecting on this principle in relation to tattoos, Falkenstern stresses that because they act as inscribed reminders of specific moments in an individual's biography, they consequently visually map the advance of time. As a consequence, reflecting upon her own tattoos, she views them as evocative 'mementos of past experiences, including the experience of getting tattooed and the surrounding circumstances, and how they also remind me of how I have changed since then. Thus, their permanence acts as a marker of the passage of time' (2012, p. 100). Hence, even if the original meaning of a tattoo has changed because the individual's life has changed, for example a tattoo dedicated to a lover or spouse can, if the relationship breaks down and ends, ultimately become a semiotic symbol signifying fortitude, or simply a reminder of youthful impetuousness.

Given the ability of tattooing to epistemically enable the wearer to communicate meaningfully to the world and the self, and to mentally shift temporal spaces, Falkenstern argues the tattoo is a phenomenological object because

[i]t's a point of reference – a visible, physical connection between the past and the present. In this way, tattoos can be thought of as an attempt to hang on to this world or to the past, and perhaps as a way of holding on to the present or of trying to control the future. As grandiose as this may sound, it's nonetheless common. For example, memorial tattoos carry such a significance for the individual bearers; a memorial tattoo is a material representation of a memory. If I'm constantly reminded of a person or an event by my tattoo, this reminder is a way of ensuring that I don't forget in the future. (2012, pp. 105–106)

Tattoos, then, represent semiotic images that can communicate aspects of the wearers' sense of self, but the phenomenological onus upon symbolic communication, lived worlds of meaning, and the temporal states of past, present and future within the individual's understanding of the essences that make the world understandable all stress a distinctive focus upon the dynamic relationship between an individual's sense of being in relation to time. Furthermore,

this is a dynamic that suggests the relevance of a further key phenomeno-logical theorist, Martin Heidegger.

TATTOOED DESEIN: HEIDEGGER AND THE SEARCH FOR AUTHENTICITY THROUGH INK

In the view of Thomas Sheehan, Heidegger's conception of phenomenology is one predicated upon the philosophical analysis of the meaningfulness, 'the lucidity of things, and the search for the 'essence' of things to explain what, why and how things are as they are and how this sense contributes to an individual's sense of 'being'. This search for the sense of being is a fundamental component of human culture, because Heidegger's argument is that at 'least since Homo Sapiens came on the scene some 200,000 years ago, "to be" has meant "to be meaningful". Meaningfulness is inevitable for us' (2015, p. 111). Moreover, meaning plays a key role within the world because it is a major force that 'staves off chaos for a brief stretch of time in the losing battle of life' (2015, p. 115). With regard to the phenomenological ideas already presented, the relationship of meaning and tattooing fits into such a view of the philosophy, but Heidegger's concept of being is also an important factor in deepening the analysis of the nature and status of the tattoo within contemporary culture. Although a notoriously multifaceted and ever-evolving concept within Heidegger's work, in his 'magnum opus', *Being and Time*, Heidegger states of 'Being', or what he calls Dasein (derived from the German 'das sein' – 'to be')

> Dasein is an entity which does not just occur among other entities. Rather, it is ontically distinguished by the fact that, in its very Being, that Being is an *issue* for it. But in that case, this is a constitutive state of Dasein's Being, and this implies that Dasein, in its Being, has a relationship towards that Being – a relationship which itself is one of Being. And this further means that there is some way in which Dasein understands itself in its Being, and that to some degree, it does so explicitly. (1962, p. 32)

For Heidegger, individual Dasein engaging in the world constitute a 'Being-in-the-world', a space in which we conduct our various 'dealings', the space in which it is absorbed. It is important to note that for all of the abstraction that Heidegger's ideas communicate, the 'world' is very much the world of the 'everyday', and we are absorbed into the world and meaning through our interaction with social 'Others', or the 'They'. In Michael Watts' analysis of Heidegger, he points to the way in which in a world of diverse beings, only humans can and do question their 'Being' and explicitly ask 'what is Being?' In this regard, argues Watts, however vague the sense of 'Being' may be for an individual, nevertheless, humans are constantly reflecting upon their

immediate world. Moreover, a person does not have to actively question the meaning of their existence to still attain some measure of understanding of their sense of 'Being', because simply living in the world inevitably means perpetual interaction with the 'Being' of others, which leads to reflection upon the nature of personal 'Being', and the Dasein of others. In this sense, then, Dasein is the 'there' of 'Being', and so Dasein 'is the site at which Being can manifest itself as the light of man's understanding: it is the human being's selfhood' (2011, p. 41), with the more immediate forum to understand Dasein's mode of existence and selfhood being that which is closest to it: its 'everydayness' based simply upon the way in which Desein lives from one day to the next. Importantly, however, Heidegger speaks of the Dasein as 'being-there' in the world, but not a physical world, but rather a space of meaning, 'a domain of possibilities that is inhabited by Dasein's *active* under-standing, which manifests as Desein's knowing *what* to do and *why* it makes sense to do it' (2011, p. 41). This sense of world, therefore, refers to all of the experiences that impinge on and influence an individual, such as the country that the Dasein resides in, its culture, educational attainment, family, friends, employment or hobbies. Consequently, a Dasein is influenced by its immedi-ate world and through the fact that it lives in an 'ordinary' and immediate world in which it has a practical involvement with: a world into which the Dasein has been effectively 'thrown' into.

The concept of 'thrownness' is an important one in that as individuals we have no choice with regard to the 'world' into which we are born into, with its attendant religious values, cultural identity, environmental nature and familial space. The individual Dasein did not choose any of these worldly factors, but they represent a fundamental force in the influence of both the present and future nature of their 'Being', a process which transforms the Dasein's 'facticity'. As Watts explains,

> [o]ur facticity is the sum total of our current situation, combined with what this enables us to become in terms of our own future possibilities; in other words, every morning when I awaken, and at every moment of my existence, I am faced with the responsibility of choosing what I can be on the basis of what I have been and what I am. (2011, p. 52)

However, the state of being 'thrown' is a perpetual one in the existence of the Dasein as it is thrown from the past, into the present, and then into the future, but is still influenced by the past. This results, argues Watts, in an incessant struggle between the desire to fulfil autonomous capabilities and personal promise, and the influence of thrownness. This is achieved through the relationship between what Heidegger calls the everyday Being-one's-Self and the 'They', the 'Others' who are constantly 'there' in a Dasein's every-day existence, transforming it into a 'Being of the Other', a 'dictatorship of

the "They"' that tends to impose a status of 'averageness' on the individual Dasein, with the result that

> [w]e take pleasure and enjoy ourselves as *they* ... take pleasure; we read, see, and judge about literature and act as *they* see and judge; likewise we shrink back from the 'great mass' as *they* shrink back; we find 'shocking' what *they* find shocking. The 'they', which is nothing definite ... prescribes the kind of Being of everydayness'. (1962, p. 164)

The result is a state of averageness, a mode of being that suppresses the exceptional and which manipulates all that has been hard-won through struggle to induce a process of the 'levelling down' of the possibilities open to the individual Dasein. Hence, the 'Self of everyday Dasein is the *they-self* which we distinguish from the *authentic self* – that is, from the self which has been taken hold of in its own way' (1962, p. 167). As Watts explains, this thrown state means that individuals constantly carry their past with them, which is a set of conditions that influence and restrain present and future behaviours and possibilities, rendering the Dasein as an inauthentic 'They-self'. This is because Dasein predominantly forgets its unique sense of being, its ability to live authentically due to assimilation into the surrounding everyday world that is provided by the 'They'. Accordingly, the ubiquitous influence of the 'They' expresses itself into a Dasein's clothes and hairstyle, whereby the Dasein 'conforms' to the style of a specific world, such as those who work in the world of business, or a uniformed service (the police, army etc.). Furthermore, this extends to would-be rebellious members of subcultures, whereby those who sport outlandish hairstyles, body-piercings and tattoos are mistaken in their belief that they are living authentic lives. This is because such 'non-conformists are merely conforming to the They of the counter-culture world. Indeed, these types are often rigid conformists within their chosen subculture' (2011, p. 54).

The reference to tattooing in direct relation to Heidegger's conception of the nature of Being/Dasein, and authentic/inauthentic existence obviously raises a means by which to apply this phenomenological approach to tattooing in an evaluative manner. Taking the issue of thrownness in relation to tattooing, then Watts' application can be discerned. For example, looking again at Hambly's (2009) historical/anthropological survey of tattooing within 'tribal' cultures (as discussed in chapter 1), tattooing was an endemic cultural practice performed on members of the community as part of the cultural and symbolic life of the group. For example, young women would be tattooed to signify their attainment of puberty, marriage or denote how many children they had borne, or the case of the male youths of Shan, who were not considered to have attained manhood until they demonstrated their courage through undergoing the pain of tattooing.

In these instances, tattooing is directly the result of thrown-ness, whereby tattoos are not the subject of individual choice, but worn as a consequence of being born within those cultures that have made tattooing a symbolic component of the maturation and developmental status of its members. Hence, the history of tattooing is replete with examples of cultures that explicitly illustrate the use of the tattoo as the product of the 'They'. Similarly, reflecting Watts' example of the tattooed counter-culturalist who wears her/his designs as a mark of individualised rebellion, Steward's retrospective appraisal of his tattooing career cites numerous references to the 'outsider' gang member seeking a tattoo as a means by which to fully belong to his 'herd' but, ironically, cement their conformity in that 'when one got a tattoo, they all wanted one' (1990, p. 116). In this sense, as Camphausen (1997) stated, a crucial factor in the mainstreaming of tattooing has been that so many 'rebels' possessed them. More contemporaneously, as discussed in chapter 2, the substantial trend of visible tattoos within popular culture, fashion and celebrity has produced a new strata of social 'They' by which tattooing has been increasingly mainstreamed. Moreover, whereas the 'They' of *Being and Time* is an abstract cultural force, fashion and celebrity-inspired tattoos are the result of observation and consumption of an identifiable 'They', a roster of public figures whose bodily habitus stimulates tattoo emulation and inspiration.

Hence, the idea of thrown-ness and the social and cultural influence of the 'They' represents a conformist view, as Watts suggests, that nevertheless enables tattooing to be firmly aligned with Heidegger's phenomenology. However, given the primacy of 'Being' within his work, a far more positive application can arguably be made. With regard to the tension between authentic and inauthentic 'Being', the role of tattooing is more significant than simply false subcultural rebellion. Indeed, acquiring a tattoo in order to visibly communicate social defiance is but one motivating factor in electing to be tattooed. As such, tattooing can be seen as a part of the process of establishing some degree of authenticity, of Dasein deciding to 'do their own thing' (Watts, 2011, p. 59). For example, with reference to the model and actress, Ruby Rose, her bodily discourse is, within the context of mainstream fashion and cosmetics advertising, radically individual. While there are fashion models who sport tattoos, few, if any, are as extensively tattooed as she is. Adding her gender fluid self-representations, she can legitimately be argued to be a public figure that manifestly is doing 'her own thing' (and heavily tattooed runway models are still rare). To be truly authentic is a great challenge given that individuals are born and socialised within societies, cultures and temporal spaces that are not of their own choosing. Indeed, perhaps only Nietzsche's heroic and superhuman Ubermensch could truly transcend their culture and create their own values, so, the 'everyday' Dasein is content with

individualised actions that attempt to stake out authenticity. As the tattooing literature argues, while rebellion may have had some legitimacy as a motivating factor, the desire to use tattoos as an individualising marker is compelling, because, as Sanders (2008) found through his interviews, a frequent statement about their tattoos was that they made the wears feel 'different'.

In this manner, tattoos can be read as part of a Dasein's strategy at the resistance of inauthenticity. For Raymond Angelo Belliotti, living inauthentically means, 'I am *clinging to fixity* if I accept that I have a fixed, unalterable essence. Doing so denies my transcendence – my freedom and capability of transforming who I am' (2010, p. 75). Furthermore, this Heideggerian quest for authenticity is aptly described by Carol Selby Price and Robert M. Price (1999) as a process in which individuals strive to *design* themselves, a factor that is literalised with regards to an individual's sense of 'Being' and the decision to be tattooed.

This is all the more pertinent with regard to tattooing because to be tattooed is a transformative bodily experience and process. As Hemingson explains, human skin comprises of three major layers: the epidermis, the dermis and the subcutaneous or hypodermis. A correctly applied tattoo injects ink pigments underneath the epidermis and into the skin layer between the dermis and epidermis, trapping the ink in the dermis layer. As a wound, the tattoo activates lymphocytes – the white blood cells – which attempt to remove pigments, which in the case of the ink, they cannot, so consequently another form of white blood cells, macrophages then attempt to eliminate the foreign object. This is a crucial process because 'if the pigment particles is inorganic and non-toxic, the macrophage will begin a process that results in the formation of scar tissue around the particle, walling it off and anchoring it in place. And there it will remain, indelible and permanent' (2009. p, 17).

In this fashion, the act of tattooing is a transformative one that alters the body and changes it from that which it was originally 'thrown', and illustrates Heidegger's notion of social, cultural and environmental thrown-ness. For example, as discussed in chapter 1, Nasir's research illustrates the manner by which tattooing acts as a conscious transgressive cultural act by Malay Muslim members of Chinese gangs. While the tattoos may conform to the strictures of gang culture, they represent a decisive break from the cultural fixity of the members' 'thrown' Islamic culture, which routinely forbids such permanent bodily modification. As such, tattooing can be read as a physical act that authenticates a person because, as Sanders (2008) points out, tattoos symbolise the separation of the tattooed individual from other individuals and groups such as parents, spouses, employers and other significant 'They'.

For Heidegger, authenticity is an act of the Dasein 'doing their own thing' (Watts, 2011), or of striving to find itself, and tattooing transcends simply

the others' influence in the form of influential peer groups offering pseudo-rebellion to symbolically communicate identity expression. As Thompson reflectively explains in relation to her own choice to become a heavily tattooed woman, it is a distinctive 'practice of the self' and one that challenges pervasive gendered beauty standards, as evidenced by the frequency by which Thompson and many of her respondents experienced having their tattoos touched without permission by strangers and unsolicited requests from members of the public to explain the meanings behind the images. These instances of the 'othering' of heavily tattooed women stress the ways in which tattoos can and do act as transformative bodily modifications, which change both the physical and symbolic nature of the wearers' sense of being and identity. As one female tattoo artist Thompson interviewed stated of her comprehensive tattoo collection, 'I can't imagine myself without them. I don't know myself without them' (2015, p. 64). In this sense, tattoos can be argued to constitute a bodily example of the phenomenological experiential questioning that poses interrogations such as 'what is a sense of self?' (Smith, 2001, p. 66) that at least addresses the issue of authenticity in a Heideggerian sense. As Botz-Bornstein explains,

> [t]attoos alter nature and resist time as they create lasting marks on the body that defy aging. Tattoos also signify commitment. In contemporary civilization, the body is more and more caught in the expectation that it should constantly be modified and reformed through diets, aerobics, plastic surgery and fashion. Here tattoos can re-establish the body as a concrete, stable, and reassuring human condition and provide authenticity where identities become increasingly disposable. (2012, p. 54)

Returning to the issue of a fixed sense of essence, tattoos counter this by their transformative nature, and while they may not result in a truly authentic sense of 'Being', they can/do alter the essence of an individual with regards to the changes within their skin, the attitudes of others, and, most crucially, how tattoos transform an individual's sense of being through time. As Thompson argues, the tattooed body 'is literally a body-in-progress, telling the story of past journeys and those yet to come' (2015, p. 37). With reference to Heidegger's examination of Dasein in relation to time and temporality, it is a thing that is always dying (a condition that begins from birth), but this is commonly sublimated as a condition that is happening to others, and when it is acknowledged openly, it 'gives us the assurance still more plainly that 'oneself' is still 'living'' (1962, p. 298). As mentioned earlier, memorial tattoos inscribe this 'still living' sensibility into the skin as a constant semiotic communicator of what Heidegger calls an individual's sense of its Being-towards-its-end. In this sense, memorial tattoos are reflecting changes in cultural

attitudes to death, signalling a move away from 'letting go' of the deceased, to symbolically forging a relationship that signals 'a new and appropriate place for the dead in their emotional lives, which enables them to live effectively in the world' (Alison Thomas, in Brown, 2015b, pp. 80–81). In the case of memento mori tattoos, these are explicitly designed to signify the temporality of life and remind the wearer to maximise the potentials offered by the condition of 'still living'. In articulating his conception of the temporality of 'Being', Heidegger encapsulates it in the following way

> [w]hat seems 'simpler' than to characterize the *'connectedness of life'* between birth and death? It *consists of* a sequence of Experiences 'in time'. But if one makes a more penetrating study of this way of characterizing the 'connectedness in question, and especially of the ontological assumptions behind it, the remarkable upshot is that, in this sequence of Experiences, what is 'really' actual is, in each case, just that Experience which is present-at-hand 'in the current "now"', while those Experiences which have passed away or are only coming along, either are no longer or are not yet 'actual'. Dasein traverses the span of time granted to it between the two boundaries, and it does so in such a way that, in each case, it is 'actual' only in the 'now' and hops, as it were, through the sequence of 'nows' of its own 'time'. (1962, p. 425)

However, tattoos enable a Dasein to carry elements of their many 'past nows' with them, through time. As Heidegger asserts, the past is that which is no longer present-at-hand, but aspects of the past remain to have an influence on the present of a particular Dasein's 'now'. To illustrate, Heidegger likens this to the remains of an ancient Greek temple, whereby ' "a bit of the past" is still "in the present" ' (1962, p. 430). In this sense, tattoos arguably act as personal 'Greek temples' as time passes, whether acting as constant positive reminders of components of identity or aesthetic choices, or sources of nostalgia (even if regretted in the 'now'). Tattoos, as Thompson states, carry a person's past into the present and into the future, fitting into Heidegger's later definition of 'Being' as dominated by the desire to 'preserve' aspects of the self and in which 'being is the "outward appearance" which bestows upon beings their particular look' (2016, p. 71). These are factors that are illustrated and validated from a phenomenological perspective in relation to individuals who inscribe themselves with tattoos. As Alex MacNaughton's collection of personal tattoo testimonies presented within his book, *London Tattoos*, reveals, tattoos are described as personalised 'snapshots in time', a means of marking off particular 'chapters' in a life. As one respondent stated of their tattoos, 'They are ... intrinsically a part of me, they are part of who I am, an outward expression of an inner sentiment' (2011, p. 23).

'HERE I AM IN THE PRESENCE OF
IMAGES': TATTOOS AND BEING

For Heidegger, 'discoursing or talking is the way in which we articulate 'significantly' the intelligibility of Being-in-the-world' (1962, 204), but in examining tattoos as semiotic communicative images of self, and expressions of phenomenological 'Being', tattoos can be added to Heidegger's roster of intelligibility-bearing mediums. As Sanders asserts, 'tattooed people voluntarily shape their social identities and enhance their definitions of self' (2008, pp. 60–61), either as a means by which to signify an association with a group or as an 'isolative symbol of unconventionality, or unique personal decoration' (2008, pp. 57). Consequently, while tattoos can be argued to act as semiotic signs that communicate aspects of the self, a phenomenological analysis illustrates the degree to which tattoos, whether in the form of clearly thought-through expressions of self or ill-conceived whims, transform the body and produce marks that carry the past into the future. Tattoos transform the body, whether they are small inconspicuous designs or a series of designs that cover the body, tattoos change the skin, from both without and within, and tattoos alter an individual's sense of 'Being'. As Grognard states, tattooing 'symbolizes the transition from one state of being to another. It bestows a socio-cultural identity on the individual who suffers to acquire it' (1994, p. 67). Subsequently, this evokes an early influencer of phenomenology, René Descartes, whose understanding of human nature and behaviour as rooted in their existence as a 'thinking-substance' was ultimately based upon the 'union and apparent intermingling of mind and body' (1997, p. 183), a fusion that coveys the essence of the tattoo: an idea (or peer/alcohol-influenced act of caprice) that is painfully etched onto the body.

The idea that tattoos serving as semiotic symbolic communicators of identify, self and temporal 'Being' will be further explored in the next chapter, based as it is upon interview data gleaned from tattooed social actors who explain and communicate the motivations for their tattoo designs and their self-reflective stories that explore their feelings about being tattooed, and how other social actors perceive this state.

Part II

ETHNOGRAPHIES OF INK

Tattoos as Communicative Practice and Phenomenological Expression

The Tattooed Perspective

Chapter 3 looked at the ways in which tattoos can be argued to act as semiotic signs, what Eco calls 'communicative devices', and as a phenomenological practice. Consequently, tattoos can arguably act as transformative aspects of being, as a a means of communicating to the self and the external world a sense of personal identity through images or text that convey temporality, and which can map out differing aspects of the self which are carried by the body through time as the wearer ages. Within this chapter, then, the focus will be upon exploring these ideas in relation to ethnographically obtained social actor thoughts and feelings about their tattoos, why they choose the images that are inscribed into their skin, what the imagers may or may not consciously signify about themselves and how being tattooed affects their sense of being with regard to how they see their tattooed bodies, and how others perceive them in terms of their tattoos. This chapter will cite existing examples of ethnographically based studies of tattoos, but the main substance and content of the discussion will be based upon material drawn from my own interviews with tattooed individuals.

ETHNOGRAPHIES OF INK

Within tattoo studies, the ethnographic approach has been an influential methodological tool with which to fully explore social actors' motivations for being tattooed. As Hammersley (1990) notes, ethnography is perhaps the loosest of all the social sciences methodologies, as it is not so much a method as an 'approach' that is characterised by diverseness. Hence, unstructured interviews, case studies, participant observation, secondary documentary analysis and the life history all fall under the banner of ethnography. But,

underscoring such methodological variety is the 'meta' conception that a social actor's behaviour must be studied in everyday contexts, in an unstructured manner, and on a relatively small-scale. The motivating drive has been (and continues to be) the attempt to gain naturalistic insight and understanding into 'a social group's observable patterns of behaviour, customs and way of life, to achieve a compelling sense of the emic perspective – the social actor's/insider's distinctive "perspective of reality"' (Fetterman, 1989, p. 27). In this sense, ethnography has proven to be an effective means of capturing the rich and multifaceted nature of tattoo culture, as expressed in classic texts such as Sanders' *Customizing The Body: The Art and Culture of Tattooing*, DeMello's *A Cultural History of the Modern Tattoo Community*, Atkinson's *Tattooed: The Sociogenesis of a Body Art* and contemporary works such as Thompson's gender-based *Covered In Ink: Tattoos, Women, and the Politics of the Body*. From a distinctive sociological perspective (evoking postmodernism and Durkheim's theory), Atkinson's Canada-based ethnographic research explored the motivations tattoo 'enthusiasts' have for engaging in the practice of tattooing, raising the issue of social actors acquiring tattoos as a part of a distinctive 'body project' designed to deliberately contravene conventional cultural body codes. In some instances the motivation to be tattooed was to gain acceptance into distinctive 'outsider' groups which, through tattooing, 'violated' middle-class bodily behaviours, a factor especially in evidence when aligned to using tattoos to resist prevailing mores.

As Atkinson reflects, 'scores of the women tattoo enthusiasts I met stressed the importance of taking personal control over the body in a culture that promotes a degree of individual body play, yet regulates, restricts, and prohibits the completely free pursuit of bodily jouissance via rigid beauty codes' (2003a, p. 173). Although the prominent cultural visibility of figures such as Angelina Jolie, Cara Delevingne and Ruby Rose have arguably helped to transform perceptions of the status of gender and tattoos, Thompson's ethnographic research, which was based upon tattooed females primarily in the 18–30 age category, similarly found that many respondents acquired tattoos as a means by which to 'reclaim' their bodies as a reaction to the 'other oriented' nature of many women's lives (with regard to children, spouses, partners) in which 'tattoos are something for oneself' (2015, p. 52). In this regard, Thompson's interviews found that many respondents described their tattoo designs in terms of them acting as inscribed symbols of self-empowerment and self-expression, as one women stated of the symbolic significance of her tattoos, 'It's my personality on my arm' (2015, p. 56). These views reinforce Atkinson's findings which pointed to the ways in which many of his interviewees reported that their tattoos acted as a bodily means of enduringly marking into the skin symbols of significant life changes and transitions, whereby their bodies became a 'travelling scrapbook upon which memories are permanently imprinted'

(2003a, p. 187). As such, many of the tattooed people Atkinson interviewed articulated how their tattoos performed distinctive emotional functions in that the designs provided them with a unique 'way of venting emotions publicly through the body' which could act as 'a signifier of a new life trajectory, a fresh beginning for the person' (2003a, pp. 187 and 194). Sanders' ethnographic work similarly concurs with this symbolic view, arguing, as he does from his interviews conducted within tattoo studios, that the decision to be tattooed is a quintessentially social act as it is inspired by an ethos of how the tattooed person defines themselves, and so it takes the form of a 'ritual commemoration' of a significant life event. Sanders records that two principle motivating factors were present from those that he interviewed: firstly, those who obtained a tattoo as a means by which to connect them to another person or group of persons, such as a gang or a sports team; secondly, tattoos were gained as idiosyncratic representations of their perception of self, from personal traits or leisure pursuits, but regardless of the design or the bodily placement of the tattoo, respondents reported that tattoos served to change their sense of self-perception and to make them feel 'different' (2008, p. 51).

A thought-provoking aspect of Atkinson's tattoo research is the consistent, and persistent, degree to which respondents felt that mainstream Canadian society was rooted within a Christian and distinctly middle-class standpoint that clung to the negative perceptions of tattoo culture that still linked it to criminality, social deviance, anti-social otherness, the exoticism of the carnival/circus and the 'primitive'. However, DeMello's ethnographically based research explored the distinctive ways in which the 'Tattoo Renaissance' signalled a decisive and enduring shift with regard to who elected to be tattooed. In DeMello's analysis, while tattooing may have once been resolutely linked to those experiencing marginalisation from society, the widespread and growing adoption of tattooing by the middle-classes radically transformed the purposes and meanings attached to tattooing and tattoo designs. A key factor here, argues DeMello, is that this wider social and cultural proliferation of tattooing moved it into the realm of self-actualisation rather than a spontaneous choice of predesigned and generic Flash art hanging on studio walls that could have been applied to countless clients. Alternatively, middle-class tattoo wearers sought individualised 'custom' images that exclusively reflected their personal identity and consciousness. As such, within this context tattoos took on a 'story-telling' function so that 'tattooed people – especially those who look like they should not wear them – are frequently asked about their tattoos and have thus created lengthy narratives to explain them' (2000, p. 151). Yet, while tattooing has long eclipsed its subcultural 'Bowery' origins and is a practice that is now routinely observable in fashion magazines, celebrity periodicals, the sports field and the coffee shop, the motivations to acquire a tattoo, and meanings that they communicate, have become more pronounced

and multifaceted, and researchers have continued to analyse the motivating factors behind twenty-first century tattoo culture.

For example, within Silke Wohlrab, Jutta Stalh and Peter M. Kappeler's (2007) analysis of tattooing and body piercing, and acknowledging a popular media influence in the popularisation of tattooing and piercings, they identify a number of key motivating factors that influence such body modification customs. On the one hand, the researchers identified 'traditional' explanatory factors such as the acquisition of tattoos to signal group affiliation and sub-cultural membership in addition to the related 'resistance' motivation aligned with subculture membership. While on the other hand, issues such as gaining tattoos to signal personal pain endurance and toughness were/are also factors, as is tattoo addiction and those who ascribe no particular motivation aside from (often alcohol/substance-fuelled) impulsive whims. But more substan-tively, Wohlrab, Stalh and Kappeler identified factors such as tattoos acting as expressions of personal spirituality, and the desire to use tattoos as a means by which to establish a visible indicator of individuality in which the tattoo design is imbued with a distinct personal semiotic narrative-telling function. These latter elements are what will be explored within this chapter in rela-tion to my ethnographic research. Within the existing work the symbolic and signifying characteristics of tattoos are frequently mentioned, but are seldom, if ever, linked explicitly with semiotics. As such, rather than repeat a 'catch-all' examination of motivations, the issue of semiotic communication, phenomenological expression, temporality and Being-modification are the key factors that inform the methodological approach underpinning this study of contemporary tattooing.

ACCESSING THE TATTOOED

The ethnographic approach to tattooing is an effective methodological means by which to gain a biographical insight into why social actors elect to be tat-tooed and while much of the work is American (or Canadian, in Atkinson's case) a British perspective is a useful one in further mapping tattooing culture. Unlike quantitative methods such as surveys, which are designed to access large datasets, ethnography is, due to its face-to-face nature, necessarily small-scale, so the research presented within this chapter makes no claims at any macro-level representativeness. But notwithstanding the localised nature of ethnographic research, the primary strengths and value of the ethnographic approach lie in its basis in naturalism and its principles of 'getting close to the inside', 'telling it like it is', 'giving an insider's account' and producing 'deeply rich' data (Brewer, 2000, p. 37). Moreover, the method is especially pertinent in relation to phenomenology as Heidegger stressed the need to

consider Dasein in relation to average everydayness, which 'acts as determinate for the character of its Being' (1962, p. 38).

In terms of British-based tattoo 'storytelling' accounts, MacNaughton's book, *London Tattoos* (2011) takes the form of photography-based personal tattoo profiles of some fifty-one women and men who are extensively tattooed. Much of the focus within the book in relation to the featured individuals' tattoos, given that MacNaughton is a photographer, is on the visual, with only short introductory texts provided for each person that briefly allude to their bodily artwork and any meanings that specific tattoos may or may not possess. Alternatively, my methodological approach sought to place the emphasis firmly upon the narratives surrounding the acquisition of tattoos. As Armstrong, Owen, Roberts and Koch argue in their university student based study of tattooing in relation to image and identity, college students 'are no strangers to the world of tattooing. In fact, they have been one of the liveliest groups to embrace tattooing' (2002, p. 22). And so it was with my study.

In terms of methodological approach, I engaged in two periods of semi-structured interviews that was based predominantly within the university at which I work in the city of Newcastle, located in the northeast region of England. The method by which I attracted respondents was to produce invitational posters (strikingly designed by a Graphic Designer colleague) that were placed throughout my main building and initially directed towards media/ mass communication students. The posters garnered a very good degree of response and resulted in a number of interviews held in my office. This primary interview phase was informed predominantly by undergraduate students (although there was one mature PhD respondent) and the questions focused exclusively upon the semiotic motivations and meanings that inspired tattoo designs. In terms of responses, while some tattoos had no conscious meaning (often the first design) other than representing a rebellious desire to be tattooed (frequently while with friends, or on holiday, to mark closure or specific events), or they were motivated exclusively for their aesthetic qualities, many did have specific meanings and were indicative of the 'declarations of "me-ness"' Benson (2000) identified within modern tattoo culture. While some respondents' tattoo designs signified popular cultural connections (such as band motifs), others fused with personal aspirations. For example, one male respondent, Peter, who has a graphically detailed image of one of the demonically possessed characters from Sam Raimi's 1981 horror classic, *The Evil Dead*, stated that the image represented his longstanding love of horror cinema, but also (as a film making student) his aspirations to be a film director, stating that the tattoo 'always reminds me what you can achieve on a shoestring budget'. Other examples included a quote from the film, *Top Gun*, and the Batman symbol that celebrated a female respondent's love of the 1989 Tim Burton film. Regarding the influence of pop cultural figures

and celebrity inspiration, one respondent, Ben, had a star design tattooed on his stomach because Simon Neil, the lead singer/guitarist of the Scottish hard rock band Biffy Clyro, has it, and it was acquired simply because it 'looks cool'.

The use of specific symbols to represent personal issues were recurrent throughout the interviews, such as the respondent, Sarah, who employed Biblical motifs to reinforce her Catholic family background coupled with a reflective awareness of the communicative function tattoos can have. As she stated, 'People who have tattoos are more interesting, aren't they? They have a story to tell'. However, other respondents used abstract imagery to signify specific episodes within their lives. For example, Samantha wore three frangipani flowers on her stomach as a symbol of her solo travelling experiences in Australia, stating of the design that, 'It will always remind me that I managed to achieve that'. Other tattoos had extensive stories behind them, even when the designs were simple. For example, Charlotte had one tattoo located on her wrist of the word 'amour', but revealed that it was not simply the word 'love' in French, but that it was inspired by an artist who, when spurned by his lover, wrote the word in chalk on pavements and windows to attract her attention. The respondent (an art student who had travelled to Paris and met the artist) ensured that the tattoo she sported exactly matched the handwriting of the artist's work. In evaluating the symbolic nature of her tattoo, she stated, 'I don't believe in getting a tattoo without it really meaning something to you. I don't like getting it done just because it looks pretty'. Other respondents did have designs because of their aesthetic of 'pretty' qualities, but they were related to specific artistic/tattoo traditions, most notably American Traditional, or, in the instance of one female respondent who has a self-designed origami crane, symbolic of a love of Japanese culture. Therefore, while some designs were expressly symbolic, others reflected general personal feelings and attitudes, or stood as family tributes. Furthermore, tattooed lyrics of favourite bands was a significant theme within the interviews in this regard and were justified in terms of their ability to express personal feelings and outlooks on life. For example, a female respondent had both a tattooed logo of the Canadian hardcore band, Alexis on Fire, together with a tattoo of one of their lyrics that combined to express a particular time in her life when the band resonated keenly. Nonetheless, she acknowledged that her enthusiasm for the band would inevitably wane, if not potentially dissipate entirely as she grew older, but the tattoos would always serve, she believed, a signifying purpose and would 'remind me of when I was a teenager and music helped me a lot'. In this manner, the idea of tattoos serving as symbols of life stages, as a visual symbolic 'diary', was a common one. As a female respondent with seven tattoo designs stated of the function of tattooed symbols to wider

culture, 'If your body can tell a story and a meaning without somebody knowing anything about you, I think that's really interesting'.

These interviews essentially served as a 'pilot' study to explore the ways in which tattooed individuals self-reflexively describe their motivations to become tattooed, particularly at a comparatively young age, and frequently articulated a communicative nature of their designs. I was clear that respondents should not have felt compelled to create a tattoo narrative (avoiding a *Miami Ink*-style 'every tattoo has a personal backstory' cliché) where there wasn't one. Indeed, a number of first tattoos were the result of holiday peer-choices that were devoid of any explicit symbolic meaning bar their memory-evoking function of getting the design done. However, the semiotically based interviews did provide an indication that many tattoos were the product of individual expression, and so I initiated a second period of interviewing that continued to seek personalised accounts of symbolic and communicative motivations and inspirations to be tattooed, but also refined this to include a distinctive phenomenological focus, to enquire how tattoos may change personal conceptions of self (or in relation to how other social actors responded to their tattoos). As with the pilot phase, the immediate choice of respondents was again students within the university. Using students as a respondent group to research tattoos has been a common methodological practice (Mayers and Chiffriller, 2008; King and Vidourek, 2013; Dickson, Dukes, Smith and Strapko, 2014) as they are a readily accessible group for academically based researchers. However, I also wished to interview students as they reflected a clear expression of the changing social and cultural attitudes to tattooing as they are typically oriented to future professional employment. Also, the key age-range of 18–21 meant that this demographic constitutes the 'next generation' of tattooed social actors, and one that does potentially signal how far tattooing culture has evolved from its 'outlaw' and subcultural historical traditions, continuing the middle-class adoption discussed within DeMello's work. As such, the second phase of interviews was particularly geared to exploring the 'inked individualism' perception as discussed in chapter 1 in relation to motivations to acquire tattoos, the design choice(s), any conscious symbolic communicative functions and explore the issue of temporality and to how tattoos can alter self-perception.

In terms of gathering respondents, a second invitational poster was designed and placed in locations that would attract the attention of media and humanities students. However, unlike the pilot stage the poster was also sent in a digital format to colleagues in the fashion department for email distribution, an action that garnered good response rates from a wider demographic. Also, this run of interviews resulted in a 'snowballing' effect, whereby the interview invitation was communicated beyond the university by people who had seen the posters and passed the information onto colleagues, partners

and family that had tattoos. Additionally, a flyer version of the poster was placed in a busy coffee shop located near my university, which did attract respondents (although not to the same degree as the university-based posters), but extended the age-range of interviewees and the demographic makeup of the sample (pre-university age, respondents in their thirties and late forties and an academic interviewed as part of work I undertook in Indonesia). Finally, the invitational text and rationale for the research was posted onto the Facebook site, *Tattoo Drop*, a site that features artists displaying their work, and tattooed social actors showing their various designs.

While accessing *Tattoo Drop* gave an opportunity to potentially reach a globally diffused respondent sample, this, unfortunately, did not result in a wider catchment of respondents. While the invitation and details of the tattoo-based research garnered a number of 'Likes' from individuals interested in tattooing and its culture (which was gratifying), these did not ultimately translate into respondents coming forward to discuss their tattoo designs. Moreover, of those who did respond through the private message function of Facebook, contact was difficult to maintain. So, whilst descriptive accounts of the number of tattoos and their specific designs were provided, the more substantive questions were not answered, and promises to provide such data never materialised. Consequently, although a netnographic approach, with its periodic processes of online immersion (Kozinets, 2015), seemed forthcoming, the nature of Facebook – with its constant postings and page features being updated – meant that the invitational information was soon replaced and ultimately obscured by a myriad of other tattoo-based postings. Consequently, while *Tattoo Drop* was still regularly accessed throughout the research period as a 'state-of-the-art'/ à la mode tattoo resource in terms of representations and expressions of tattooing trends and themes around the world, the data-gathering strategy did not follow a netnographic trajectory, but alternatively maintained the traditional face-to-face attributes of ethnographic investigation (Hine, 2000).

TALKING TATTOOS: THE INTERVIEWS

With regard to the structure of the interviews, the questions were read to the respondents in a set order and developed from the informational and practical, to the symbolic and phenomenological, with an additional open-ended question that enabled, should they wish to, respondents to express their personal feelings on contemporary tattooing culture. The question content and order was as follows:

1. How many tattoos do you have?
2. What inspired you to get a tattoo(s)?

3. What are the designs?
4. Do the designs or design have any specific meaning? If so, could you tell what it or they represent?
5. How did you select an artist?
6. What was the relationship with your artist with regard to the finished design? (Was your idea the finished design/negotiation and revisions suggested by the artist/design created by the artist?)
7. How do you feel about being tattooed? Do you think about it in relation to your sense of self compared with social actors who are not tattooed?
8. Is there anything else that you would like to say about your tattoo design(s) and decision to have a tattoo?

The initial factual question that asked respondents how many tattoos they possessed quickly revealed a dramatic variation with regard to the extent to which people engaged with tattoos and tattooing. As such, the number of tattoos respondents had ranged from only one (and the respondents who had only one tattoo reported that they had no intentions to go beyond the one design), to a more common five to six tattoos designs, and respondents who had so many tattoos that they could no longer identify the precise number of their designs. As Richard, a mature art student stated to this initial question, 'I actually have no idea any more. It's something I haven't really counted in a long time. Quite a few, I guess. They've all just kind of merged together to be honest ... But I do really like my arm just being completely black for some reason, I don't know why [laughs]'. Beyond the factual/informational questions, the interviews progressed to evoke the cultural, thematic and philosophical ideas and issues discussed in the previous chapters in order to illustrate the differing perceptions and feelings tattooed social actors have towards their designs. These questions were asked to glean qualitative articulations as to why they decided to have tattoos ostensibly permanently inscribed into their skin, the choice of design (or more frequently, designs), how these designs did, or did not, symbolically represent some aspect of their personality, sense of self, or cultural mores, and, more abstractly, if being tattooed had actively altered their self-reflexive sense of being. The latter issue, rooted in the thought of the likes of Martin Heidegger, was sometimes a little difficult to precisely elucidate without recourse to a lengthy phenomenological lecture, but respondents did provide very insightful responses to this line of questioning to articulate and illuminate the ways in which tattooing can be perceived to be a transformative practice and experience.

However, as one might expect, the motivations, meanings and evaluations of personalised tattoo work yielded a variety of responses and insights. To present and evaluate these qualitative findings, they will be discussed under

three specific headings that examine peer/cultural motivations, symbolic or semiotic explanations of designs and tattoo motivations, and phenomenological issues relating to self, especially in relation to how respondents perceive their pre-and-post tattooed sense of 'Being'.

THROWN INTO TATTOOS: PEERS, CULTURE AND 'REBELLION'

Echoing one of the classic motivating factors for people to be tattooed, raised by authors such as Steward (1990), in relation to tattooing being a peer-influenced form of cultural 'rebellion', these issues did find expression from some respondents, albeit it with interesting differing degrees of self-reflexive awareness. As such, in some cases, tattoos were acquired as the result of collective group decisions that were motivated by the urge to permanently cement friendship ties, but motivated by conscious attempts to avoid clichéd 'friendship tattoo' traits and opt for more personalised and creative approaches. As Alex, a Fashion undergraduate, explained with regard to a visible Pokémon video game character tattoo on his arm:

> My little Pokémon tattoo it's just like a bit of a reminder of my two best friends from growing up. Like at the start of the game there's three Pokémon to choose from, and we all used to pick a different one, so we got like the same but with like a little difference. I'm not a massive fan of friendship tattoos as a whole when people get like, I have friends who have half a sentence and the other friend has the other half of the sentence, and I don't like things that don't make sense if you're not with those other people, so we just wanted something a little different, They're still really cool by themselves … So we just wanted some kind of, a bit cheesy, but it's a conversation starter. When I used to work in a bar this is the one that everyone used to pull my arm over the bar and like, talk to me about.

The impromptu touching of tattoos by strangers is a factor that Thompson (2015) routinely alludes to as a contemporary example of the persistent 'othering' of people with visible tattoos. But while Alex did not report any discomfort with this behaviour as it acted as a symbol of sociability in its status as a 'conversation starter', other female respondents did. For instance, Kathryn, a Film and Television Production student, responded to my invitational poster because she has an extensive collection of tattoos, including a full sleeve, and she reasoned that I wouldn't have made contact with many heavily tattooed young women. Akin to the experiences reported by Thompson and many of her respondents, Kathryn reported that strangers commenting on her tattoos was a constant factor in her life, in addition to

often unwanted physical touching. Describing the sometimes unpleasant and invasive reactions she gets in certain social situations, Kathryn stated that,

> I get a lot of attention because of my tattoos, and it does get a bit exhausting sometimes. [In certain clubs] men, they thought that they could touch my arm, and stuff. You felt a bit violated when they were all touching you and things like that. So, yeah, I never thought I'd get this much attention from people with my arm, it is constant.

Returning to peer influence and tattoo motivation, Alex's Pokémon design retained its nostalgic and sentimental value, factors that outweighed the lack of art contained within the image. Alternatively, Vanessa, a Marketing Manager in her early thirties, reported less positive feelings about her 'friendship' tattoo. In terms of motivation to become tattooed, her account of her single tattoo, acquired when she was in her late teens, evoked the essence of Heidegger's principle of thrownness, which, according to Watts (2011), conforms to the styles of the 'They' and the conformity of rebellious acts, such as tattooing. What is interesting from Vanessa's memories of her tattoo is that it was an act that was already conformist in the way in which it was acquired. As she states in response to the questions asking how many tattoos she had, what was the design, and what was the motivation behind that design

> I've got one. It's embarrassing, really. It's a butterfly. It's a butterfly on my left hip ... It was my only act of rebellion when I was younger, so when I was 18, and I did wait until I was 18 because I was that compliant, I went with my friend to the Metro Centre [a shopping mall], and we both were wearing really low hipster trousers at the time, we were both really thin, and we wanted something that looked really pretty ... it's so embarrassing. So, we both picked the same one because we thought it looked really pretty ... the lines are really fine, and there's quite a lot of detail on it. [Laughs] there's no other reason. And it probably matched, probably, it's on my hip bone so it pretty much matches the shape of my hip bone ... It wasn't planned, it was, I wanted something that looked delicate. I didn't think at all how it would look later on, which actually it looks completely fine because I've had a baby, so it's gone back, absolutely bang on. Yeah, I just wanted it to be pretty.

What is significant about Vanessa's reminiscences on a design acquired some fifteen years previously, is that it was very much motivated by a precise group of others and, although the precise tattoo had no intrinsic semiotic meaning in itself (the butterfly was selected from Flash art and chosen entirely on the basis of its aesthetic appeal), the act of tattooing was undertaken as a symbol of group solidarity. As Vanessa responded to the issue of any symbolic meaning being intrinsic to the tattoo,

[i]t probably had a symbolic meaning to my personality then because I was trying really hard to fit in. I was 18 and I was going off to university, all my friends were getting tattoos and we wanted to do it as a group thing. So, a couple of people had got them before, and my friend and I were the people who were the outliers. I really was stuck to that group because we were all splitting up for university, so I felt it was a bit of an affinity thing to a group. But of course, don't speak to any of them. Barely spoke to any them 6 months after I went to university, so it was ridiculous doing it that way or for that reason.

For Vanessa, getting tattooed was a 'typical' and contained act of rebellion, a factor that she wryly notes in relation to her assiduously waiting until she was eighteen until acquiring her design. Also, the rationale of the tattoo acting as a means of establishing a form of symbolic solidarity to a social group on the brink of geographical dispersal is also interesting as the limitations of this function evaporated very quickly. But, the memory of these motivations remains, no matter how 'ridiculous' the reasons for having the tattoo now seem, in hindsight. When asked if she would consider having the design removed, she responded, 'No, I'm totally content to keep it … I think, if I'd come out of having a baby and it was misshaped or I had stretchmarks or something like that, I would maybe get it lasered, but it isn't. It's more of a cosmetic thing to me. I wouldn't get another one. I don't see the point'. However, when Vanessa was pregnant, the tattoo did produce conflicting feelings as it raises personally troubling emotions in relation to tattoos, rebellion, class affiliations and the perception of tattoos from the perspective of medical professionals. As Vanessa stated in relation to how her tattoo could affect her sense of self,

> I think in terms of reflecting who I am, I kind of almost felt when I was going to have a baby, when I was going for scans and things like that, I felt like people were judging me that I was a Chav because I had one, because people at the hospital give you scans and stuff. And I kind of felt myself more conscious of that I had it then because people were actively looking at that area of my body. And I actively didn't wear white things over my bump because you could see the black through it, because I thought the perception of a mum with a tattoo was something that would be like really rough, very chavvy and didn't necessarily fit with the image that I wanted to project with being a mum … I still think if I was in that situation now I'd be exactly the same. Because, it's really snobby, I wanted to be seen more as a typical middle-class mother who is competent at looking after her baby, and that doesn't fit at all with any rationale around why you'd have or wouldn't have a tattoo, but I think the perception is you're a bit rough, or a loose cannon, or not in that prime ABC1 category of being respectable, which is ridiculous!

The issue of the being aligned with a 'Chav' identity, with the chav being a quintessentially British class-based subculture that has variously been

applied to segments of young working class people with a penchant for casual sports clothing (with Burberry as a once-favoured brand) and extending to antisocial thugs (Jones, 2012) is an interesting one. Although Vanessa tacitly acknowledges that her fears are 'ridiculous', it is nevertheless significant that a residual lower class/deviant-based association with tattoos remains, and that the presence of a tattoo can be perceived by professionals as a means of negating Vanessa's middle-class sense of self, and, as such, could have the power to negatively label her as being 'lower class'. However, the issue of tattoos as being representative of 'otherness' was expressed in a very different way by other respondents, who, unlike Vanessa, sought to celebrate its 'underground' heritage and reclaim it from its apparent contemporary mainstream currency.

Such a sentiment was expressed by Kim and Mick, both of whom had more than ten tattoos, with Kim having had one of her arms designed into a Disney Princess-themed sleeve, including Cinderella, Snow White and Alice in Wonderland (whose non-princess status was justified on the grounds that she was 'still Disney'). While Thompson's (2015) ethnographic research with heavily tattooed women stressed a feminist-infused resistance to imposed standards of Westernised female beauty, Kim didn't see her extensive and highly visible tattoo collection as being in conflict with a feminised image, and nor that her tattoos would inspire any such perception from those who see her designs. As she rationalised, 'I think I can get away with it a bit because like, I'm a girl and mine are a bit girly, so people don't like look at me and think "Whoa, she looks rough or anything" they're like "Oh, that girl's got tattoos, that's different". I like it'. Mick's tattoos, alternatively, included an assortment of designs that include roses, demons, religion and, reflecting Thompson's view that tattoos frequently 'sample' popular culture, from film and television, to graphic novels, video games and music. Of the latter, music is the dominant motif that underscores Mick's tattoos, and it was the original inspiration for him to become tattooed as a teenager, as he states, 'When I started getting tattooed, that was when I was about 17, that when I was really started to get into music … it was just, I suppose, they were like idols and music I really, really enjoyed, and just really wanted that tattooed on me, really whether to remember it or I just liked that band or artist'. Such influence is (literally) illustrated through designs such as the tattoo homage to the American heavy metal band, Mötley Crüe, Mick's 'ultimate favourite band', and indeed it was individuals such as Mötley Crüe's heavily tattooed drummer and bassist Tommy Lee and Nikki Sixx who served as Mick's idols and sources of tattoo emulation. While Kim's Disney-based tattoos reflected memories of her childhood home in Florida, complete with regular trips to Disneyland, music also played a decisive role in her decision to become heavily tattooed, because music and tattooed musicians 'puts the idea in your head, like when you see them. If

your idols look like that, I suppose it starts to seem a bit normal to you'. This sentiment keenly reflects Armstrong, Owen, Roberts and Koch's study of college students with tattoos in which they found that tattooed students not only reflected the tattoo artist Lyle Tuttle's maxim that tattooing represents 'external designs for internal feelings', but that 'tattooed students positively identified with tattooed people' (2002, p. 28). This sentiment was perfectly reflected by Eve, an undergraduate student, who keenly felt a kinship with other tattooed social actors, as she stated of her five tattoo designs: 'I feel united with other people who've got tattoos, I feel all of us band together'. Kim and Mick expressed a similar sentiment, but they were critical of the apparent mainstreaming of tattooing and the erosion of tattooing's traditional status as a symbol of otherness, and as a sign of belonging to a niche 'underground' subcultural group. As such, both Kim and Mick reported 'mixed feelings' about the normalisation of tattooing as a cultural bodily practice, but expressed a strong sentiment that tattooing ideally reflects a particular lifestyle and popular cultural fandom:

Kim: I'm happy it's more accepted, but I'm not happy because now everyone's doing it and I don't feel as different anymore, and I like to feel different.

Mick: If our generation's getting tattooed then it means there will be more leniency with, like, work, jobs, different things like that. Even still now there's a lot of places that won't accept tattoos and stuff, but on the other side of things you kind of lose that individuality ... If you look around now, or even if you walk around town, everyone tends to have a sleeve or loads of different tattoos.

Kim: You shouldn't have tattoos unless you're into all of the things that tattoos come with [which is subcultural values and rock music, without which tattoos have become meaningless fashion items].

Interestingly, the oldest respondent, Vincent, regarded his tattoos as an expression of 'mature rebellion', a factor all the more significant in comparison to Kim's music/subcultural rationale for getting tattooed, as Vincent was a teenager at the height of Punk in 1970s Britain (in which tattooing was often a visual factor in the look). However, as Vincent stated, rebellion was still an important issue in his decision to become tattooed in later life:

I got my first tattoo at 42, so I was quite old when I got me first tattoo. I'll tell you what put me off until then, my granddad was a sailor, and he had tattoos, he had the traditional swallows in the curve of the hand, and he had a few others which had blurred and you couldn't really make them out. And he always put me off when I was younger. I never fancied then, I was a punk but I still didn't fancy them. I had friends had them. Another friend got a scorpion tattooed

with nine legs, by mistake. That's another thing that makes you think 'why do I want to do that?' But then, married, children, children got bigger and you hit your second childhood when your kids are old enough [laughs]. And then I just thought, then I separated, the wife and I separated. We're still very good friends but, you know, I just though I'm going to do something for myself. It wasn't like 'I'll get a tattoo' and I got a tattoo, I think it was trying to find myself after a different kind of thing. So I did a lot of research, looked around, looked for a design I liked and then eventually looked for a studio and then just got my first tattoo. A bit of rebellion, I suppose, at 42. You know, work, and all that, I think that's really what it was. You're used to working in a shirt and tie, a suit, and I just thought 'I'm going to get one'.

Vincent's waiting for the right moment was related to what he perceived to be the poor quality of tattoo work that was abundant in his youth. As such, his embrace of tattoos from his forties saw him elect for high-quality work carefully selected from artists whose designs he carefully researched and it resulted in the acquisition of five large tattoos thematically linked to vintage American pinups (what he calls 'The Girls') that signalled his fandom of 1950s and 1960s science-fiction movies and that particular science-fiction aesthetic, and so keenly reflecting a desire to express a key element of his self within his tattooed art.

TATTOO MOTIVATIONS: SELF/SYMBOL/ART

The issue of acquiring tattoos containing distinctive semiotic/symbolic communicative features was also an evident factor within the second data-gathering period, whereby tattoos were self-reflexively felt to act as (in Eco's term) communicative devices that expressed key aspects of their personalities and/or life events. This potential with tattooing was poignantly expressed in my interview with Angelica, a Filipino academic in her forties that I spoke with in Indonesia. In Angelica's case, her tattoos were explicitly motivated by emotionally painful familial experiences from her past that inspired her to relocate with her two sons from the Philippines. Drawing upon the 'totemic' image of the dragonfly, an insect Angelica has loved from her childhood, she obtained a tattoo of three dragonflies that representing her and her two sons flying to Indonesia to start a new life, thereby representing an inscribed symbol of her personal strength and growth. This design was subsequently paralleled with the tattooed words 'Daughter of God' written in Hebrew on her arm to symbolise her renewed commitment to her Christian faith, and representing a further highly personalised statement indicative of her sense of self.

In other instances, tattoos symbolically spoke to attitudinal maxims and personal history. For example, James, a Fashion undergraduate, had two tattoos, the first an hourglass, with the second being a stylised portrait of a dog wearing a suit. In terms of the inspiration behind the design choices, they were both distinctively symbolic, albeit it differing ways. With regard to the hourglass motif, it consciously represented time, but more importantly it represented a form of memento mori, a graphic reminder that time is constantly passing and must not be wasted. In this regard the tattoo is, as James expressed it 'basically a giant YOLO' (the acronym for 'You Only Live Once'). Alternatively, the tattoo of the dog was a tribute to the family dog that James grew up with, a much-loved pet that James considered to have been 'a gentlemen', hence the artistic addition of a suit in his design. In terms of tattoos possessing symbolic meanings, James argued that this was a key aspect in being tattooed, stating that tattoos act to externally display your personality, and as such, that they should 'have a story or they are irrelevant'. Again, reflecting Armstrong, Owen, Roberts and Koch's college-based research, being a tattooed student can lead to interactions with other students bearing tattoos, a factor that definitely serves to create a sense of commonality, and communicating an assumption that tattooing is a an increasingly common bodily practice among the university-aged demographic. And so, in evaluating his tattoos in relation to other students, James concluded, 'It's cooler to have a tattoo than not to have one. Coming to university, everyone has a tattoo and everyone has a weird little story behind it'.

In other instances, the stories that lay behind a tattoo were subtle and almost accidental. For instance, Courtney, an undergraduate student, had one small tattoo design, a palm tree on her ankle, that both reflected a gentle sense of peer pressure and the popular cultural renown of the celebrity tattooist. As she explained of her decision to get tattooed,

> I have a friend who's got a lot of tattoos and she was 'you should really get one'. I don't know if you've heard of "Bang Bang" He's an artist in New York, he's quite famous. He does lots of celebrity's tattoos. And I followed him on Instagram and I saw a palm tree that I liked, and I just thought that'd be a good tattoo to get as a first tattoo. I was originally going to get it on the back of my ankle because that's a bit more subtle, but me and friend actually got matching ones, yeah, so. And it's a little bit bigger than I was expecting, but, never mind … I still like it. It's not quite like the picture I had, so I think I pitched it a bit differently, but no, I'm still happy with it. Me and my friend had been travelling together in Thailand and we met doing a season in Greece, and we just thought it was a good idea. She's got loads, she's got a sleeve and all her wrists and she just said 'you should get a palm tree'. It was quite random.

Courtney's account of getting a tattoo raises a number of issues pertinent to the tattooing process, not least the hints that getting a design is not always a

smooth process, and that the finished design does not always match expectations. In earlier interviews I met people who had experienced disappointing work, from a design that was altered without consultation, to simply poor-quality tattoo art. Courtney's design, while not exactly what she requested in terms of the "Bang Bang" original, nevertheless took on a personally symbolic and communicative significance post tattooing. As she explained,

> I like that I have something discreet. It does look a little bit random, well, it is a little bit random, but, like, I still see a sense of self in it. Sounds a bit weird, but, you know? Yeah, yeah, it says a bit about me because every summer for the past four years I've gone and worked in Greece in water sports instructing, yeah, from that, I'd rather be abroad kind of thing, I like being abroad, and travelling and all that, exploring new places.

However, to stress the modes by which tattoos are frequently, as Thompson also reported, rejected by family members, Courtney's tattoo was not met with approval from her father, who made her promise not to get any further designs. Indeed, she reported that her social circle generally express negativity towards her tattoo and routinely fail to interpret it as a symbol of travel. As she stated of reactions to her image, 'They just think it's very random. I haven't had that many positive reactions to it, actually'. Similarly, other respondents also bestowed a form of post hoc symbolic value to tattoos, as was the case with Jason, a PhD student in his mid-thirties, who had come to see tattoo designs such as a Metallic logo (drawn from the heavy metal band's 1990s *Load* album-era) as defunct in terms of his current musical affiliation (Metallica being a band that he no longer had such fervent feelings for), and although he acknowledged that it was a design he would now choose not to have 'if I was older and wiser', it had still acquired a symbolic value as it was now the kind of design that served to 'remind you of different times, different artists'.

Alternatively, other respondents began ensuring that every tattoo they have is imbued, to lesser or greater extents, with personalised meaning. Of particular significance in this regard was Sally, a film production student, whose six tattoos all express distinctive components of her personal and professional sense of self, beginning with relatively simple designs and graduating to more detailed work. In outlining the number and design of her tattoos, Sally declared,

> [m]y first few beginning ones were very basic, like, I've got a little panda that I got for my 18th Birthday, and they've progressively gotten more gnarly, as my artist calls them. So I've just got a bit done on my back, it's a big skull, it's got like blood dripping off it and stuff, it's got 'Fuck Off' stamped on his head. So, I've stepped my game up a little bit!

In revealing the meaning behind her tattoos, Sally explained how all of them were linked to her personality in terms of her past and present biography. For example, the panda motif was not acquired simply because it was a 'cute' image, but was selected because it is a longstanding family based joke, because, due to her childhood 'chubbiness' and fondness for using heavy black eye-makeup, 'The Panda' was her familial nickname. However, with regard to her skull design's unadulterated expletive, Sally was not concerned that the tattoo would be interpreted by other social actors as an act of anti-social provocation, or as an expression of negativity and aggression. While this would always be possible, the intent of the tattoo and its symbolic value lies in its inspiration – that of a personal family joke that she shares with her mother, and therefore acting as a symbolic 'secret idiom', the meaning of which is the preserve of a small interpretative circle which understands the meaning. Consequently, although (as discussed in chapter 3) the semiotic nature of a tattoo is constantly open to oppositional readings, and the Skull/Fuck Off design could result in a more negative or dismissive social reaction (given that the 'true' meaning is personalised), Sally was unconcerned with this potentiality. However, echoing Atkinson's findings, this tattoo, given its placement on her back, is a design that can be easily privatised, reinforcing the personalised meaning that inspired it. As Atkinson reflected, a 'tattoo can attain heightened personal meaning if kept hidden from a majority of others. Enjoying one's tattoo in semi-seclusion indicates how special the symbol is for the enthusiast' (2003a); and this is an evaluation that Sally's perception of her more personalised tattoos accorded with, as she explained in relation to the possible misinterpretations her tattoos could elicit:

> My tattoos are for me. I don't get tattoos and then cut my clothes up to show them off, they're there. I know they're there, and if anyone's interested enough that they want to know, then ask me, and I'll tell you. Don't just look at me and then be, like, 'Oh'.

With regards to future plans, Sally's intention is to continue with symbolically meaningful tattoos that personally and publically communicate her personal and professional development. This orientation stemmed to a popular-culture-inspired tattoo she possesses on her arm, which is that of the character of Jack Skellington from the 1993 Tim Burton–produced/ written film, *The Nightmare Before Christmas*, a tattoo that Sally intends to ultimately extend into a full sleeve with the addition of other characters from the film. The motivation for this tattoo choice is twofold, firstly that the text is one of her favourite films, and secondly that it represents her professional destination as it is also the film that inspired her to want to become a film-maker and embark on a degree in the subject of Film &

Television Studies, reflecting Hewitt's notion that the public tattoo invariably carries a message that transcends its visual content, but acts as a distinctive expression of 'self-symbolizing' (1997, p. 83). But, this is not to say that all of the respondents elevated the symbolic over the artistic, because they did not: art is also a primary motivation and significant source of tattoo satisfaction.

The issue of art over symbolism is a significant theme given the artistic development of tattoos that characterised the 'Tattoo Renaissance', and for some respondents this was the key motivating driver to procure tattoos, and it underscored their appreciation of tattoos and the art of tattooing. This sentiment was clearly articulated by Eve, an undergraduate, whose five tattoo designs were a mixture of peer-influenced designs (one that was suggested by her friend on their trip to a tattoo studio), a personalised rose design that was a memorial tattoo, and others which were simply chosen for their aesthetic visual appeal. As Eve rationalised on her choice to become tattooed, and her feelings about other social actors who elect to acquire tattoos,

> I love tattoos. I always have loved tattoos. I love art. I just think they make everyone look prettier. Even if someone's got, well no, not all tattoos because some people can get disgusting tattoos, but even if it's a tattoo that I don't personally like or it's not my style, I still think that it looks really nice on that person, I just think they look really pretty on people.

In many instances, with respondents who had a number of tattoos, often the first would be the least symbolic as it was frequently the result of impulse, as the Journalism undergraduate, Juliette, stated, 'I just wanted a tattoo, to start with'. In such instances (as with Juliette) the first tattoo was often the least appreciated as it was invariably inexpensive and frequently acquired in a studio chosen for its geographical proximity rather than through any careful process of choosing a particular artistic style or a specific artist. In this regard, later tattoos frequently reflect an individualised ethos whereby the image has a resonance with the individual's sense of self, or an aspect of their personality and life. As already discussed, there were numerous examples of this motivation, but there were also respondents for whom the symbolic value progressively became secondary to the quality of the art. This was the case with Elisabeth, a Fashion undergraduate, whose three tattoos reflected this process. Beginning with the word 'Espérer', meaning 'Hope' in French, and obtained when she was eighteen, even though the design was not quite what she expected in terms of thicker line work than requested, she would never consider either removal or a cover-up because tattooing 'is really, really personal'. However, in addition to two text-based designs which were imbued with personal meaning, Elisabeth's largest tattoo, a rose on her lower

arm, had no meaning at all beyond its aesthetic effect, a factor Elisabeth had reflexively considered and evaluated:

> I used to think, when I was little, or younger, I used to think why would anyone have a tattoo that doesn't have a meaning to it, I just thought, what's the point of kind of you like having a drawing on you, I just didn't understand it at all. And I think, because the first two I got, were, they were because of a meaning and they were because of something that happened in my life, and I wanted to put something positive on myself, you know, through overcoming it [an earlier illness]. But then I got the flower, and I just thought, it's something that's more kind of beautiful, so why can't you have something that's more you know, like decorative rather than words, they are still both positive.

The issue of artistic value and visual impact over symbolic meaning was a factor central to Megan's tattoos. As one of the youngest interviewees, aged eighteen and studying at college prior to going to university (she had been alerted to the research by a friend who had seen a flyer in a coffee shop), Megan had acquired four tattoos in less than a year, two mandala designs, a snowflake, and the image of the Disney animated character, Wreck-It Ralph. Megan's initial interest in tattooing had been sparked by watching *Miami Ink* and seeing the various designs inscribed on its featured clients, which spurred her desire to become similarly tattooed. However, rather than immediately obtaining tattoos at the age of sixteen (which Megan acknowledged would have been inevitably 'awful'), by waiting for two years the theme of art crystalized as her primary motivating factor in design choice. While at one level the reference to Disney represents a further fandom/popular culture motif, the driving force was the parallel aesthetics of animation and tattooing. As Megan explained,

> I got the *Wreck-It Ralph* one because *Wreck-It Ralph's* like one of my favourite films. And, I think all of mine are kind of inspired by art. So like the reason I love *Wreck-It Ralph* because it's so visually, it's amazing, there's no detail spared. Have you seen it before? It's incredible, like, I love it. I just think there's just so much detail. So I think all of mine are basically just to do with like the art. None of mine really have a deep meaning, it's just the art, I think, yeah.

In order to capture the perfect likeness of the Disney character and replicate its artistic quality into her tattoo design, Megan sought out a northeast of England based female artist whose specialism is animated and video game characters. Megan selected this artist because she considered her work to be 'impeccable':

> I have quite a high standard, so like, I'm not one of those people that could go to a tattoo studio and just have anyone do that tattoo. I really needed to find someone who's perfect at it. So I went on her page and looked at all her stuff and I was like, yeah, she could do it.

Other interviewees reported a similar motivation in choosing the exact artist whose individual style they wanted, frequently through social media platforms such Facebook, but especially Instagram, on which artists post their portfolios and daily work. In these instances, respondents would travel across the country to be tattooed by their chosen artist (and one interviewee traveling to New York), and they reported that they were happy to be guided by the artist and did not seek to impose personalised/symbolic essences that would affect the stylistic features of that particular artist's oeuvre. However, the artistic nature of such tattoos did not mean that they could be readily displayed in every social setting, as Megan revealed:

> I work in a children's retail store, so I'm not allowed to have my tattoos on show, which I can understand, but also this day and age, like, you would think people wouldn't be judged … Mine aren't offensive, they're just nice and they could never offend anybody, so I don't think there is a reason to get offended.

As Thompson discusses within a contemporary cultural context, irrespective of the 'mainstreaming' of tattooing numerous workplaces impose dress code policies that prohibit visible tattoos, a factor especially acute within the service sector. Indeed, 'Starbucks only began allowing some visible tattoos in October 2014, after having maintained a long ban on ink previously' (2015, p. 92). The issue of future and present employment was a recurrent factor within the interviews, an element exacerbated by the fact that the majority of the interviewees were studying at university to ultimately gain professional employment following graduation. While the issue of professionals electing to be tattooed, and the reactions that they face from family, friends, work colleagues and employers, from acceptance to stereotyping has been a cultural and social trend that has caught academic attention for some time (Armstrong, 1991), it is still a salient factor. Unsurprisingly, many respondents elected for designs that could be easily concealed within employment situations, either in the service-sector jobs many held while pursuing their studies, or for their future employment. This issue was the focus of Erin Pappas' study of librarians who wear tattoos, and it evokes the semiotic nature of tattoos, and how these can be potentially problematic when involving 'bodies at work'. As Pappas argues,

> [c]ommunicative practice lies at the heart of tattooing, even if the tattoo is intended only as a message to oneself. Tattoos, however, carry different meanings for wearers and audiences. What role, if any, can tattoos play in the construction or dissemination of a professional persona? Given that the precepts of professionalism redirect focus away from the body as a source of labor, tattoos draw constant attention to the embodied self by being literally written on the skin. In the professional workplace, tattoos can impact relationships, perceptions, and paths to advancement. (2014, p. 192)

Referring to the multiple meanings that tattoos can communicate, Pappas stresses that tattoos are the locus of polysemic and deconstructive interpretations by other social actors, which can be read in contradictory ways. This was a factor that emerged from Pappas' qualitative interviews with tattooed librarians, in which results included acceptance for visible tattoos, but also public expressions of disapproval that tattoos contravened the common image of library employees. In my research, I also found this, for example, Angelica's calf tattoo did alter how she dressed for work at her college because when she initially wore dresses or skirts for work some colleagues did communicate disapproval to her in line with a professional view that teachers were positioned as role models for their students, a status potentially contravened by visible tattoos within the educational environment. Consequently, Angelica opted to wear trousers to conceal the tattoo while at work. But, some respondents in Pappas' research rationalised their tattoos as a means of breaking outmoded social and professional conventions, as one of Pappas' interviewees asserted, 'Being a tattooed librarian is awesome. I think it shows people that librarians can be more than just frumpy old ladies that remind you of your grandmother. It shows that librarians are a diverse and really interesting group of people!'. (2014, p. 201)

With regards to my interviewees, this kind of ethos was also evident, although there were instances in which older respondents in professional employment roles were conscious of placing tattoos in areas that could be concealed. However, this notion of 'secret tattoos' was a source of pleasure for some respondents, as it was for Vincent, whose tattoo 'adventure' began when he was forty-two. In his role as a Business Relationship Manager for the Civil Service, a status that required a formal dress code, Vincent stated that as a professional with a collection of large and ornate tattoo designs, 'I loved wearing a suit and knowing, it's something different, nobody else knew … I'd go to meetings and people would take their jackets off and roll up their sleeves and I'd do mine and you'd see some people look, you'd get a lot of nice questions about them, you know. People liked them'.

Alternatively, younger student respondents who had visible tattoos were unconcerned with any professional reactions to them in the future. On the one hand, this sentiment was based on their perception that tattooing has now become a mainstream practice, linked to its pervasive cultural and social visibility (from Reality TV and celebrity, to the sheer abundance of social actors bearing 'ink'). On the other hand, however, given the creative industries that these students were bound for, such as fashion and film/television/media production, the presence of tattoos within such environments was not seen as being problematic given the prevalence of tattoos evident in those industries, and the feeling of creative, non-corporate freedom perceived to characterise those professional worlds. This attitude was especially acute from speaking

with Martin, the most heavily tattooed interviewee I spoke with (he couldn't identify how many tattoos he has). Although only twenty-two (and having received his first tattoo at the age of fifteen (a Biomechanical design that has since been covered up in favour of a Japanese design that reflects his overall Japanese-oriented art) in terms of the extent of his tattoos, Martin has full sleeves and a back piece in progress (he was off to the studio as soon as the interview concluded to have this design completed), but also designs that cover his hands and fingers, the palms of his hands, small tattoos on his ears, and a facsimile of Marilyn Monroe's autograph on his neck. As a Film and Television Production student, Martin's trajectory as a future film-maker was not personally perceived as problematic in terms of his heavily tattooed body, so much so that he soon intends to have his entire throat tattooed. Indeed, in addition to being a student Martin works as an actor, mainly in locally produced children's dramas, and his visible tattoos have resulted him being cast in the roles of drug dealers or bullies, an interesting cultural reflector of tattoos still acting as signifiers of otherness. But, in terms of Martin's own self-reflexive feelings about being so heavily tattooed at such a young age, he concluded that the process of tattooing had transformed his sense of self, that his external markings have made him more confident, as he explained about the difference between his sense of being prior-and-post tattooing: 'I feel more confident, to be honest. I've always been a really shy lad, and they burst out my confidence ... they are my way of feeling better about myself'.

THE IMPORTANCE OF BEING INKED

As a kind of conceptual crossing point between semiotics and phenom-enology, Berger and Luckmann envisioned a symbolic universe made meaningful through symbolic language, with social interaction designed to communicate expressivity (1991). Within the context of tattooed social actors, this idea was discernible in the ways by which tattoos were acquired to express (to themselves and others) salient aspects of themselves, from expressions of popular cultural fandom or semiotically familial 'secret' symbolic language, to a desire to be part of tattoo culture, a motivation spurred by seeing tattooed social actors on television and in everyday life. In this sense, tattooing can be seen as a mainstream practice into which adherents have been 'thrown' into and which reflects the 'They' of subcul-tures and celebrity cultures, and so, as Heidegger expresses it, within this context, and an individual simply drifts 'along with the fads and trends of the crowd, oblivious that one's own being is an issue' (1962, pp. 56–57). With regard to the ways in which tattooing has become an endemic feature of celebrity discourses and the fashion industry, such a 'faddish' view is

apt, but, as Vanessa demonstrated, teen rebellion can quickly be recognised as a socially predictable cultural pattern, a factor that Vincent also self-reflexively recognised in his adoption of tattoos as a mode of self-knowing 'mid-life rebellion'. However, phenomenological ideas of self and being were more abstract (and in many interviews the questions needed to be rephrased and repeated), but phenomenological factors were evident in interviewee responses, especially as many respondents reflected what Heidegger termed the Dasein's potentiality-for-Being, a state by which a 'being discloses in itself what its Being is capable of' (1962, p. 184).

At one level, this takes the form of the essence of the past 'haunting' the present and, as Sartre expressed it, being 'stamped' onto an individual, or, as Heidegger argued, the past is akin to the remains of an ancient Greek temple because, for the Dasein, fragments of the past remain in the present. Echoing this sentiment, and Bergson's conception of memory becoming 'actualized in an image' (Ansell and John, 2002, pp. 156–157), respondents such as Jason (as discussed earlier) reconceptualised their early tattoo work along such phenomenological lines. While keen not to 'over romanticise' the 'memory-marks', tattoos that might lead to regret (inscribed symbols of fandom to bands no longer revered) alternatively served as visual historical relics' of a previous age. In Heidegger's conception of time in relation to the temporal space between a Dasein's birth and death, he argues that a Dasein 'traverses the span of time granted to it between the two boundaries, and it does so in such a way that, in each case, it is "actual" only in the "now" and hops, as it were, through the sequence of "nows" of its own "time." Thus it is said that Dasein is temporal' (1962, p. 425). Yet, tattoos can ensure that past 'nows' can travel with the wearer, and temporally intrude upon the present. In this regard, tattoos can re-activate the past in the form of memories being inspired by a tattoo in unexpected and, at times, self-surprising ways. For example, Vanessa's single tattoo, and its position on her hip, meant that she frequently had the memory of the tattoo and its inspiration when others witness it, and when she unexpectedly catches sight of it. As such, when asked about whether having a tattoo has altered her sense of self-perception, she responded,

> I don't think as being tattooed at all. I totally forget I have it. So, on holiday, like if I wear a bikini, and I'm with family members who don't necessarily know that I've got one, I'll be … shocked that they notice it because if I'm getting dressed in the mirror, I don't necessarily see it, even though it's quite big … I think I have to be reminded that I have one.

Alternatively, Molly, a Humanities academic in her thirties, consciously ensured that her tattoos reflected a need to change, but also to visibly unite her personal and professional sense of being. So, in terms of motivation and

memory, Molly stated of her decision to be tattooed, and her subsequent desire to acquire more tattoos:

> I was actually going through a really bad breakup ... So I got piercings and I got tattoos. And a friend of mine and I were both going through a breakup at the same time and so we used to go out into Manchester and yeah, do something ridiculous like get a piercing or a tattoo, and that was initially it. So my first tattoo is really memorable because, at one point, my friend made me giggle and there's a tiny little hiccup in the line, and I love that because that's where my friend made me laugh in a really bad time of my life ... They all relate to my work or to, kind of like a place I'm in, or was in during my life. So a lot of them are Irish Studies texts, so I've got Ulysses, the occult symbol is Yeats, that was my PhD, and yeah, they're all about my work to a greater or lesser degree.

For Molly, each tattoo design keenly reflected a key component of her personality and professional status, in addition to acting as an epistemic relationship with time and the past. As Molly stated of the symbolic nature of her tattoos: 'They flag up particular points of my life, they flag up some extremely good memories, and they also flag up my status as an academic, albeit an alternative one'. Similarly, Tara, a media academic in her thirties whose research focuses upon the figure of the dandy and masculinity within television discourses, also incorporated tattoo designs that reflected her professional role. As such, she revealed 'I have quite a few dandies on me, but this is my sort of "Ur-Dandy," John Steed, of *The Avengers*. So I've got him, and I've got Emma Peel as well, on my leg. She's my entire shin, she's quite big. So yeah, those have to do with my research ... most of the faces on me have to do with that'. These tattoos, while symbolically communicating themes of interest to each woman, were also consciously selected to mark a keen sense of professional self, to disclose the cultural aspects of their lives that define the nature of their academic lives and professional research focus. However, the issue of being and time (and space) was an avowedly explicit orientation explaining why the interviewee, Christopher, a mature architecture student, had decided to become tattooed, and what the thematic nature of his designs meant to him.

When asked how many tattoo designs he currently wore, Christopher's response was that that the figure is 'unknown' due to the fact that he had been actively engaged with his personalised tattoo 'project' for some ten years. In terms of the characteristics of his work, Christopher revealed that his tattoos had been progressively joining together over the years to ultimately combine and create a clear and conceptually rich piece of body art. Acquiring his first tattoo at the age of eighteen (the animated character, Marvin the Martian), a design that had no symbolic resonance beyond simply being chosen as an image to be tattooed with, Christopher slowly began to transform his skin into

a series of themed sections united by the 'metanarrative' of time and space. Hence, his portrait of the iconic revolutionary, Che Guevara, chosen because of its use by the politically based rock band, Rage Against The Machine as the cover for their 'Bombtrack' record, became reconceptualised as a 'Faces from Time' portrait gallery sleeve, including The Blues Brothers, Albert Einstein and the image of an Easter Island sculpture.

As Christopher continued to be tattooed, a specific conceptual theme based explicitly upon time and space became the dominant inspirational core of his work, from 'astronomical' images such as a black hole, stars, moons and a satellite, all combined to represent a distinctive sleeve, and mirrored by a further set of designs that, through the artistic representation of geological strata, show 'buried' items such the Holy Grail, pirate treasure, a T-Rex skull, the skeleton of a Dodo, fossilised trilobites and ammonites, ancient cave paintings and stalactites and stalagmites. Conceptually, the work communicates a tattoo representation of a journey back in time, a factor artistically reinforced by the image of a Salvador Dali-style painted Grandfather clock and Einstein's $E = mc^2$ equation. Furthermore, the structure of the images is designed to ultimately be unified into a Japanese Iruzumi-style tattoo body suit, but in Christopher's conception, the finished work will take the form of what he calls a 1920s-style formal tailcoat jacket.

In terms of the inspiration for the work, Christopher keeps an ever-growing portfolio with him that is filled with 'random' ideas that may ultimately become part of the 'tails jacket' and in some instances the ideas do not come to inked fruition for a year or two, but the ongoing nature of the tattooing is a source of satisfaction, as Christopher states: 'It's been going about 10 years, the ideas just keep going ... I like having unfinished tattoos, because more ideas can follow ... I like having a tattoo booked to get something new, so I'm quite happy it's taking so long'. Christopher's body, therefore, is an ongoing and dynamic tattoo project that ultimately is unified into a disclosable 'time and space' bodily concept, indeed, he frequently recounts the narrative that will result in much of his body being completely covered in tattoos (barring visible locations such as hands, neck and face), as he reveals: 'I've been telling the story for quite a while. I'm quite practiced at this'. Consequently, Christopher's tattoos represent a fundamental component of his sense of Dasein; a radical body project that could appear to some to be a random collage of images, but which is instead a personally coherent and conceptual meditation on time and space that combines personalised images (a Stonehenge armband design that serves as a tribute to his father's reminiscences of his visits to the primordial site in the 1970s), with cultural and musical elements of Christopher's own past. However, given the ongoing conceptual underpinnings of his work, the tattoo is constantly in a Bergsonian temporal state of reflecting the past, present and the future. Furthermore, the

finished work also evoked bodily sensations that reminded Christopher that being tattooed had altered him artistically, and experientially, as he answered in response to whether he did feel that being tattooed had changed his sense of self,

> [i]t's just always just seemed right, it just seems normal. However, there's parts of it where, here, definitely here, possibly here [points to specific designs] where it's scarred my skin rather than tattooed it. So, it has a different feeling now. Like, the majority of tattoos you don't know there're there touching them, but there are a few sensitive parts that tend to scar, and you find yourself not catching them, but feeling them more often.

Given phenomenology's onus of understanding the 'essence' of things, the idea that being tattooed could be a transformative experience was similarly expressed by other respondents, especially those who were extensively tattooed. The perception of tattoos making a person feel 'more me' was a common element, that they are a fundamental component in terms of personal development, to the point that their pre-tattooed state of 'Being' was subsequently perceived as a negative period. As with Thompson's research, in which she reported tattooed social actors who declared that they wouldn't know themselves without their tattoos, my interviewee, Tara, in response to whether she was aware of her sense of self as a tattooed person, stated,

> I just forget about them ... Most of the time I just forget they're there ...
> If I'm looking at old pictures that don't have my tattoos that need to be there, I get really upset, I don't like looking at them because that's not me, they're not there. So, acutely aware of them and not at all, I guess is the answer there. I'm not aware of them most of the time until I am, then I'm very aware of them.

In other instances, a life deprived of tattoos was considered anathema. As Mick unequivocally stated when asked if he could imagine being without his tattoos, 'I couldn't even comprehend that, I couldn't even think about it. It wouldn't make sense'. Hence, for Mick, if his tattoos were removed, he would be a different person. If, then, as Heidegger asserts, to be meaningful is a behavioural trait that humans have engaged in for thousands of years, tattoos have, can, and do, play a significant cultural role in this process of engaging in expressivity through inscribed bodily symbols and markings that alter the body communicatively and, crucially, physically. However, this is not to suggest that all respondents saw their tattoos as celebratory acts of Heideggerian 'transcendence'. As a heavily tattooed man, Richard's response to whether his extensive array of tattoo designs affected his sense of identity was very different to that of Mick's. While answering yes, he explained that this was,

[n]ot necessarily even in a positive way, but I suppose, yes and no. I mean, if I could choose not to have them, I probably wouldn't anymore, it's just something that's ended up happening over time, but I'm not bothered by the fact that they're there. So I don't go like go oh, I regret this or I regret that, but I'd be indifferent if I didn't have them. Like I wouldn't really be bothered anymore, but I don't know if that's because I've been desensitized by being around them so much. (2008)

Richard's desensitisation was of particular significance because, at one level, he was habituated to his highly visible collection of tattoos that covered much of his body (including black work on his arms and a prominent portrait of Albert Einstein on one of his hands), but on the other, Richard was also a practicing tattoo artist, and has been for a number of years. Therefore, his approach to tattoos was both personal, and professional. A key element within the interviews was the relationship that the tattooed social actors forged with their artists – the individual responsible for inscribing their images and enabling them (where relevant) to symbolically express aspects of their selves, and the trust that is a factor in a service relationship that is unique in that the client leaves the studio 'transformed'. And it is to the distinctive world of the tattoo studio that we now turn to explore its distinctive art word and its phenomenological nature.

Chapter Five

Needle Work

Tattoo Artists and the Studio Space

In the course of interviews with tattooed social actors, the role of the artist and the tattoo studio was a primary element of their recollections of their tattoo experiences. Responses to the relationship with artists ranged from immediate interactions with available artists at convenient studios (usually in relation to a first tattoo design acquired as a spontaneous 'just want one' attitude), to careful national artist selection conducted through social media portfolio searches and scrutiny, and even establishing longstanding professional and friendship relationships with specific artists who provide personalised, bespoke and stylised designs. More importantly, however, respondents spoke of the unique relationship of trust that exists between the tattooist and the tattooed, because the act of tattooing is not one that can be readily reversed, given the relative permanence of the work. In this regard, I did hear accounts of the breakdown of trust, from artists who simplified designs brought by the client without any consultation, an, artist who began sleeve work, only to abruptly, and with no communication leave for their native Europe so the work had to be completed by another artist, and poor quality work that needed to be rapidly covered over with a new design. However, the majority of responses stressed positive accounts, and fully acknowledged a rewarding relationship of trust within the tattooing process. As the interviewee, Amy stated of the issue of trust that existed within her relationship with her artist, 'It's crazy important ... It's about his personality. We just meld together ... Just his attitude towards you. He's not just treating you like a customer that's just a piece of skin, he's treating like someone who collects art, which I think is really cool. So trust is crazy important'.

So, having explored personal elucidations of tattoo motivations, design choices, attitudinal feelings towards tattoo culture, and, crucially, their relationships with tattoo artists, this chapter will examine the production side of

tattoo culture of the artist and their distinctive 'art world' – the tattoo studio. In terms of methodological approach, I adopted a similar style to that of Sanders' (2009), that of periodically 'hanging out' at studios style, as I began to visit a particular tattoo studio in Newcastle on a number of occasions to interview artists, the owner and the studio manager, but also to observe the environment of the studio. However, although the bulk of the research was conducted in this studio, I also visited others to get alternative artist perspectives on their training as artists, their personal styles and individualised perceptions of their profession and the culture that has developed around it.

FROM FLASH TO ART

Modern professional tattooing was arguably initiated with the invention of the tattoo machine by Samuel O'Reilly, a technology that was a development of Thomas Edison's 1876 patented Autographic Printer, an electric engraving mechanism that was designed to engrave solid surfaces. In order to transform the machine to the task of electric tattooing, O'Reilly essentially modified the tube system and so his patent was only for the tube assembly 'since the rest of his machine was identical to Edison's original patent for his engraver' (Alayon, 2004, p. 23). The most significant impact of the tattoo machine was that it could tattoo more efficiently than previous work produced by hand techniques, because the tattooist 'had more control of the flow and pacing of the ink injection and could create a finer line and shading than with the traditional hand poke' (Thompson, 2015, p. 25). While much discussion of the early days of the tattoo industry revolves around the use of the nascent tattoo machine as a means by which to easily 'trace' identical stock Flash designs on numerous clients, the artistry that could be achieved with the machine did flourish. As Hemingson, in his account of the historical development of tattooing in Britain, argues, while the first professional artist was D.W. Purdy, who founded a tattoo shop in London in 1870, it was Tom Riley (the cousin of Samuel O'Riley) who quickly established a reputation as an expert in the nineteenth century art. Having honed his artistic skills tattooing numerous regimental crests on his fellow soldiers while serving in South Africa and the Sudan, he turned to tattooing as a profession when he left the army and opened a tattoo shop in London. However, in addition to turning his natural talent for drawing into a tattoo career, Riley's status and success was that he artfully combined his tattooing skill with a keen sense of attention-grabbing and self-selling in the staging of publicity events such as 'the all-over tattooing of an Indian water buffalo at the Paris Hippodrome in 1904' (2009, p. 75).

However, Riley was not the only early British 'superstar' tattooer, as evidenced by the work of his chief 'rival', Sutherland Macdonald, who

introduced a distinctive ethos of art into his work. Writing in the context of tattooing representing a distinctive and distinct art form within Britain, Matt Lodder points to the ways in which tattooing's status as a medium with connections to art and fashion was established early in British tattooing culture with specific reference to the work of the artist Sutherland Macdonald. It was Macdonald who revolutionised the colour spectrum of inks (employing vibrant blues and greens in an industry dominated by black, red and brown), and pushed the boundaries (and class distinctions with his clientele that included the cream of European royalty) of what artistic works could be inscribed into human skin. Hence,

[f]rom the very beginning of the professionalization of contemporary tattooing in the 1870s, when permanent tattoo studios began to open in the major cities and ports of the Western world, many tattooists have presented themselves as artists, and made their names producing art on skin to rival anything being produced in other, more conventional media. (Lodder, in Klanten and Schulze, 2012, p. 5)

Like Riley, Macdonald had served his tattooing 'apprenticeship' in the army, but he also had a foundation of art school training and he noticeably went against the grain of the 'backstreet' tattooer in terms of skill (opening his London 'studio' in 1890) and, crucially, he also adopted a distinctive sartorial style. As Hemingson explains,

[h]e dressed formally and called himself a 'tattooist' rather than a 'tattooer'. Macdonald enjoyed a privileged status with the Royal Navy and he advanced his career by courting journalists to ensure he became the subject of flattering magazine and newspaper articles. In 1897, *Le Temps* reported that he had elevated tattooing to an art form and in 1900 he was referred to in *L'Illustration* as 'the Michelangelo of tattooing'. Macdonald continued to tattoo until his death in 1937. (2009, pp. 75–76)

While Riley and Macdonald built their reputations, and pushed the boundaries of what tattooing could do as an artistic form, they were joined by younger artists such as George Burchett who, learning the trade of tattooing while serving as a sailor in the Royal Navy, opened his first studio at the age of twenty-eight and established such as a professional and artistic reputation that he garnered the title of 'King of Tattooists' (2009, p. 76). Emerging as an early 'celebrity' artist, Burchett tattooed numerous regimental designs for soldiers serving in World War II and appeared in cultural mediums as disparate as cigarette trading cards, newspaper features and early television shows, Burchett produced what is now a celebrated collection of ornate Flash work (including Victorian Oriental dragons, storks, snakes, tigers, 'coquettish' pinups and military insignia), an archive that was assigned by Burchett's

tattooist son, Leslie (who retired in 1974), to the famed American tattoo art-
ist, Lyle Tuttle (Lodder, 2013). In the wake of such early 'stars', the British
tattoo industry has produced many more lauded artists, from Les Skuse and
his sons, Bill and Danny Skuse, Rusty Field, Lal Hardy and Louis Molloy, to
contemporary practitioners such as, Dan Gold, Dan Hancock, Matt Adamson,
Kym Munster, Jethro Wood, Lucy Pryor, Alex Wright, Gari and Kayley
Henderson and Cally-Jo Pothecary, whose work is routinely exhibited within
tattoo magazines, tattoo websites and edited collections of leading tattoo art,
such as those produced by Lal Hardy (2014).

THE TATTOOIST AND THEIR PRACTICE

In terms of evaluating the work of the tattooist and the nature of the studio,
arguably the most influential study has long been that of Sanders within his
now-classic text, *Customizing the Body*. Writing of 1980s American tattoo
culture, and its professional practice, Sanders argued that the career of the
tattooist was one that invariably lacked any overt prospects for vertical mobil-
ity, in which the tattooist entered a level within a studio and remained in that
position throughout his or her career. Instead, employment mobility tended
to be strictly horizontal and limited to moving between different tattoo shops.
As such, Sanders concluded,

> [i]t is rare that a person focuses on becoming a tattooist and systematically
> goes about seeking to achieve that occupational goal. Instead, entry is typically
> 'adventitious' ... Rather than purposefully setting out to become a tattoo artist,
> the individual drifts from job to job before, almost accidentally, encountering
> tattooing and coming to define it as a viable occupational alternative. Entry is
> relatively spontaneous and impelled by a variety of situational contingencies.
> (2008, pp. 62–63)

Within this context, the tattooists that Sanders interviewed entered into tat-
tooing from more routine jobs, partly motivated by a conviction that they had
an element of artistic skill that could be expressed through the practice of tat-
tooing, an interest in tattooing itself and a 'fascination' with the culture of the
tattoo shop. However, artists' entry into the industry of tattooing was revealed
to Sanders to be a difficult process and the result of practices of 'hanging
out' at particular shops to learn the rudiments of tattooing by observing art-
ists at work, or, more formally, by being accepted as an artist's apprentice, a
status that included support activities such as cleaning and preparing tattoo
machines, sterilising tattoo equipment and work surfaces, or shaving the areas
of clients' skin that will receive a design. It was usually a long time before
any actual tattooing was undertaken. As such, while the permanent nature of

tattoos necessarily means that aspiring artists worked on surfaces as disparate as fruit, pig skin and their own legs, and so,

> [t]he next stage in the learning process typically involves the apprentice doing a limited amount of work on one of the host tattooist's clients. Since it presents fewer opportunities for irremediable error, the novice is usually allowed to color in part of a design that has already been outlined. Once the tattooist is satisfied that the novice has achieved some modest level of technical expertise, he or she is allowed to do a complete tattoo. (2008, pp. 74–75)

As the skill of the novice progressed, the technical aspects of tattooing, argues Sanders, would be the combination of tattooing technique and a clear implementation of a distinctive aesthetic style. This combination expressed itself visually in technical issues such as clear and uninterrupted lines, effective shading and colouring, the correct and appropriate placement on the client's body, and no damage to the skin through excessive needle application. However, a further skill routinely developed is that of working effectively with clients in a way that gives the client what they want, but in a manner that does not affect the reputation of the artist. As such, merely 'complying with the customer's requests may result in a product that will have negative consequences for the tattooist, the client and/or the reputation of tattooing' (2008, p. 78). At one level, this may take the form of not inscribing tattoos on 'public skin', such as on the neck, the face or the hands, but more potently, by refusing to tattoo antisocial images or politically extreme symbols (such as swastikas). While the issue of 'public skin' tattoos has changed since Sanders' research, with hand and neck designs becoming much more publically prevalent, both in everyday life and within popular cultural expressions such as celebrity (as illustrated by figures such as Rihanna, Chris Brown, Mike Tyson, Ruby Rose and Justin Bieber), the issue of artist guidance is a crucial one. With respect to my interviewees, the matter of trust was a central factor, but so was the principle of communication and the vision and style of the artist. For example, Vincent's tattoos were all done by the same artist and he described their relationship as the mix of a 'bit of negotiation and a bit of trust. You've got to trust the person who's inking you'. Beyond the degree to which trust is based upon the execution of an aesthetically pleasing tattoo, the principle of trust also extended to the surrender of skin to the selected artist's skill and judgement in relation to their particular style, a factor Sanders points to as a key career developmental issue for tattooists. In this manner, as the interviewee James stated of his two tattoos, 'probably about 80 percent of the finished design is mine, the second tattoo was wholly designed by the artist'. This was a first factor echoed by Richard, who stated of his relationship with an artist doing work on his body: 'If I like their work or what they do, and their style of their artwork, I'll just let them do whatever they want'. Artistic

reputation, therefore, enhances visibility within the industry because gaining 'a reputation for quality work also allows one to exercise significantly more control over one's work life and leads – at least potentially – to increased income' (Sanders, 2008, p. 84). In this sense, as an artist's reputation grows in relation to specific design styles, they can progressively begin to special-ise in custom work instead of routine Flash-based tattoos. Furthermore, this spirit also transforms what is essentially a 'service' occupation because while a 'product' is delivered to the client at a price, the relationship is nevertheless unique because the client is not merely a customer, but becomes a central, and crucial, component in the artistic practice of tattooing. This is so because

> [t]he tattooee is, in essence, the tattooist's canvas. No other creative product involves the intimacy and indelibility of the tattoo. The tattooist creates an object/service that is a part of the client's 'self' and his or her appreciation (or, in some cases, regret) is of paramount importance. (Sanders, 2008, p. 89)

As Falkenstern concurs, this status bestows upon the tattoo a particular status within the arts because the medium of the tattoo is the wearer's skin, and so, unlike art works such as a painting or a sculpture, the tattoo invariably lasts until the wearer's death (although there are instances historically of tattooed individuals donating their tattooed skins to museums and art collectors). But in the main, the standard, but artistically unique, relationship between a per-son and their tattoo is one in which 'just as the tattoo is integrated into the person's body, so too is the bearer a part of the work – if you take the person away, there is no tattoo' (2012, p. 98). However, the day-to-day business of the tattoo shop, argues Sanders, has served to create a schism between routine and custom tattooing because the tattoo is a highly 'conventional-ized' art-form in that clients traditionally enter into tattoo shops, peruse the various Flash designs on display/offer and subsequently select a standardised motif. While such tattooing ensures a regular source of business, it frustrates the fine art tattooist', because once 'they have established a "name" and have acquired expertise, the fine art tattooist takes a more active role in educat-ing clients or shaping their wants so that the products are artistically unique' (2008, p. 101).

The salient features of Sanders' research into the professional practices of the tattoo artist chiefly surround the depiction of tattooing as a somewhat itin-erant profession, and the ways in which tattooing has been balanced between routine Flash-based work and more custom-oriented designs that give clients unique designs that are not to be found on other tattooed bodies. However, it is factor that has changed, and very radically, since Sanders' now-classic ethnographic work was undertaken. Certainly, the question as to how far tat-tooing has been considered to be an artistic practice has been present since the classic practices of Sutherland Macdonald, yet it would remain a dogged

question as professional tattooing developed throughout the twentieth century and into the twenty-first. In appraising the nature of professional tattooing, Jill A. Fisher argues that tattooists' aspirations tend to fall into one (or both) of two categories: owner of a profitable shop and recognition as an artist, and of the latter, the issue of the artistry of tattooing has long been an factor in relation to the charge that the tattoo machine effectively 'deskilled' tattooing through the standardisation of tattoo designs. As Fisher states of the figure and status of the tattooist,

> [c]an their craft be considered art when it is based on a skilled service and profit-driven? Many people, especially those in the art world, argue that it is not an art. How can tattooing be art when most of the work done is based on standardized designs that the clients choose from the wall of the tattoo shop? (2002, p. 99)

While Flash art is still readily available (although it is often used as part of the aesthetics of studios rather than as the traditional roster of image choices), and some people will choose Flash, the significant nature of tattooing has been the increasing primacy of artistic skill and individual choice. As Picerno argues, the development of the practice of tattooing has been one in which the quest to have Flash-based art that means one shares a design with countless other people has progressively given way to the desire for bespoke designs that bestow tattoo designs that emphasise a potent sense of uniqueness that is 'tailored to oneself' (2011, p. 17). Furthermore, as Patricia MacCormack similarly observes, this ethos has been mirrored by artists because the 'modern tattooist relies less on individual images on walls being chosen by clients, and is now more likely to design an image in sympathy with the musculature inflections of the client' (2006, p. 71).

The issue of tattooing as an artistic practice is central to Kosut's analysis of the industry, whereby, in the wake of the 'Tattoo Renaissance', not only did tattooing become a much more culturally diffused practice, but the artistry of many practitioners became markedly more prominent, and tattooing became more identifiable as a distinctive 'art world'. Subsequently, as Kosut argues of the transformation in self-representation within the tattooing industry, the 'deliberate self-positioning of tattooists as tattoo artists, coupled with the increase in academy-trained artists within the tattoo profession, reinforces the increasingly commonplace idea that some tattoos are indeed art, rather than craft or commonplace bodily decoration' (2014, p. 146). As such, since the 1980s there has been a significant increase in the amount of university-trained artists, with one significant issue being linked to the opportunities that tattooing offers as a supportive and financially rewarding destination that patently differs from the 'over-saturated and seemingly impenetrable contemporary art world' (2014, p. 150). Consequently, argues Kosut, artistic techniques, from practices such as drawing, graphic design, the fine arts and painting,

have been transferred into tattooing styles and have manifested themselves in two distinctive ways. Firstly, knowledge of these techniques have influenced new tattoo aesthetics and genres, such as New School, Biomechanical and Black and Grey, and secondly, the influx of graduates communicated a clear sense of commitment to reconceptualising tattooing as an artistic practice, one that enabled tattooists to move away from limited designs with equally limited colour palettes. As a result, in the wake of the 'Tattoo Renaissance', producing tattoo art has been predicated upon 'the development of original designs, an ability to draw and tattoo with great aptitude, proficiency in a range of tattoo styles, and some familiarity with the visual art world' (2014, p. 153). Furthermore, the influx of academically trained artists has also influenced tattooists who did/have not received formal artistic training, but have been inspired to develop their skills in relation to the genres that were introduced by formally instructed artists. In this sense, maintains Kosut, there is now a clearly defined 'tattoo world' that reflects the central tenets of Becker's sociological notion of the art world, a professional space in which all 'artistic work, like all human activity, involves the joint activity of a number, often a large number, of people' (2008, p. 1), a process that is central to the work of the tattoo artist, and the milieu of the tattoo studio.

STUDIO CULTURE

In terms of the business side of the artist/client relationship, the process, argues Sanders, is built upon the routine practice of making appointments with artists for a set time to be tattooed (although studios do often advertise that they accept walk-in clients or have specific walk-in time slots) and the paying of a deposit for their design. But much more potently, the tattoo studio can be perceived to represent a forbidding environment, a space that inspires heady feelings of anxiety, especially for those entering to have their first tattoo, a state in which the 'novice client possesses, at best, minimal knowledge of what the tattooing process entails' (2008, p. 119). Certainly within my own ethnographic research with tattooed social actors, this sentiment was reported. For example, Megan stated of her first tattoo experience: 'Trust is essential as the first tattoo is an unnerving experience: You don't know what you're going into, so you walk into it and all you hear is "mmmmm," like all the needles, and you're all like, "Oh, what's going on?"'. Adding to this sense of apprehension is the rare relationship that exists between the tattooist and the tattooed, as it is a liaison that dramatically disrupts conventional bodily norms between 'strangers'. This is because the tattoo studio and the act of tattooing necessitate a unique mode of interaction within the retail or bodily service industries, as Sanders

states, there 'are few settings in everyday life in which extensive physical contact, the wilful infliction of pain, and exposure of intimate parts of the body to virtual strangers are routine aspects of commercial interactions' (2008, p. 121).

The infliction of pain is a crucial factor of both the studio experience and the act of tattooing in terms of the bodily 'price' that the client must pay (in addition to the financial payment) for their chosen design, and the pressure to endure this pain. This is a factor influenced by bodily placement (with ribs, inner arms and feet being acutely painful, and the time taken to inscribe the design) in a manner that ensures that they 'sit well', meaning that they remain perfectly still and do not make any sudden movements that will affect the line work or any other delicate and precise part of the artist's performance. Examining the role of pain within the tattoo experience, Cyril Siorat (2006) concurs with Sanders' view that there are few instances in which social actors willingly (or at least professionally) accept the infliction of pain on their bodies, and that in most instances these are restricted to biomedical professionals such as doctors, surgeons, dentists, nurses and other medical practitioners. In this sense, then, tattooists and piercers are one of the few non-medical examples of pain-inducing professionals that social actors routinely engage with and who share in the act of piercing the skin and drawing blood as a central aspect of their procedures. Of course, as a response to the increasing pervasiveness of HIV and HCV infections in the 1980s, tattoo studios became markedly more medicalised in terms of the degree to which the studio space and work surfaces were disinfected, needles sterilised through sterilisation technologies, and artists routinely wearing surgical gloves while tattooing clients. Nonetheless, in Alayon's (2004) view, although regulatory bodies (in the United States this is the Board of Health, while in Great Britain the Department of Health produces guidance for local authorities in the regulation of piercing and tattooing businesses) decree that needles can be reused if sterilised, the conventional industry practice is to always use new needles for each client. As Thompson (2015) notes, such developments were necessary as the previously unsanitary nature of tattooing was another major factor in considering the practice to be deviant and illicit, and throughout much of the twentieth century many 'Bowery' type tattoo shops had no running water and made no efforts to sterilise needles, indeed, uncleaned needles would be routinely used on multiple clients. As such, outbreaks of diseases such as Hepatitis B in the early 1960s in New York resulted in tattoo shops being officially banned in the city, a prohibition that was not formally repealed until 1997 in the wake of strict regulatory hygiene standards. But, it is important to recognise, as Thompson argues, that tattoo infection stigmas nevertheless remain in the form of the prohibition of those who have received a tattoo in the previous year from donating blood.

For Siorat, regardless of the extent to which the tattoo studio has adopted professional medicalised hygienic practices, the relationship to pain within the tattoo experience is very different to that intrinsic to biomedical processes and surgeries because the pain endured during tattooing, while potentially excruciating for some, nevertheless acquires a positivity in relation to the resultant tattoo design. Hence, 'tattoos are potent symbols of the suffering endured in the process of acquiring them [and] pain and suffering are integral to the practice of tattooing and to the symbolic and aesthetic repertories of tattoos' (2006, p. 368). As a heavily tattooed person, Siorat reflexively reveals that he possesses a low pain threshold, and therefore the pain of being tattooed was difficult to endure, but it became a crucial aspect of his self-exploration, and the tattoo studio becomes the focal point of this process and the intense bodily experience it creates. To illustrate, Siorat cites a tattoo enthusiast that he has been in correspondence with who shares his perception of the tattoo studio as constituting a unique 'safe location' in which to undergo this process of pain, because 'in a tattoo shop, you consciously decide to be in pain. It is your decision, your choice of place and time and after all the pain you end-up with a beautiful tattoo, so pain becomes something positive and almost welcomed' (2006, p. 377). It is in this regard that Sonja Modesti has read the nature of the tattoo studio as representing a distinctive postmodern spatial form.

In Modesti's analysis, a postmodern space is one that 'must cater to a variety of people, styles, and tastes. These spaces must allow for the creative expression of artistic variations and not enforce rigid expectations [or] standards of behavior' (2008, p. 200). From this perspective, spaces of postmodernism are configurations that experience, or are resolutely designed, to be spaces that are characterised by the blurring of spatial boundaries in which the everyday lives of social actors within such spaces become inundated with artistic expressions, imagery and symbols within which the essence of bodies become subject to discourses of rhetoric and continual visual performances. While this may appear to be somewhat abstract in an everyday sense, as critics of postmodern culture tend to agree is the case when applied to everyday material cultural and economic life (Callinicos, 1990), the fusion of ideas and bodies is, as Modesti stresses, a constant factor within the tattoo studio working environment as they serve as the space in which the 'performance of agency' routinely occurs. As such,

[a]n undeniably strong statement for people to make, tattoos can be a disconcerting performance of ferocity, can signify conscientious radical self-definition, may signify sexual independence for women and ultimately help people reclaim their physical bodies ... Therefore, individuals living in the postmodern condition are inevitably drawn to spaces such as tattoo parlors that allow for the performance of agency. (2008, p. 202)

While (as explored within chapter 3) postmodern ideas have been effectively applied by academics to tattooing, the phenomenological approach is equally evident in the ways in which the tattoo studio becomes the site of personal transformation through the inscription of tattoo designs. As Siorat reflexively reveals in relation to his personal bodily progression to a heavily tattooed state,

> [m]y decision to acquire more tattoos was, in many ways, existential in nature. It concluded with my decision to begin divorce proceedings to end my seven-year marriage and nine-year relationship. It also came at a time when I was trying to come to terms with the murder of a friend in Durban, which unearthed issues regarding the murder of my grandmother twenty years earlier. In other words, I was dealing with a great deal of emotional suffering. (2006, p. 376)

While acknowledging that not all individuals who elect to be tattooed experience a 'spiritual' feeling, Siorat does argue that the pain does unite (however individualised the act of tattooing may be) the tattooed into a collective 'technology of the body' and that tattooing can be, and often is, used as 'a tool of self-discovery' (2006, p. 379). Within Siorat's personalised account of his progressive adoption of an extensive array of Polynesian-inspired tattoo designs, the issue of his individual sense of Heideggerian Dasein is a critical factor – that his tattoos represent an avowedly 'existential' adaptation that uses bodily inscription to articulate a spiritual and emotional transformation in his sense of personal being, and a transformation that comes at the expense of great physical pain. This idea of transformation is also evident in the work of other tattoo researchers, such as D. Angus Vail and his ethnographic study of 'hardcore' tattoo collectors, the individuals who seek out the very best artists in order to have their work tattooed on their bodies, and so become living canvases displaying elite-level tattoo artistry. As such (in terms of the tattooed individual's sense of being in the wake of the acquisition of such tattoos), the role of the artist as the transformer of the client is a salient one. Such changes may be physically minor (a single, small, subtle and hidden design), but is frequently extensive and highly visible. As Vail states of the avid and committed tattoo collector,

> [b]ecoming a tattoo collector is a transformative experience in more ways than one. This transformation is physical (i.e., one actually alters skin pigmentation), psychological and subcultural. Becoming a collector involves not only changing the way the light reflects off one's skin, but also the way that others view that skin and the person inside it. (1999, p. 258)

The tattoo studio, then, is the site of this process, a place in which the artist wields a unique transformative power, a privatised space in which the client's ideas are translated and transferred onto their skins, or, to evoke Modesti's postmodern spatial characterisation of the tattoo shop, where rhetoric and discourse becomes embodied. Consequently, having explored Sanders'

ethnographic experiences and observations, the chapter will now focus on the studios that I visited and the artists and studio managers that I spent time with, looking at the dynamic of the studio space, the artistic journey of the artists and their perceptions of their craft and artistic visions, and the sense of self-perception and the degree of trust and responsibility that the inscribing of ink permanently into the skins of strangers on a daily basis evokes within them.

'STANDING BETWEEN TWO WORLDS':
THE ART WORLD OF THE TATTOO STUDIO

In terms of methodological approach, my intent was to replicate Sanders' (2009) approach of 'hanging out' at a particular tattoo shop and interviewing the owners, studio manager and artists. In terms of selecting a studio, I had identified a number close to the university, but I was fortunate in that one of my early interviewees was also a practising tattoo artist with over ten years of professional experience. As such, not only did he become my first substantive source of data relating to the artists' perspective, but during the course of the interview I was furnished with the name of a tattoo studio in Newcastle upon Tyne, Northern Glory, and the names of the owners that he had worked with and which he highly recommended that I approach to undertake qualitative research, citing his name as a means of establishing a connection with the studio, produce a rapport with the owners, and gain access to interviewees. This proved to be especially valuable as the environment of the tattoo studio did inspire distinctive feelings of nervousness as I entered into it, and for many reasons. Firstly, the space of the tattoo studio is a 'phenomenal' one; it is an environment that uniquely unites sound and smell into a distinctive sensory and auditory experience. This is a perception that arose from my interviews, especially in relation to the first tattoo, but it is a factor that has been identified as a highly salient feature of the professional tattoo milieu, as Moedesti observes of the fusion of the distinctive sound of the tattoo gun, but also the idiosyncratic antiseptic smell of the tattooing environment. As such, the senses 'are additionally awakened in this unique space by a keenly distinct odour – that of topical antibiotic ointments. The smell is one of many tools used to create an atmosphere of hygiene' (2008, p. 206).

This smell was my first sensory contact as I entered into the Northern Glory studio for the first time, and the aroma never failed to register on all of my subsequent trips (and which is the result of the extensive use of the cleaning product Dettol). Visually and spatially, the studio consists of a reception area flanked by couches on which clients await their appointments with their artist, or await an initial consultation with an artist to decide upon their chosen design. However, whereas the studio of Sanders' research was festooned with

Flash on the walls, this studio establishes its tattoo ambience via tattoo magazines, tattoo-themed books, collections of portfolios showcasing the artists' work and framed paintings that illustrate many of the artists' particular tattoo styles and specialisms in addition to a tattoo-themed clothing and accessory line designed by one of the owners and featuring designs created by studio artists. In terms of Flash, within this studio Flash is employed exclusively as decoration as the studio specialises in custom work.

Once inside the studio, the pitching of me and my brief as a researcher and academic from a local university was the initial challenge as the typical entrant into the studio is a paying customer, and within the tattoo business, time is most certainly money, so my request for interview time was potentially a difficult one. However, adding my 'artist endorser's' name at the end of my research spiel immediately overcame suspicion as my interviewee was well known within the studio, and I was able to ask to meet the owners by name. Furthermore, when being shown around the studio by the manager and I was introduced to some of the artists, it was interesting that an initial hesitancy and distance was quickly overcome when I was asked if I had any tattoos, which I responded with yes. This information was important in assuring the studio that I wasn't a 'critical outsider' looking to produce work that was critical of tattooing and tattoo artists, especially in the sense of perpetuating negative appraisals of contemporary tattoos, or sustaining any residual depictions of tattooing as a deviant practice. From this introductory meeting I was then invited to return to the studio to observe the dynamics of the studio, and interview any artists who wished to be interviewed (some were reluctant, so I did not press any artist to participate who clearly did not feel comfortable being interviewed), one of the owners (also a practicing artist), and the studio manager. As a result, I obtained insights that covered new and long-established artists, a perspective that gave a rich comprehension into how the craft of tattooing had developed in recent years, especially in relation to entry into the industry. Moreover, to gain a wider perspective, I also conducted single-visit interviews with artists working within two other Newcastle-based studios.

In meeting a number of individuals within the studio, I was able to ascertain the distinctive division of labour involved in the running of a tattoo-based business and how the organisational and craft dimensions of the tattoo studio clearly reflect Howard Becker's conception of what he dubs the 'art world'. As Becker argues,

> [a]ll artistic work, like all human activity, involves the joint activity of a number, often a large number, or people. Through their cooperation, the art work we eventually see or hear comes to be and continues to be. The work always shows signs of that cooperation. The forms of cooperation may be ephemeral, but often become more or less routine, producing patterns of collective activity we can call an art world. (2008, p. 1)

While the tattoo design is the product of the tattoo artist, the supporting fac-
tors and arrangements that enable the artist to do their work are not. Within
the studio I undertook the bulk of my research in, it soon became evident that
the studio manager plays a vital support role to set up the artists to do their
tattooing effectively. At one level, this involves ensuring that each artists
work station is fully set up, seeing to it that all of the tattooing equipment
and surfaces of work have been sterilised, ordering tattooing supplies and
arranging the stencils for designed tattoos to be produced. The manager acts
as the first point of contact for each customers, which involves undertaking
the initial discussion of the customer's desired tattoo design or idea and then
recommending the appropriate artist to discuss and then ultimately deliver
the specific style, taking customer telephone calls and managing the studio's
social media presence, reflecting Becker's articulation of the cooperative
networks that enable art to be created. However, a further crucial aspect of
Becker's analysis of the nature of art worlds is the primacy of conventions
of artistic practice and production, as these set out the distinctive relations
that exist between artists and provide a professional foundation for the co-
ordinated activity that occurs between artists and their support staff. But, a
significant aspect of artistic conventions is that they are rarely inflexible and
unchangeable, because even 'where the directions seem quite specific, they
leave much to be resolved by reference to customary modes of interpretation
on the one hand and by regulation on the other' (2008, p. 31).

Furthermore, Becker argues, artists also 'learn other conventions – profes-
sional culture – in the course of training and as they participate in the day-to-day
activities of the art world' (2008, p. 59). But while these aspects of convention
application and learning clearly encapsulate the wider perceptions of art in
the form of painting, sculpture and other fine arts, and so on, they are equally
valid, perceptible and practiced within the culture of tattooing and the art world
of the tattoo studio. With regard to the learning of tattooing conventions, the
traditional training process for aspiring artists is the apprenticeship, and in Karl
Broome's (2006) study of tattoo artists, it is a process that was traditionally
a difficult and demanding experience, often incurring a period of financial
penury. In this fashion, according to one of Broome's respondents, the bulk of
their time in the studio that accepted them as an apprentice was spent sweeping
the floors, tending to the removal of clinical waste products, and making tea
for the established artists, a process that continued for a protracted period of
time before they were allowed to engage in any form of tattooing. Within my
interviews I found similar stories, especially in relation to artists who had been
professional tattooists for over ten years, as one artist stated of his experience,

[m]y apprenticeship lasted for years 'I was taught the Old School way. I had to
learn to solder needles together myself, how to fix any electronics, how to make

my own stuff as well ... I was getting paid £10 a day, it was pretty much slave labour for years, but that's always kind of been the standard among tattooists and the apprentices to make sure they are going to stick about ... It was a good two years before I started tattooing, really.

This account was echoed by another experienced artist who had made the decision to switch from his training within graphic design in his late teens to wanting to become a tattoo artist, and so from the age of 18–21 he sought out an apprenticeship opportunity (working as a graphic designer in the interim and building up an artistic portfolio to present to would-be mentors). When he was eventually accepted into a studio it was again a training method that instilled the 'Old School' approach, meaning that his teacher would not let him touch a tattoo machine for the first year of his apprenticeship, and he worked for little pay, but as he reflects, 'You just had to suck it up, really, and do whatever you needed to do to get an opportunity to tattoo back then', which included the standard sweeping up of the studio space and the setting up the established artists' stations, but in his case the apprenticeship experience even extended to cleaning his mentor's house. Consequently, the path to learn the conventions of tattooing have been onerous and almost designed, as one artists stated, to be a deterrent to all but those individuals who truly wish to be a professional tattooist. Interestingly, Sanders view of people 'accidentally' becoming artists, and inadvertently drifting into the profession was still evident within my research. For example, the artist who acted as my 'contact' responded to my question of why he originally decided to become a tattoo artist, by revealing,

I didn't, originally. It was right place at the wrong time, I guess. I had a friend who was doing it, I was more interested in music and I wasn't really that bothered about getting tattoos, either. He asked me to help out in the shop, so I did. The guy who owned it, my friend wanted me to help him on the desk one day, he saw me drawing and said 'You're really good at drawing have you ever thought of being a tattooist?' and I was like 'Nah, but sounds cool, I'll do that, sounds interesting'.

And nor were all entries into the profession straightforward, as another artist I interviewed in another Newcastle-based studio (who had been a professional artist for four-and-a-half-years) said of his experience,

I wasn't one of the ones that came straight into it. I sort of did it back-to-front. I started off with my own shop and worked my way backwards [laughs] to become a tattoo artist ... I was managing around seven to eight artists at one point. And then it got to the point where I was practising on myself, I was drawing a lot, I was practicing on my friends, the ones that were daft enough to let me [laughs], pig skin and just doing lots of stencils and things like that.

Having been medically discharged from the army due to injuries received in combat, this artist invested his compensation funds into a tattoo studio that he managed, but then began to develop as an artist, and so effectively conducted his apprenticeship within his own studio. However, the apprenticeship took the novel form of a fusion of a traditional studio-based training, and the home-based approach Broome argues mirrors that of the professional studio, in which the aspiring artist uses themself as the initial tattooing subject. As the artist explained of his acquisition of tattoo conventions,

> [i]t is supposed to be a two year period, but I'd already been practicing quite a lot on myself at home, which I should never have been doing, but it's one of those things that a lot of people do. I was practicing on myself for a long time and when I got into the shop I was probably doing that for another year I would say and then there came a day when everyone who was there said 'You're ready, you don't need to be under the guidance anymore. You're just doing your own thing'.

For many of the artists interviewed, the choice to become a tattooist was deliberate and not the result of any gradual 'drifting' into the industry. For instance, a young female artist reported a much more art-based and less toilsome apprenticeship experience, as she had harboured a desire to be a tattoo artist from around the age of thirteen, an ambition that was acted on in her late teens. In taking steps to secure an apprenticeship, the artist recalled that,

> I went round speaking to people … they told me to go away and get portfolio together and get a college course to practice drawing and gain some sort of knowledge from that. So I went to college and did a year at college [studying Graphic Design] and built myself a portfolio in my spare time … I just had to round the shops, really, and just go in and ask them. So yeah, that's pretty much how it went about.

In a similar vein, I interviewed artists whose backgrounds included fine art, graphic design, illustration, and media publishing, skillsets indicative that the influx of tattoo practitioners with artistic backgrounds noted by a range of tattoo commentators (Vail, 1999; Atkinson, 2003a; Kosut, 2014) is an established common feature within the contemporary industry. So, as one such artist stated, while the routine nature of many tattoo requests means that he can seldom engage in what he would regard as 'artistic practice', his tattooing skillset has proven to be an invaluable resource in his work as a practicing artist beyond the tattoo studio, as he reflected,

> [t]he benefit that's come from tattooing that's been sort of vital in my artistic practice outside of tattooing is that it did enable me to just learn how to draw anything. So, if I need to draw anything I can, and do it relatively quick, because

you have to, if someone comes in and says: 'I want a tattoo of that, a rose' you have to be able to just draw a rose straightaway.

Moreover, this artist recognised the artistic change that occurred within the culture of tattooing as he trained in the early 1990s, seeing the paradigm shift within the industry as the 'Tattoo Renaissance' established its effects. As he recalled, "tattooing was taking a big shift, where there were artists coming up who could actually do really artistic things, it wasn't just the old Sailor Jerry flash off the wall". In this sense, the conventions of style and technique development endemic within Becker's art worlds have been explicitly evident within the tattoo industry, as Becker states of the professional working practices and developmental nature of artistic production, artists 'usually develop their own innovative materials over a period of time, creating a body of convention peculiar to their own work' (2008, p. 64). Within tattooing, the development of a signature style, as Sanders noted, has long been a key component of the art world of the tattoo studio and the individual practice of the artist, and this has developed apace since Sanders' ethnographic work as the primacy of Flash art has diminished in favour of custom designs and artist guidance. All of the artists I interviewed either had signature styles or, if they were younger or less experienced artists, were actively forging their own favoured technique and genre preference and expertise. However, within the culture of the tattoo studio, this development is one that is not only gradual in terms of the honing of a particular style, but one that must be balanced with the commercial demands of a vibrant and economically successful studio with a regular client base. This sense of balance was perfectly reflected by a young female artist when asked if she possessed a favoured personal style, and how she developed her tattooing technique,

[t]raditional, yeah, Traditional, but it's quite feminine. I tattoo mainly females simply just because of the colour palette. I put a bit more into it than like really traditional stuff. It's one outline, single pass outline. It's like four or five colours, shitloads of black and like, it's very simple, you know, like textbook. But I've kind of taken that and tweaked it a bit and like done my own thing with it. Mind, I've taken a lot of influence from like loads of different tattooists. There's quite a lot of girls who do that sort of style, who've been doing it for years … I found them through social media and Instagram, and that's when I kind of knew that's kind of where I want to go with my style of tattooing.

The tattooist/client nexus point has long been read as a dynamic relationship that is the ultimate engine for artistic transformation; a dialogue that has seen artists asked to produce images they hadn't considered before. Therefore, as William C. Sturtevant states in relation to classic tattooing, 'it is the customers and not the masters who are really responsible for new fashions in design'

(1971, p. ix). The movement from simple designs, or making basic designs more personalised in terms of developing a unique style was a clear factor in this artist's creative and professional development, as she further explained,

> [s]o I started out really traditional, like very basic. I did a lot of watercolour paintings and Flash sets and stuff, and then I just started messing around with different medias and like, finally found this style which I've been stuck in for the last two years and it's just got better and better, and like a bit advanced and a bit more detailed as it has gone along, and I'm still trying different things to this day. Every other day I'll try something new ... It is an experiment every time is an experiment, in a sense, otherwise you would just get stuck in a rut and things would look the same. Everyone would walk around with the same piece on then, so if you don't experiment you don't get anywhere.

This artists' self-reflection evokes Richard Sennett's sociological conception of the craftsman: the artisan as 'maker' who is driven by the desire to produce work at the highest level for its own sake as much as functional outcomes and who is 'seldom satisfied by just getting by' (2008, p. 45). Craftsmanship, Sennett argues, is built upon the foundational principle of a productive skill-set that is developed to the highest degree and which is rooted in an acute sense of pride in the products of work. Applied to tattooing, this ethos was evident in the pleasure artists take in reaching a level of reputation that enables them to focus on their personalised tattoo craft, rather than having to produce standard work, but this takes time and the necessity to carve out a sustainable financial basis means that for young artists, the craft component of their work is a gradual process, as the same artist stated,

> [a]t the start you would rely on walk-ins. It's not a job where you really think about money. You don't really think about it, you don't worry about it because you're more into the art side of it because you're more bothered about making a nice tattoo. But, to get by you had to rely on walk-ins, like, in the meantime you had to grow and grow and grow and try to push your own style. That's what I found myself doing, I found myself doing stuff I didn't really want to do at the beginning, like a lot of very simple, generic tattoos you know, that everyone in Newcastle probably has got one, you know what I mean? People go through trends and I found myself falling into that in order to make money and get where I wanted to be at the time. But now I'm pretty much booked up and I've got my own clients, people who travel and come to me because they want my stuff on them.

The crucial factor regarding this development is the degree to which the craft quality of both the artist and the work means that clients feel confident in allowing the artist to express their creative vision with little or even no input from them because they are confident in the craft skill of the artist. As

such, when asked how often she was given artistic freedom on the skins of her clients, the artist declared,

[a]ll the time, I love it. People will get so embarrassed about it, like, they'll sent me something, say it's a really complicated idea that they can't quite explain, especially if I'm messaging someone and they're not in person, I say 'just sketch something', like they'll say 'I can't draw', but I'm like 'It doesn't matter, just do the crappiest sketch and send it across and I can take so much from that rather than trying to put into words what it is'. Some people will come in with stuff they've drawn, or a friend has drawn for them, and they'll think the world of it, they'll think it's amazing, and I'm a bit like, not to be harsh to them but like, I know what's going to work from a tattoo point of view, I know how it's going to translate onto skin, and what they fetching in isn't always easy to do it like that. So sometimes convincing people to allow you to change things and make it a bit easier to work with, it can be hard sometimes, some people won't shift and they just want that on them, and that's the way it is. But most of the time most of my clients pretty much will give me the most basic idea and they'll say 'Just literally, do what you want'.

In other instances, artists had similarly specialised in signature styles, such as Black and Grey, Portraiture, Photorealism and New School (a genre that fuses elements of American Traditional tattooing with the vibrant colours of Japanese/Irezumi tattooing and graffiti painting techniques). However, the production of 'art' within the milieu of the tattoo studio is inevitably tempered with the pressures to maintain what is a business, and one that exists in a highly competitive landscape (e.g. the online business directory Yell. com lists some 180 tattoo studios in the north east of England region), but the onus on art within Northern Glory is paramount, and explains why the contemporary apprentice experience is not like that of the more experienced artists who work there. As one of the owners (and practicing artists) stated of the culture of his studio,

[w]e always said we want them be artists, so just draw your own stuff, tattoo your own stuff, like don't be worried about knocking jobs back and stuff like that. But [they, the owners] weren't as fortune as that. We worked in shops where you had to do everything, so we are pretty much capable of doing anything, but if I had to choose I would just be doing Japanese all day, or something like that. But … it keeps you fresh, you know, doing different bits and pieces, so I'm just prepared to tattoo anything, basically [laughs].

The artistic space of the tattoo studio in line with this mode of perception extends to the bodily style exhibited by the artists themselves. Within the context of Atkinson's (2003a) ethnographic tattoo research, he reads this ethos with reference to Pierre Bourdieu's (1984) concept of habitus, which

describes specialised techniques and embedded knowledge which enable people to navigate different levels of life and cultural tastes and the social dispositions that are '"inscribed on the body" through body techniques and modes of self-presentation' (Craik, 1994, p. 4). Within the context of tattooing, the sense of values and feelings being 'inscribed on the body' is literalised and constitutes a particular form of 'lifestyle' in the form of denoting a passion for tattooing, a factor that becomes especially acute when attributed to the figure of the tattoo artist, whose sense of 'habitus' is dominated by tattoos, which bestows a distinctive lifestyle that is typically visually communicated through extensive and visible tattooing. Indeed, for the heavily tattooed artist, there is a distinctive fusion of the private and professional self that would be difficult to articulate beyond the professional culture of the tattoo studio and the tattoo industry within more 'conventional' spheres of employment. So, within the context of Atkinson's research, being a tattoo artist is (for many) a fundamental fusion of profession and lifestyle. However, while the sociology of Bourdieu is illustrative, so too is Heidegger's conception of phenomenology, because Heidegger's description of the word term 'world' can be read in ways that keenly articulate the specific sense of Dasein possessed by the tattoo artist and expressed within the environment of the tattoo studio. Referring to Watts' discussion of this aspect of Heidegger's theory, an individual's sense of being is shaped by the world into which it finds itself. At the macro level, this will include factors such as the nationality, culture or religious values of the individual's world, but as Watts points out, it also includes micro-level cultures, and especially professional cultures. As such,

> Dasein might inhabit primarily a business world or sporting world, academic or entertainment world. Each world gives us different potentialities for being: a different set of possibilities for determining who one is and how one can live. Thus the world in which a particular Dasein is involved will structure its mode of living. (2011, p. 44)

In terms of tattoos and employment-related settings, Atkinson stresses that a 'tattooed body offers a stark contrast to discourses promulgated in the occupational sphere, and is typically hidden away from the prying eyes of potential critics (2003a, p. 256), but this does not apply within the 'world' of the tattoo studio and, in line with the Heideggerian perception, the mode of living of the tattoo artist is an immersion into tattoos, an interest that frequently predates their status as professional artists, but finds a perfect expression within the milieu of the tattoo studio and wider tattoo culture. As such, many artists (from those interviewed, those seen as I 'browsed' within numerous studios, those witnessed at tattoo conventions and the numerous artists appearing within the various tattoo-focused media of magazines,

television and social media/websites) have bodies that are structured by their 'mode of living', but their extensive tattoos do not conflict with their employment environment, but, alternatively, harmonise with it. At one level, each artist enters into a culture of the 'They' – the artists that have preceded them or who represent the industry as they seek to enter into it, and the tattooist mentor constitutes a powerful expression and representation of a professional 'They' who instil the conventions of the industry. Alternatively, the nature of employment within the tattoo industry enables the heavily tattooed to find a degree of authenticity regarding their tattooed lifestyle that is not evident in many other employment environments, regardless of any ostensible 'normalization' processes that have occurred in recent years regarding the social acceptability of tattooing. This freedom to wear tattoos openly afforded to artists was self-reflexively appraised by an artist interviewee. As he stated of his own tattoo designs (which include designs on his hands and neck),

> [i]t's like you wake up one day and you just think 'I can wear whatever I want, I can get any tattoo that I want, because that's my industry, nobody judges you'. Like everybody else out there, you think it must be hard having to watch what you do with yourself because of your job, it's stupid, you know what I mean? You should be able to do what you want to do, but we're just fortunate enough to be in that industry where you can.

In Heideggerian terms, the tattoo artists, within the context of wider employment conventions and expectations, represent, from a tattooed perspective, Dasein that resolutely 'do their own thing' within the context of a situation that Heidegger within the context of a situation whereby the 'They merely influences Dasein's interpretation of the tools it is using to carry out the everyday actions, but not the actions themselves' (Watts, 2011, p. 59). As such, the profession of tattooing is often not viewed as work at all, as an artist from an alternative Newcastle-based studio explained of his perception of tattooing:

> It's more of a lifestyle than a job, I'd say. It's really amazing to be able to be creative every day and not to have any limitations on your day ... it's interesting, it's always interesting. Every day's interesting. It is nice to be creative. A lot of people lose that creativity. A lot of people get a job and then just kind of just don't bother doing anything creative. I think it's really important to keep your mind creative, your imagination moving and that. I'm quite grateful, I'm really grateful to have a job where I can do that every day.

Within the dynamics of the tattoo studio, the working environment is seldom one that reflects either corporate, retail or service industries, and so working practices are more flexible, relaxed and idiosyncratic than a more routine

'9–5' working environment, as one of the owners of Northern Glory stated of the working environment he has established within his studio:

> The customer's feel comfortable with it, you know, and we all have a bit of a laugh. Tattooists, when I was younger, was an intimidating place to walk into, now it's not, you know? You still see it on people's faces when they come through the door. They are intimated and they do feel like, you see they're nervous when they walk through the door and we just make them feel relaxed. We've got three girls working here and there's nothing intimating about them in the slightest. It's just that sort of atmosphere now, everyone just sits and as a laugh with you and can chill out [laughs].

Furthermore, although the apprenticeship process is invariably onerous and consists of a hierarchical instilling of the fundamental conventions of the craft of tattooing, once it is completed then the professional artist is free to pursue his or her own personal style and artistic trajectory. At one level it may be argued that these styles are themselves influenced by a tattooing version of a 'They' which established each tattoo genre, but like artistic practice, the craft of tattooing is one that witnesses original breakthroughs and the establishment of entirely new styles (from New School to Trash Polka), so in other words, professional tattooing is a culture in which authenticity, what Heidegger articulated as 'a modified way in which ... everydayness is seized upon' (1962, p. 224) can be expressed. However, a significant factor that ran parallel to this freedom was an acknowledgment that social actors living and working outside of the tattoo industry did *not* have the same degree of freedom, and this did impact on what artists would and would not inscribe on their clients.

In questioning artists about what they would not do, responses resonated with similar findings from Sanders' now-classic research, namely that of politically noxious symbols (such as swastikas). In other instances, artists would not perform work in a style that they knew they were not fully proficient (and were happy to refer client requests in such areas to other artists working in their studios), they would not inscribe designs brought in by clients that they felt were artistically poor, and they also would not copy another artists' work (a common factor, with client's locating tattoo designs online and bringing them to the artist for replication). Although it is worth noting that one artist's response to this question was the more prosaic: 'Shit tattoos [laughs] shit ideas ... that wouldn't make for a good tattoo'.

These factors were closely aligned to protecting professional reputation, as one artist stated of overtly and controversial political symbols, they attach the tattooist's name to the design and are therefore 'bad for business', but other examples were tied to the effects that they might have on the client's sense of being. In this regard, there was a tendency to be reluctant to do tattoo designs

on hands and necks when the client seemingly had no other visible tattoos and facial tattoos were a major issue. As one artist stated, with a clear linkage to the effect such designs can have on the wearer's sense of being:

I won't tattoo people's faces. Never tattooed people's faces, never will ... Because I know what that can do to people. I've met many people over the years that've got their faces heavily tattooed ... it just changes their lives. Their friends and their families just look at them differently.

Within the interviews with tattooed social actors, I repeatedly asked about the issue of trust that they establish and place in the artist that they choose to perform their desired tattoo designs because of the permanence of their work, and that they will be changed when the tattooing procedure is completed. As Broome notes, evoking the essence of Heidegger: 'Tattooing, and being tattooed is a particular mode of "being-in-the-world"' (2006, p. 346), and it is a transformative process for both agents in that the tattooed person's body is modified by the actions of the tattooist, whose work is designed to remain in the skin on a permanent basis. For one artist, the issue of his work changing his client's visible appearance was a factor that he sometimes reflected upon, in addition to the infliction of often intense bodily pain his work could cause. As the artist stated on the issue of the sense of responsibility that is a fundamental part of the tattooing process:

Yes ... That's like such as massive responsibility. I do sit there and think that sometimes, like when I'm in the middle of a tattoo and I'm just like, 'Shit, I'm drawing on someone, like I'm doing like a picture on someone, that's absolutely insane'. That's, like, a crazy responsibility. It is really bizarre for me. I picked up tattooing really slow compared to a lot of people because I was really worried about hurting people and how it would affect them.

Yet, another artist expressed this relationship and 'power' in terms of pride, in relation to the client's decision to choose him as the person who will permanently mark their body, as he stated, 'It's quite an amazing thing, really, for someone to come to you with that trust, really, isn't it? ... You are making someone feel something special. And they get to keep it forever'.

THE TATTOOISTS' CRAFT:
FROM CONVENTIONS TO CONVENTIONS

The recognition that tattooing consists in the act of 'drawing upon' the human body evokes key aspects of Heidegger's analysis of the origin of works of art, but tattooing serves to unite Heidegger's conception of Dasein and 'Being'

with the ways in which art is presented in a unique fashion. This is so because in speaking of the nature of art, Heidegger stresses its quintessential 'thingly' nature. As he explains within *The Origin of the Work of Art,*

> [t]here is something stony in a work of architecture, wooden in a carving, colored in a painting, spoken in a linguistic work, sonorous in a musical composition. The thingly element is so irremovably present in the art work that we are compelled rather to say conversely that the architectural work is in the stone, the carving is in wood, the painting in color, the linguistic work in speech, the musical composition in sound. (1977, p. 151)

In relation to Becker's approach to the visibility of art works, in that having created a piece of work, the artist must secure a mechanism for the work to be seen and for a public to gain access to it, the 'thingly' nature of the tattooist's canvas is the human body, or the dermis of a social actor. Moreover, as Heidegger states, the thingly component is 'so irremovably present in the art' – a factor that is the essence of the tattoo in that it exists *within* the canvas – and that the immediate distribution mechanism is the canvas itself, as the tattooed person moves through the world displaying their designs. However, Heidegger's analysis of the origin of art also stresses the contribution of technology, the craft mechanisms that enable the artist to 'bring out' their works of art. Within the context of tattooing, its history is one of the progressive development and utilisation of technologies, from bones and shells to the various versions of electric tattoo guns, to 'bring out' and inscribe their (or their client's) design vision upon their skins. As Becker states, there are art worlds that 'begin with the invention and diffusion of a technology which makes certain new art products possible' (2008, p. 311), and while the electric tattoo machine initially was argued to be responsible for the artless tracing of Flash, tattoo application technologies have been essential to its progressive development as a custom art form.

For Heidegger, then, technology 'is a way of revealing' (1977, p. 294) and within the context of tattooing this can be argued to describe the act of tattooing, but also the revealing of artistic work in a distributive sense. In this regard, I refer to the ways in which artists' work is communicated to wider audiences, and digital platforms such social media networks have enabled artists to consolidate and advertise their reputations, and now transcend the limitations of traditional wall-mounted Flash collections, printed portfolios, and word-of-mouth, to communicate their work regionally, nationally and internationally. Hence, just as social media platforms such as Facebook have transformed the marketing potential of a range of industries and brands (Kerpen, 2011), so too has it impacted upon the business of the tattoo studio. While the tattoo manager still attends to the traditional components of studio maintenance, increasingly, a significant proportion of their professional role

is devoted to the upkeep of the studio website and social media platforms, such as Facebook, Twitter and Instagram that visually showcases both the studio and each respective artist and their work. Therefore, as Northern Glory's co-owner stated of the impact of social media as a studio-advertising medium:

> I always say to a lot of artists: 'Make sure you are putting everything on line because your portfolios are the only way you are going to get yourselves out there, like taking pictures of your work, making sure people see it.' So definitely, social media is huge at the minute. I know a lot of successful people just off running social media ... That's what probably is boosting business, in my eyes, making sure that people are seeing what you're producing.

The tattoo artist and the tattoo studio represent the primary locus of tattoo culture, it is the environment in which the tattooing process takes place, the location in which the social actor who wishes to inscribe their body with ink enters, negotiates with the artist, who either produces exactly what is required, or puts their skin in the hands of the artist and grants them the opportunity to design a custom image that is unique to their authentic, personalised style. As such, the tattoo studio is an evocative space, a sensory environment filled with sounds, smell, blood and an array of tattooed bodies, from the images on the walls and tables, to the artists and managers, and, of course, the clients. Above all, the tattoo studio is a setting devoted (at a financial cost) to bodily transformation, where a person's being-in-the-world is visually inscribed by individuals who possess tattooing skill. As Sanders states of the status of the artist (with applicability to the tattoo artist/client relationship):

> Both participants in the creation of art works and members of society generally believe that the making of art requires special talents, gifts, or abilities which few have. Some have more than others, and a very few are gifted enough to merit the honorific title of 'artist'. (2008, p. 14)

Within the tattooing industry, skill levels similarly vary, and in discussing their employment backgrounds the long-established artists gave accounts of good and bad studios, stressing the studios that put the quality of art first and were not reluctant to turn clients away if they could not deliver exactly what they wanted, or if asked to produce work in an unfamiliar style, and those based upon the goal of simply making money on a 'get them in, get them out' client ethos. Moreover, my interviews with tattooed social actors uncovered accounts of poor quality work, but there are also numerous instances of good, solid practitioners and 'superstars', from the internationally renowned celebrity artists, to the professionals in every city whose work is of such an artistic standard that their waiting lists run into months, if not longer.

Therefore, like any other art world, the tattoo industry is one bound by conventions that have been, and continue to be, modified and revolutionised to produce new styles and genres, or fuse existing styles into fresh expressions of tattooing. Yet, tattooing constitutes a specific tattoo-based art world, and it is one whose creative networks extend beyond the studio. This is because, in addition to conforming to artistic and organisational conventions, professional tattooing also finds expression within the literal arenas of conventions, tattoo events that take place across the world, bringing together tattoo artists and tattoo enthusiasts to both engage in the practice of tattooing and to celebrate the 'inked lifestyle'. And it is nature of the tattoo convention that will be explored in the next chapter.

Chapter Six

Tattoo Conventions

Fandom and Participatory Art Worlds

Having examined the perspectives of tattooed social actors and the artist-and-studio environment, this chapter looks at the populist and public meeting points that unite the two in environments that transcend the micro-situation of the client/artist interaction. As such, in addition to the cultural representations of tattooing, from tattoo-based television series, tattoo magazine publications, and its visibility within popular cultural and celebrity discourses, a now long-established forum for the active celebration of tattoo culture is the tattoo convention, social events that are held across the world and which represent a meeting point between artists, individuals seeking to be tattooed, and tattoo aficionados. On the subject of the nature of tattoo culture, one interviewee, Tara, held that the idea that the degree to which such a culture is manifestly observable is difficult to sustain. As she stated,

> [t]hey are so personal ... It's not easy to say there's even a tattoo culture, because we're widespread and these days most people I know have them ... Do those people count as being a tattoo culture because they've got one 'J' on the back of their arm [their child's initial]. I personally haven't found anyone being extra nice to me because I've got tattoos ... I'll get more conversations because of the specific tattoos I have. I haven't found that there's even a culture, and I work at a tattoo parlour. So, there are most of us just sat round with lots of tattoos that pretty much only have meanings to us and we talk about television shows, not tattoos.

However, a potent indicator that such a collective culture is discernible is represented by the tattoo convention. Although the British tattoo artist, Les Skuse, creator of the Bristol Tattoo Club in 1953, established the annual Bristol Tattoo Club Convention in the 1950s, Thompson (2015) argues that it was in the early 1970s that the tattoo convention became a firmly established

feature within the Western tattooing world. As Thompson argues, prior to the 1970s (with the notable exception of Skuse's work in Britain) there was no culturally perceptible 'tattoo community' beyond those attached to specific tattoo shops/studios, partly because artists did not wish to share their practice and tattooing 'secrets'. However, this began to change with the first American-based convention of artists at the National Tattoo Club of the World, held in 1974. This event (which would later become the National Tattoo Association), and the proliferation of conventions that followed, including Henk Schiffmacher's tattoo conventions held in Amsterdam from 1984 (Friedman, 2015), constituted a forum for both tattooists and tattoo collectors to meet, and so they have become a firm part of the tattooing business and culture, and an important attraction for those with tattoos and those interested in tattoos. As Thompson explains their significance,

> [t]attoo conventions are important in the industry for artists to network, see new developments in the industry, and work on new clients otherwise inaccessible geographically. It also provides exposure to work by other artists as well as opportunities to be featured in tattoo magazines. (2015, p. 143)

From their 1970s development, tattoo conventions have both proliferated and become firm and anticipated annual features on the tattoo enthusiasts' calendars across the world, with key examples including, *The International London Tattoo Convention, The Manchester Tattoo Show, The Poços Tattoo Convention, Tattoo Jam, The Hell City Tattoo Festival, The Brussels Tattoo Convention, The Golden State Tattoo Expo* or *The Hong Kong Tattoo Convention*. Furthermore, the nature and organisation of conventions has evolved profoundly, too. As Picerno states, tattoo conventions 'are no longer the grimy biker dens they once were: they are family-friendly occasions, in some cases even offering crèches' (2011, p. 20). In this regard, argues Picerno, tattoo conventions have played a decisive and influential role in the popularisation of tattooing as they serve to showcase artists' work (and frequently the most respected artists in the industry) and enable spectators to explore tattooing without any pressure to be tattooed, and without any of the anxiety that can be felt on entering tattoo studios as part of any speculative or 'educational' explorations of tattooing. Consequently, the tattoo convention offers a fusion of industry exposure and cultural and social event, as Picerno explains,

> [t]hese conventions attract tattoo artists from around the world and provide a bridge to those artists many punters would not otherwise get access to. Visitors do not necessarily go in order to get tattooed, although plenty do. It's an opportunity to soak up the atmosphere, to watch tattoo artists work, have a drink,

socialize, see some art, enjoy performances and indulge in a spot of shopping as there is usually plenty of merchandise, from books to clothing to original artwork. (2011)

TATTOO FANDOM

As expressed by Picerno, the multifaceted, but celebratory nature of the tattoo convention aligns the tattoo enthusiast with the popular-culture-oriented 'fan'. Although a notoriously ambiguous term, Mark Duffett stresses that a fan is conventionally 'a person with a relatively deep, positive emotional conviction about someone or something famous, usually expressed through a recognition of style or creativity' (2014, p. 18). Furthermore, as Matt Hills (2002) states, fans commonly 'participate in communal activities – they are not "socially atomised" or isolated viewers/readers'. In this regard, the cultural and sociological study of fandom has progressively stressed the multifaceted nature of the phenomenon, exploring the creative characteristics of fandom, such as Henry Jenkins' (1992) now-classic conception of the culturally productive fan. In this tradition, fans utilise their experience and in-depth knowledge of favoured cultural texts as the basis for forms of artistic creation such as writing new stories, composing songs, making videos, artworks, and so on, that extends, in a creative fashion, the relationship between the fan and their object of fandom. The crucial point here, stresses Jenkins, is that such fan behaviour does not occur in isolation, but is shaped through contributions from and interaction with other fans. This leads to the second component of active fandom in which Jenkins argues that fandom constitutes a particular 'interpretative community'. This is so because of the social nature of fan reading practices, and as such fan interpretations have to be recognised in 'institutional' in preference to individual terms. This institutional behaviour manifests itself as fan club meetings, the production and consumption of newsletters and fanzines in which textual interpretations have been offered and, more importantly, negotiated with other fans and entirely new readings debated, challenged or accepted.

However, with direct reference to tattooing and the tattoo convention, this sense of active engagement underpins Jenkins' third level of active fan behaviour which articulates fandom as constituting a specific art world. This concept is drawn from the work of Howard Becker (as discussed in chapter 5). For Becker, all 'artistic work, like all human activity, involves the joint activity of a number of, often a large number, of people. Through their cooperation, the art work we eventually see or hear comes to be and continues to be' (1992, p. 1). In Jenkins' view, the art world involves networks of artistic production, distribution, consumption, circulation and

the exhibition and forums for the sale of artworks. In this regard, argues Jenkins, fandom constitutes a facet of the mass media art world. Thus, fan conventions are not simply events in which fans can interact with fellow fans, but they also perform a key role in the distribution of knowledge about media productions and are one of the modes by which producers promote cultural products such as comic books, science fiction novels or new film releases. More importantly, conventions provide spaces in which writers and producers have the opportunity to communicate directly with the con-sumers of their cultural products and so have established more concrete understandings of audience expectations. Yet, aside from economic aspects, fandom also represents an art world in its own right as the consumption of professional texts is the grist for the production of new fan-produced cul-tural creations and conventions serve as stages for elaborate costumes and self-created artefacts. The idea of a fan art world ultimately underscores the final fan component, that of fandom constituting an alternative social com-munity. As Jenkins states,

> [t]he fan's appropriation of media texts provides a ready body of common references that facilitates communication with others scattered across a broad geographic area, fans who one may never – or only seldom – meet face to face but who share a common sense of identity and interests. (1992, p. 213)

In Jenkins' view, the explanatory factor that has seen such groupings acquire the nature of a community is that many societies have experienced an erosion of traditional forms of cultural solidarity and community. But, an increas-ingly atomistic society has not destroyed a need to participate within cul-tural community. Consequently, then, fandom can fill this communal void, but with specific differences because what 'fandom offers is a community not defined in traditional terms of race, religion, gender, region, politics, or profession, but rather as a consumers defined through their common relationship with shared texts' (1992, p. 213). In terms of gratification and the motivation to engage in such groupings, fans view such communities as existing in a state of conscious opposition to the 'mundane' world inhabited by non-fans, and so construct social structures more accepting of individual difference, more accommodating of particular interests and more democratic and communal in their operation. As Lynn Zubernis and Katherine Larsen argue, while online technology and social media platforms have resulted in Jenkins' ideas radically transforming in terms of fan connectivity and has enabled fans to establish digital fan spaces to communicate and productively interact within, these 'communities' also routinely engage in face-to-face fandom within the environment of conventions. Referring to science fiction/fantasy media-based Comic Con-style events, Zubernis and Larsen state that at 'conventions, fans perceive themselves as moving from the mediated world

of the mass audience to the more intimate relationship afforded audiences in close proximity to performers' (2012, p. 21).

While the nature of tattoo fandom is obviously different from those directed towards the likes of *Star Trek*, *Star Wars*, *Doctor Who*, *Game of Thrones*, and so on, the intimate nature of the tattoo convention is similar, as is the issue of the proximity of attendees to the tattooists who are featured guests. In some instances, tattoo conventions do feature prominent celebrity figures from the tattoo industry, especially those featured within Reality TV tattoo shows, such as Ami James and Megan Massacre. However, while the majority of artists who appear at conventions are not routinely featured within mainstream media discourses, they nevertheless possess a distinctive cache of professionalism and have highly respected reputations as artists. In this sense, many of the artists who appear at conventions accord with a category that Bertha Chin and Matt Hills (2010) call the 'subcultural celebrity', a kind of celebrity that is restricted to specific audiences rather than to a wider general public, but which is nonetheless recognised and respected by subcultural niche groups. Therefore, while the artists may not evoke any generic public recognition, they possess extensive professional reputations within the tattooing art world, and their presence at conventions become considerable sources of attendee attraction. As Thompson points out, it is not only tattoo enthusiasts who are attracted to specific conventions because of particular featured artists, but tattooists themselves, as conventions offer opportunities to receive tattoos from the best in the business. As Thompson explains, 'Artists are often elite tattoo collectors themselves – collecting ink from artists they admire, mentors, and friends during this time together' (2015, p. 144).

In this regard, the tattooists who appear at conventions utilise them as a means by which their work can be communicated to a larger audience than their conventional studio-based practices, and in this sense, the convention accords with a primary aspect of Becker's conception of the professional art world, whereby artists, 'having made a work, need to distribute it, to find a mechanism which will give people with the taste to appreciate it access to it' (1982, p. 93). While the tattooed client, the studio website and the artist's social media site can distribute the products of their art, the convention enables a wider audience to gain direct access to the work, often as it is being performed on clients within the confines of the convention. As Duffett argues, a key element of wider fan cultural behaviour are the 'pleasures of connection' that fans seek with the objects of their fandom in the form of engaging in encounters with performers and either speaking with them, or simply obtaining an autograph. At the tattoo convention, enthusiasts can speak with artists, purchase original artworks and merchandise, but, uniquely, the convention attendee can also experience a pleasure of connection that is intrinsic to the tattoo convention: the acquisition of a tattoo design by a featured artist. In

the view of Kosut, the recent history of the tattooing industry has progressively become recognised as representing a distinctive art form, a legacy of the 'Tattoo Renaissance', a context within which many artists (and clients) position tattooing within the tradition of the fine arts.

Consequently, stresses Kosut, Becker's conception of the art world can be refigured as a distinctive *tattoo world* as it now consists of a firmly established 'professional milieu comprised of divergent actors, networks, reward systems, and hierarchies. Historically, tattooing was an insular trade ... with skills acquired through internship and personal determination ... Today, the business of tattooing has expanded into a complex profession with a range of norms, aesthetics and business practices' (2014, p. 147). While this assessment refers to the changes in studio practice, skills acquisition and performance and the cultural visibility artists can attain (through online broadcast), the tattoo world also includes the convention within the networked organisation and practice of artists.

THE CONVENTION EXPERIENCE:
THE WRITTEN BODY IN MOVEMENT

While many tattoo commentators refer to the convention as a key part of the 'tattoo world', Mindy Fenske has examined the specific dynamic and organisational form and expression of the convention in detail. In Fenske's analysis, tattoos retain their power to visually communicate positions of class and status, and that they may still retain the power to act as signifying representations of deviance. Even in the face of the apparent populism that has characterised social and cultural attitudes to tattooing, Fenske nonetheless stresses that excessive tattooing retains its power to subvert social bodily norms, that the heavily and visibly tattooed or those social actors who wear facial tattoos can and do 'violate class or gender norms because of their size, style, or location' (2007a, p. 54). Tattoos retain this power, argues Fenske, because of their intrinsic nature: their bodily permanence. In this regard, tattoos can arguably resist 'normalisation because they visibly 'mar the pure and "natural" surface of the body. Metaphorically and literally, therefore, tattoos illustrate and confront the inscription of social norms and codes upon the body' (2007a, p. 55). Hence, tattoos arguably retain a status that can be read as denoting deviance if the tattoos fall outside of expected normative assumptions, whereby bodies 'violating social norms through their expression therefore are interpreted as external manifestations of internal social deficiencies' (2007a, p. 55).

For Fenske, this can become evident when social actors elect to have tattoos in bodily locations that transgress standard constraints for class and

gender-based bodily display, for example, a female college undergraduate who does not elect for a typically feminine tattoo design and elects to have that design inscribed not on a part of her body that can easily be concealed, but as a motif that covers her entire arm. Such an issue informs Thompson's research into the social perceptions of heavily tattooed women, many of whom did report gender-transgression-type critiques, and it is a factor within my research, whereby many undergraduates (both female and male) balance their desire to be tattooed with an acknowledgment that the 'middle-class' mores of the professional world will reject visible tattooing, and reject them as candidates for employment. Consequently, Fenske stresses that, when viewed from this perspective, that tattoos are 'a particularly problematic form of adornment because of their relatively permanent inscription. The sign of the psychological deviance is more potent, and carries more social force, because it is a permanent choice to mark the unremarkability of the classed body' (2007a, p. 56).

However, Fenske's methodological approach to explore how tattooed bodies navigate their cultures was to conduct ethnographic research within tattoo conventions, a space in which tattoo designs, the art of tattooing and the displays of tattooed bodies are all subjects that are actively celebrated within the spatial zone of the convention environment. In defining and explaining the multifaceted nuances of the convention experience, Fenske states,

> [t]attoo conventions constitute a space where tattooed individuals congregate for 'long periods of time' and provide a locale for the enactment of tattoo community ... [They are] 'an occasion to mix with cohorts, see and show tattoos, enter tattoo contests, go to seminars and collect a tattoo as a memento of the event ... Tattoo conventions provide the tattoo artist and tattoo consumer with the opportunity to gather together and celebrate their bodies and art' (2007a, p. 56).

A prominent feature of many conventions, notes Fenske, is the popularity of tattoo live competitions, whereby tattooists compete against each other to display their artistic prowess on the skins of their clients. In addition to the artistic dynamic of the competition, their significant function is that they become the arena for the active display of tattooed flesh. When the tattooing is done, the recipients of the designs then showcase their work onstage before a panel of judges (usually well-respected tattoo artists) who evaluate the work before the convention attendee audience and ultimately award the winning design. In this sense, tattooist proficiency, the issue of bodily display and the exhibition of tattoos, is a prominent component of the convention experience as the 'tattoo contest is a venue within the convention that heightens the behaviour of the tattooed body by placing the body onstage and before an audience for the express purpose of being evaluated as a tattooed body' (2007a, p. 57). In the view of Christine Braunberger (2000), as a staple of the

convention since their popularisation in the 1970s, the tattoo contest (which conventionally has no financial reward) represents a unique hybrid form that is part beauty contest, part traditional freak show.

From Fenske's observational studies while attending a number of conventions, Braunberger's description is apt as she too identifies a prominent touch of the carnival or 'modern-day sideshow in the aesthetic layout of the events. For example, citing one event held within a hotel ballroom, various booths had been erected around the ballroom's wall that housed artists in their temporary and mobile "studios", the names of which were communicated via cloth backdrops. Moreover, the conventions were invariably marshalled by a host, or MC, who periodically directed attendees' attention to various events going on, most notably the tattoo competition, a substantial feature subdivided into various categories (best colour tattoo, best portrait, best sleeve, best black and grey, etc). With regards to bodily display, participants showcase themselves simply as the bearers of tattoos. As such,

> [t]he norm was for the individual to walk to centre stage and stand passively in a pose that allowed the audience to see the tattoo entered in the competition. It was the tattoo, and not the tattooed body, that was the focal point of this performance. For example, a man with a tattoo on his throat threw his head back; another gentlemen featuring his calf-tattoo placed his leg in front of him and bent his knee so that his leg pivoted on pointed toe; and a women who was revealing a tattoo in her pubic region unzipped her pants just far enough to display the artwork. The performance was a display of body parts ... This tattoo classification system virtually dissected the human body for tattoo inspection (Fenske, 2007a, p. 60).

The nature of the tattoo competition harks back to the perception of the P.T. Barnum-presented tattooed body from the 1880s to the 1920s, the height of what Atkinson (2003a) dubs the Circus or Carnival Era, whereby the tattooed were presented to the public as an object of entertainment, the most notable example being Prince Constantine, the bearer of over three hundred and eighty tattoos, and other heavily tattooed men and women such as Jack Tryon, Irene Woodward, Betty Broadbent, Artoria Gibbons, Princess Beatrice, Miss Creola and Nora Hildebrandt (McComb, 2015; Mifflin, 2013; Braunberger, 2000). However, it is not merely the contemporary parade of tattooed bodies that Fenske stresses links the tattoo convention to the sideshows of old (although a key difference that must be stressed is that unlike the Barnum-style audiences who came to witness tattooed 'others', the core audience of the convention tattoo competition is as equally tattooed, if not more so than the competitors), but the mise en scène of the convention environment, with its booths backed with various images communicating the world of tattooing and heavily tattooed human bodies has a distinctive carnival-style ethos. Thus, these

aesthetic factors, in addition to events such as the tattoo competition, visually echo and reproduce 'the logic of the sideshow community within the space of the convention' (2007b, p. 66).

In this context, Fenske considers the convention to represent an example of a Deleuze and Guattari-style 'striated space' (a concept that she applies to the tattooed skin), spaces marked by constant shifts and levels of control. In this sense, individuals can free themselves from the restrictive practices and boundary-setting natures of striated spaces to engage in processes of 'reterritorialization', the repositioning of the self 'within new regimes of striated spaces' (Ringrose, 2010, pp. 602–603); a condition Deleuze and Guattari aptly state can be achieved 'by immersion in an ambient milieu' (2000, p. 494). Within the context of her entrance into a tattoo convention, Fenske evokes this sense of 'immersion' and movement from one form of space into another, as she recounts,

[o]nce my ticket was purchased, a wristband attached, and the program collected, I entered a vending area that marked the interior lobby of the Expo. Vendors sold back issues of tattoo magazines, jewelry, t-shirts, food, and alcohol. On the other side of the vendor's area was the entry into the ballroom proper where the tattoo artists, piercers, and the tattoo equipment vendors were located (2007b, p. 60).

In Fenske's view, the clearly demarcated boundary between the inside and outside of the convention is a mode of striated territorialisation that is visually represented and communicated by the skins of the participants, whereby 'the tattooed bodies represented the realm of the inside and non-tattooed bodies circulated along the periphery or outside. The ticket booth regulated the flow of bodies' (2007b, p. 60). However, this notion of a striated state whose boundary is regulated is an important one in terms of the sentiments that characterise attendees, and which serve a basis of a mode of 'inked solidarity'.

As my interview respondent, Tara, stressed in her rejection of the idea that a discernible sense of a tattoo culture exists, in the main, the act of tattooing is individualised relationship between the tattooist and the tattooed, but the convention does represent an instance in which a sense of tattoo-linked community occurs, even just for the duration of the event. This is a significant feature because the convention has the capacity to suspend the social reactions that visible tattooing can elicit, moreover, even for those whose tattoos are not routinely on display, the convention represents a forum within which they can be revealed with no risk of censure. Evoking the sociology of Émile Durkheim, who was concerned with the ties that binds individuals together to form a functional and integrated society, he explained how (whether through religious rituals or the division of labour) individuals 'are solidly tied to one another and the links between them function not only in the brief moments

when they engage in an exchange of services, but extend considerably beyond' (1984, p. 21). In the context of the tattoo convention, it is possession and display of tattoo designs that establishes a group sense of solidarity, because, as Fenske stresses, they 'are safe havens where tattoo artists and tattoo collectors gather together to compare tattooing techniques and show-off their tattoos' (1984, p. 21). As such, the convention is an arena in which the extensively/heavily tattooed body can be, and is, overtly displayed, subsequently negating any social sanctions that may still operate which judge such bodily displays as conflicting with mainstream social norms and values, or, to simply enjoy being in a closed communal environment in which the wearing of tattoos *is* the norm.

As Braunberger states, echoing the idea of the 'safe haven', for both genders, tattoo conventions promise – and deliver – relief from the alienation they have written upon their bodies' (2000, p. 17). As a result, while the convention began as a meeting point for tattooing professionals, it has subsequently evolved over the decades into more of a vibrant and creative 'fan space' and the site as a meeting point between tattooists and the tattooed. This is because, as Braunberger further elucidates, the environment of the convention is one conducive to the exhibitionist celebration of tattooing, as it is a space in which people are 'free to stare; strangers touch each other as they admire tattoos, they tug clothing away; most wear little to begin with' (2000, p. 16). In this way, as a 'revival' of the sideshow (but without the voyeuristic hucksterism of the 1880s–1920s era), they are an arena in which participants can, in the words of Merleau-Ponty, state, 'I must be my exterior' (2014, p. lxxxvi) with regards to how their tattoo images communicate their status as a tattooed social actor to the other individuals who inhabit the space, and who, as Braunberger suggests, react to this communication as fellow aficionados of the art and the practice.

BEING AT TATTOO CONVENTIONS

While Fenske's research into the convention experience represents one of the more significant studies, I wished to take a similar observational approach within a contemporary British context and attended *The Great British Tattoo Show*, staged at the Crystal Palace in London, *The Annual Scottish Tattoo Convention* held in Edinburgh, and the *Manchester Tattoo Show*, held within Manchester Central, a converted train station in 2015 and 2016. All of these conventions acknowledge in their official programmes a commitment to bring together not only respected tattoo artists from around the world, but also a range of cultural events that (as *The Great British Tattoo Show* guide expressed it, with a clear focus on the 'subcultural' tradition of

tattooing) were motivated by 'a desire to bring together as many elements of the inked lifestyle as possible'. Such a statement serves to again reinforce the 'safe haven' perception of the convention environment but also stresses the intention to provide, albeit for two days, a creative and expressive space in which tattoos can be prominently displayed and images of tattooing, from the 'pop-up' studio to the merchandising vendors and the various staged activities, can potently and evocatively represent and communicate a distinctive tattoo culture.

Akin to Fenske's experience, the entry into a convention is one marked by either displaying a pre-purchased ticket, or paying at the entrance, with access visibly denoted by a wristband that enables one to exit and re-enter the convention space throughout the day (or return for the second day of the event). On entry into *The Great British Tattoo Show*, it immediately became apparent that the demographic for the event was a diverse one in terms of gender and age, with an even distribution of men and women, but also the 'family atmosphere', referred to by Picerno, was evident with regard to the number of attendee couples who had brought their small children to the convention. Again, with reference to Fenske, the physical layout of the space consisted of a mix of food stalls and bar areas, merchandising and clothing stores, and, predominantly, a large number of pop-up tattoo 'studios'. With regards to atmosphere, the 'alternative' ambience of the event was created through distinctive rock music combined with live unplugged sets, bestowing an idiosyncratic and evocative 'festival' spirit to the convention. However, as one would expect, the majority of the convention attendees sported visible tattoos, from the subtle and minimalist, to the much more extensive, with tattoo work consisting of full sleeves, and hand, neck, facial and head designs. Hence, while the idea of the convention representing a striated space is evident by the ways in which the convention is a closed event predicated upon the display and celebration of tattooing culture and the wearing of tattoos, the fusion of the lightly to heavily tattooed attendees suggests that the convention can also be considered to represent a liminal space.

As Zizi Papacharissi states, the concept of liminality indicates events, processes or individuals that exist within an in-between state, a space characterised by ambiguity in which a 'group of liminal actors is characterized by a lack of social markers and an in-between stage of social heterarchy that renders all actors equal, for the time being' (2015, p. 32). Within the context of the convention, its liminal 'heterarchy' is visibly communicated by the differing degrees of tattoos on display, and the differing styles and quality of work that is revealed. As such, the mix of tattoo enthusiasts combines those with few designs to extensively tattooed 'collectors', whose commitment as 'core' tattoo aficionados, argues Katherine Irwin, distinguishes them from more peripheral participants, as she explains,

[o]n the outskirts of the tattoo scene are a group of middle class and largely conventional individuals who see getting tattoos as fun, hip, and trendy ... While these fashion conscious tattooees provide a broad base of support for tattoos within mainstream social groups, they ultimately select the smallest and most innocuous tattoos possible. Their cooption of this once edgy and deviant activity affords them the lowest status within the tattoo world. Avant garde tattooess represent a more revered group within the subculture. Interested in setting themselves apart from hip and trendy circles, avant garde individuals find themselves getting larger, more extreme tattoos ... Elite collectors and tattoo artists rest at the core of the tattoo world. (2007, p. 30)

However, the core can and do elicit negative reactions to their tattoos because they transgress conventional bodily norms, sometimes resulting in obvious staring and comment-making from members of the public, or the heavily tattooed being specifically singled out for attention by airport security staff, or receiving negative responses within service-sector environments such as restaurants and hotels. As such, argues Irwin,

[a]ttesting to the relative nature of appearance norms, negative reactions vary according to many factors, including individuals' ability and willingness to cover their tattoos with clothing, social context, and gender. Many wear long-sleeved shirts and pants before interacting in conventional circles. However, those who have tattooed 'public skin' such as faces, hands, and necks, find themselves unable to escape disdain and disregard. (2007, pp. 37–38)

Nevertheless, within the 'liminal' confines of the convention, the 'core' and 'periphery' freely mingle, indeed, the extent and quality of tattoos varies markedly, from small and discreet designs (displayed within the 'safe haven'), extensive and high quality work, to aged and faded designs, where such judgement (barring, perhaps, positive or negative aesthetic appraisals of particular tattoo designs on open show) is not present and where the core and periphery are liminally 'equal'. In this regard, Sarah Thornton's analysis of dance music club cultures offers distinctive parallels to the convention space, especially in its utilisation of Pierre Bourdieu's concept of 'cultural capital'. For Bourdieu, cultural capital is a process by which individuals, through the acquisition and demonstration of customs and habits and values such as cultural tastes, educational attainment levels or knowledge of the arts or culture, crystallises into a distinctive form of capital that serves to distinguish its possessors from other social groups (Bourdieu, 1984). For Thornton, this process can be identified within the subcultural space of the dance club because of the ways in which such gatherings constitute differing *taste cultures*. As she explains, club 'crowds generally congregate on the basis of their shared taste in music, their consumption of common media and, most importantly, their preference for people with similar tastes to themselves' (1995, p. 3).

Furthermore, club cultures are characterised by cultural hierarchies and distinctions, namely those that separate the 'mainstream' from the more elite 'underground'. As Irwin's research suggests, such a hierarchical distinction is equally evident within tattoo culture, but the 'safe haven' quality of the convention arguably effaces the variations between the peripheral and core groups in its overall celebratory representation of tattooing. However, where the distinction does remain is in the access some attendees have to the more prominent featured tattoo artists.

As Fenske noted of the organisational nature of the convention, the dominant physical presence are the various booths that house the invited artists, and the conventions I visited were no exception. While the conventions are spaces of movement, music and entertainment, the major attractions are the tattoo artists who do not simply appear at the event, but practice their craft there, too. At the London, Edinburgh and Manchester conventions, the roster of artists reflects a global array of talent, featuring, as they did, artists from countries such as, the United Kingdom, Italy, Spain, Poland, France, Belgium, Germany, Turkey, Australia, Taiwan, Thailand, the United States, South Africa and China. In terms of presentation, the booths, or 'pop-up studios' advertise the artist name and/or studio, and offer an array of business cards and portfolios of their tattooing work (in the form of printed images and iPad digital presentations of their work). More importantly, however, on the one hand, the artists offer a range of Flash designs within their booths (which display signs indicating whether they are fully booked or have tattooing time slots available) which can be chosen and tattooed on request by attendees, while on the other, many artists are fully booked for the day as a result of pre-convention communications by clients wishing to be tattooed by those specific artists. Alternatively, as with one woman I spoke with, who had just received an upper-arm design, tattoo ideas can be brought to the convention with the hope that a suitable artist can be located to do the work. As such, at the heart of the tattoo convention experience are the continual acts of tattooing, but with the significant difference that the tattooing becomes a part of the convention spectacle as it is performed publicly. This aspect heightens the nature of the convention as a Becker-style art world because art represents the core of the convention experience in which extensive displays of professional artists' work mingles with the prominent exposure of tattoo designs sported by the majority of the attendees, and the constant 'tattoo tableaus' of clients receiving tattoo designs, from Flash to extensive bodily designs, that give the convention its unique tattoo visualisation. This was an especially significant factor with regard to a Thai tattoo artist at *The Manchester Tattoo Show*, whose traditional hand-poked tattoo method attracted a consistently sizable number of interested onlookers.

The prevalence of live tattooing is especially significant as the practice serves to reveal the 'backstage' working practice of the tattoo artist within a public forum. In this sense, the work of the tattooists within their small temporary 'studios' evokes the social psychological perspective of Erving Goffman. Within his classic text, *The Presentation of Self in Everyday Life* (1959), Goffman explained the key spatial nature of how social actors conducted themselves throughout a variety of situations within the context of their everyday lives. For Goffman, social actors live their lives in what he called a distinctly dramaturgical style because he likened the nature of everyday life to a theatre production in which, like the front and backstage areas, social settings are divided into distinctive 'front' and 'back' regions. As such, the front region refers to the place where a performance is given while conventionally the backstage area is cut off from public view, often physically so that the 'audience' is unable to witness what is occurring. With reference to Goffman's analysis, a social backstage area is commonly physically cut off from public view so that social actors cannot see what is occurring; it is a site in which only professional participants are allowed to enter. While some tattoo studios consist of a single reception/tattooing space, the norm is that clients enter into a clearly demarcated reception stage and wait for the call from the artist to follow them into the 'backstage' studio space where the tattoos are inscribed.

Tattooing within the environment of the convention effaces this spatial divide and visualises the tattoo experience. This is all the more significant in that the backstage area of the tattoo studio also obscures any public view of exposed bodies, however, within the convention studio setting, the clients rest on the single portable table in various degrees of undress (with male and female buttocks not an uncommon sight) to receive their tattoo design(s). Moreover, as clients receive their tattoos, the booths attract a number of spectators who gather to watch particular artists at work, something that the conventional studio precludes, and coming 'to watch the artists' is a significant motivating factor in attending a convention. The public display of tattooing again reinforces the 'safe haven' nature of the convention, in that the recipients of tattoos are uninhibited with regard to their physical status of displayed body (and I saw many clients whose work took many hours) because the audience is not a general public, but fellow tattoo aficionados who are not observing the body, but the skill of the artist and the aesthetic nature of the tattoo design. In this regard, the convention serves as an arena in which a pre-planned and pre-booked tattoo is obtained from a featured artist who may be otherwise inaccessible, or it is the forum for spontaneous tattoo decisions. Similarly, the convention serves as an arena of future tattoo inspiration, as one attendee stated of his motivation to come to the *Manchester Tattoo Show*, he came 'looking for an idea'.

Explaining the nature of convention-inspired tattoos, one of my interviewees, Alex, revealed that one of her favourite designs (out of some twenty tattoos) had been obtained at a convention as the result of a spontaneous decision. While Alex had not visited the convention with the intention of being tattooed, she decided to have a moon design on her thigh to match an existing sun design she had on one of her legs, as she stated, 'I got the moon at a convention. And I went not intending to get tattooed and then I saw it and I was like, "I need to get that one!" [laughs]'. Explaining why she decided to be tattooed, and why that particular design, Alex said,

> [w]ell, I was just walking round and I saw the booth of a tattooer that I followed on Instagram, so we just went over and I was having a look because we were collecting like the cards and stuff they do, and stickers they had, and I was just having a look at his designs and I love, like celestial stuff, and I saw the moon, and it's like the moon with a face and stuff like that, and I just loved it straightaway, and I was like, 'I have to get it, I'm going to have to'. And it was kind of, like, 'I'm booking an appointment. I have to have that one right now'. So that was how it happened, it was literally just 'See it, like it, I'm going to have to get it'. I think after your first few you start thinking that way, like, 'Oh, I like that, I'm just going to get it'.

On the subject of the public display dimension of being tattooed at a convention, Alex's explanation was especially significant as it indicated that any initial feelings of decorum and embarrassment were effaced by the community spirit that animated and characterised the onlookers. As Alex stated on being publically tattooed,

> [i]t really didn't bother me. I think, originally, if that had been at the beginning of the times when I got tattooed I would have been a little bit 'Oh, God, I really don't want to be watched', but I think eventually you just stop caring about it because, obviously, when you're in a really close proximity with someone like that and they're touching you and they're essentially hurting you [laughs], you just stop caring, like, it doesn't really matter anymore. It was quite nice for people to come over and ask about other things that I had, and it was nice to be in a situation, in an area where everyone was there for the same reason, and everyone was there because they liked tattoos. Obviously you have bad experiences where people look at you and they like, tut, and it's like distaste. But there, everybody was there because they like tattoos, so people were asking who did them, and stuff like that. So it was nice to talk to other people because of it.

This belief was reinforced by other convention visitors who similarly articulated the communal and celebratory nature of the convention, as a female attendee stated, 'It's nice to know everyone here likes tattoos and is curious about tattoos'. The primacy of talking about tattoos and seeing tattoos is the

convention's dominant ethos because so many tattoos are on display, from the people receiving tattoos under interested scrutiny of enthusiasts, to the causal bodily exhibition of tattoos presented by many attendees, and, in speaking to a number of first-time convention visitors, the widespread 'exhibitionism' of those being publically tattooed is the most significant first reaction to the convention experience. As one first-time attendee stated of the relaxed bodily environment, 'People are happy to whip their tops off in public!' As such, many people wear clothing, such as vests and shorts, that reveals the upper arms and legs to expose their tattoos or, as was the case with a number of young men, often take off T-shirts to brandish the tattooing inscribed on their upper bodies and backs. Interestingly, a proportion of such exhibitionists also showed stencils that had been applied in readiness for a tattoo to be added when their slot with their chosen artist became free.

In this regard, the unselfconscious 'parading' of tattoos aligns tattoo conventions with the wider art world fan practices of cosplay. While the obvious difference between tattooing conventions and Comic Con-like environments is the issue of permanence, the ethos of both conventions is nevertheless similar. While the cosplay experience is quintessentially one of theatrical creative fandom, that of skilfully creating self-produced costumes to mimic anime characters, superheroes, *Star Wars* characters and other genre figures, the essence of the practice is evident in the tattoo-inspired fandom displayed within tattoo conventions. For example, in explaining the nature of cosplay, Anne Peirson-Smith argues that it constitutes a distinctive conflation of costume and play, whereby the fan-produced costume not only communicates the locus of fandom, but more fundamentally enables the cosplayer to engage in an '"out-of-everyday" social role or activity' (2013, p. 78). Subsequently, as Matthew Hale states of the practice, cosplay is, at its core, inspired by '"the pleasure of playing with code" … and displaying one's commitment to a "particular figure or form" … genre or community of practice' (2014, p. 8). In the view of Osmud Rahman, Liu Wing-Sun and Brittany Hei-man Cheung, cosplay is predicated upon the simulation of genre fandom, but an active exercise in temporary role playing and convention-based performance, in which they utilise 'cosplay as a form of escapism' (2012, p. 333). As stated, while there is a significant difference between temporarily adopting the costume of Iron Man, Batman, Wonder Woman, Wolverine or Harley Quinn and sporting permanent tattoo designs, the issue of the convention serving as a fan space that affords the enclosed 'striated' spatial freedom to express oneself in a visible and ostentatious display of fandom does underscore the fan nature of tattoo conventions. Like the cosplayer, the tattoo convention is a temporary venue in which tattoos can be displayed and celebrated in ways that they may not be able to be shown within environments that still sanction or restrict such displays. Consequently, the tattoo convention is the site for

communal tattoo solidarity and a location for escapism with regard to tattoo celebration and the public revelation of tattoo work. This is especially potent in relation to Hale's idea of the fan convention as a distinctive 'community of practice', a factor that is especially germane to the tattoo convention as it represents a zone for the showing of tattoo designs, and the professional act of tattooing as they bring together aficionados and artists. And while the Comic Con-style experience affords the opportunity to meet genre representatives (to receive autographs and have photo opportunities), the tattoo convention offers its fans not only the chance to meet premier artists and tattoo models, but to also receive examples of their professional practice in the form of a tattoo. However, the issue of escapism is an important one within these 'striated' spaces which offer a free expression of fandom that evades any wider social and cultural censure. As a first-time convention attendee at *The Manchester Tattoo Show* stated, the motivation to attend was fired by a desire to have a tattoo (which she did), observe artists from across the world and to have an enjoyable experience, to 'have a laugh'. But, in noting the relaxed and open bodily display of those being tattooed, she reflected that the convention was especially significant as an environment that was 'accepting of differences', again reiterating the perception of the convention as a 'safe haven' for the tattooed, the wearing of which, in wider social contexts, still may lead to critical judgements.

SHOWCASING THE INKED LIFESTYLE: THE SIDESHOW REDUX

So far I have explored the ways in which the tattoo convention serves as a site of communal tattoo celebration, the uninhibited 'showing off' of tattoo work, and the numerous opportunities to watch live tattooing, but the convention experience also reinforces the 'inked lifestyle' attitude within its organisational and entertainment offerings. While the tattoo competition remains a staple of the convention's entertainment provision (present at all of the conventions that I attended), the representation of tattooing now routinely, and dramatically, has adopted more spectacular and visually arresting (if not provocative) distractions. All of the conventions I visited clearly displayed that Fenske's 'sideshow' aesthetic is a dominant visual and experiential motif, mixing commerce and spectacle throughout the day(s) of the event. While the business core of conventions is represented by the tattoo artists and the tattooing work that they perform, a number of subsidiary vendor stalls are also a significant part of the convention experience, and they take on varied forms. As such, in establishing the 'alternative' spirit of the convention, there are numerous fashion and jewellery stalls that cater towards fashion styles

that range from heavy metal and rock, to retro-themed 1950s and rockabilly designs and vintage looks, or 'curiosity' stalls such as those selling taxidermy items. Alternatively, there are vendors that specialise in tattoo-related products, from the industry-direct sellers of ink pigments and tattoo equipment, to aftercare product sellers and skin repair serum companies that sell products that are marketed to protect and preserve tattoo designs, and tattoo removal providers who do not cater to issues of tattoo regret, but instead offer an 'Erase and Replace' maxim.

However, alongside the retail dimension of the convention are the carnival or 'sideshow' entertainments that are an intrinsic and persistent motif of the convention experience. A staple of the convention is a Master of Ceremonies whose job it is to marshal the attendees towards the stage area to introduce the various entertainers who periodically perform or exhibit themselves, bestowing a distinctive 'carnival barker' quality to the proceedings. Of the carnival style, the *Manchester Tattoo Show* boasted a fortune-teller tent prominently positioned in the centre of the venue that offered attendees tarot readings and palmistry (services which were in constant demand throughout the day), while other events took the form of a body painting competition (precipitating yet another instance of the relaxed air of bodily display as participants were publically daubed wearing next to nothing). Alternatively, the *Scottish Tattoo Convention* held public events as disparate as an onstage wrestling bout, eccentric entertainments such as a 'Best Beard' competition, and, more spectacularly, acts such as Death Do Us Part, a husband-and-wife circus-style knife-throwing act, but one that has been developed into a more extreme and gothic spectacle with the addition of knifes on fire and axe-throwing. In addition to the 'daredevil' onstage performance of Death Do Us Part, their bodily comportment and display, the donning of revealing clothing and the mutual display of extensive tattooing, also signals a further significant liminal dimension to the forms of entertainment that are provided to the convention crowd, whereby the onstage performers reflect the bodily aesthetic of the spectators, a factor that is especially evident in the prevalence of burlesque-style performances that characterise many conventions.

As Kay Siebler (2015) states, the history of burlesque emerged from the nineteenth century vaudeville period of popular entertainment, and its birth was signified by a troupe called the British Blondes which performed in New York in the 1860s. However, burlesque was always much more than simply provocative dancing, as Jacki Wilson states of the British Blondes style of performance, it was a dynamic mixture of dancing, politics and parody, and, crucially, 'scant clothing' (2007, p. 18). While burlesque would ultimately become striptease and fade away for decades, a distinctive cultural revival occurred in the early 1990s, principally associated with the performances of its star attraction, Dita Von Teese. While a cultural form

ultimately based upon women shedding clothing for the entertainment of an audience has ensured that burlesque has become a debated form within feminist discourses, a distinctive post-feminist attitude has become common in relation to neo-burlesque. Indeed, it has been read as a mode of feminist cultural expression. This is, as Siebler argues, because feminist neo-burlesque 'subverts traditional burlesque and striptease in various ways, typically in body modification, body type, and accompanying narrative' (2015, p. 564). Wilson concurs, pointing to the fact that while neo-burlesque performers do not radically deviate from traditionally masculine notions of female 'sexiness', nevertheless, performers routinely play with clichés of sexual representation and playfully mock performative stereotypes associated with the exotic dancer or striptease artist. As such, while neo-burlesque could be argued to reflect a contemporary example of a Mulveyesque 'male gaze' spectacle, the audience context of modern burlesque routinely obviates such a status. For instance, with reference to issues of a sexualised 'male gaze' dimension to neo-burlesque, Claire Nally states that,

> [w]hen female audience members are presented with a thoughtful and complex burlesque performance ... there is a collapse of the strict lines between performer and audience, and therefore we must speculate how far the 'gaze' is a hostile, heterosexual one, or rather, whether there is a sense of celebration, internal interrogation, and identification. (2009, p. 638)

The nature of neo-burlesque, argues Wilson, is predicated upon (as it was for the original British Blondes) the principles of the anarchic and the transgressive in that it seeks to undermine conventional social norms and cultural decorum and transgress routine aesthetic boundaries of bodily expression and presentation. This aspect of burlesque is the dominant motif in its expression within the tattoo convention. While there are some examples of 'conventional' burlesque – in which women remove various items of clothing in response to music (but with nothing approaching nudity in the day events, but the after parties many conventions offer are more adult in theme), the key convention performances fuse burlesque styles and bodily comportment with spectacular embellishments such as sword dancing and acrobatic displays that involve the use of apparatus that are spun while on fire, fire breathing and dramatic displays of pyrotechnics. As Wilson notes, the 'scant' gothic-style outfits the burlesque performers wear could easily fall into a 'male gaze' reading, however the audience for these performances is resolutely mixed in terms of gender, and the commonality between the performer and audience lies in the mutual possession of tattoos and the ways in which such body modification signals a reaction against conventional gender norms, a factor key to the oppositional stance Siebler states is endemic to neo-burlesque.

However, the presentation of 'transgressive bodies' also extends to a key feature of both the London and Manchester conventions: The Alternative Fashion Show. While showcasing non-mainstream niche independent designers, the fashion shows are thematically divided into vintage dress-wear, with designs that are long and flowing in a distinctive 1950s style (many characterised by distinctly 'feminized' floral motifs), with a more dramatic gothic-infused 'fetish' quality. In articulating the essence of fetish wear, Valerie Steele cites the nineteenth-century sexologist Richard von Krafft-Ebing's definition of the form as '"The Association of Lust with the Idea of Certain Portions of the Female Person, or with Certain Articles of Female Attire", a mode of dress that has taken the form of dramatically high-heeled shoes, leather, rubber, "second skins", long, tight skirts, split dresses, zipped bottines' (1996, pp. 11 and 33). All of these items of clothing find expression within the convention fashion show, but with the contemporary articulation of a conflation of the 1990s of gothic and punk fashions that also were representative of radical changes in beauty aesthetics, such as the entry of models within mainstream fashion with piercings and tattoos, and a recognition that the consumption of fetish fashion demonstrated feelings of self-comfort with personal sexuality and sexual empowerment (Hodkinson, 2002; Steele, 1996; O'Donnell, 1999). Again, as with the burlesque performances, the fashion show could be read, especially with regard to the fetish sections, as opportunities for the exercise of the sexualised gaze, but aside from the demographic of the audience, the shows are marked by the presence of male models, who, while typically dressed in T-shirts, jeans and vests and so do not mirror the female fetish-style fashions or degree of bodily display, nevertheless do form a point of solidarity with regard to the fact that every model displays extensive tattoo designs, with many of the male and female models sporting extensive arm and leg sleeves in addition to neck and head designs.

In Thompson's study of gendered tattooing, she argues that heavily tattooed women 'are deviating from gender norms by taking on a "masculine" body adornment and reframing it as "beautiful"' (2015, p. 39), and that 'becoming heavily tattooed is to negotiate this decision within our beauty culture' (2015, p. 49). Yet, regardless of the increasing prevalence of tattooing within the mainstream fashion industry (as discussed in chapter 2), there are no gender judgement issues within the context of the convention because the models mirror the bodily aesthetic of the spectators, and they are figures of celebration and fandom on the part of the audience. For example, following the fashion shows the models enter into a staging area for official photographs that may appear in a subsequent edition of tattoo magazines (both the London and Manchester conventions were organised by the *Skin Deep* tattooing magazine) and as a photo op for attendees to pose with the models and interact with tattoo-related subcultural celebrities. As Irwin states in relation to tattoo magazine 'cover girls' who appear at conventions, as with 'sightings of film and television

celebrities ... encounters with cover girls produce some excitement within the tattoo world' (2007, p. 48), as was the case at *The Great British Tattoo Show* in which the cover model, Gemma Kahlua conducted a signing of her featured section within the magazine. As such, the heavily tattooed bodies of the models find a perfect reception and celebration within the 'safe haven' of the convention, in which their bodily aesthetic is one that is commonplace throughout the convention space.

THE CONVENTION AS THE LOCUS OF AUTHENTICITY AND THE CONTEMPORARY CARNIVALESQUE

In speaking of the nature of the art world, Becker stresses the crucial interaction that must occur between the artist and a spectator. As Becker states of the process of making art,

> [s]omeone must respond to the work once it is done, have an emotional or intellectual reaction to it, 'see something in it', appreciate it ... we are interested in the event which consists of a work being made *and* appreciate; for that to happen, the activity of response and appreciation must occur. (2008, p. 4)

Within the context of the tattoo studio, this relationship is restricted to the client who receives the tattoo design(s), and those who subsequently see the work, either personally or via the artist's portfolio, but the tattoo convention puts this process into a public forum by which the tattoo work is observed and appreciated by a constant crowd of sympathetic and interested onlookers who are motivated to attend the convention by the opportunity it affords them to 'watch the artists'. Consequently, the tattoo convention, from the live tattooing to the various sideshow-style entertainments and bodily displays, not only is akin to the classic circus or carnival, as Fenske contends, but also evokes the ethos of Mikhail Bakhtin's conception of the carnivalesque, based upon historical cultures that periodically engaged in practices of exaggeration, hyperbolism and excessiveness, in cyclic instances of 'utopian freedom' that stand in opposition to officialdom and which represent a 'ludic reprieve from the seriousness of everyday life' (Halnon, 2004, p. 747). In exploring the nature of the carnival as a popular 'festive form' of the ancient and Renaissance worlds, the 'carnivalesque' has survived within periods of popular or 'folk merriment', as Bakhtin describes,

> [t]he carnivalesque crowd in the marketplace or in the streets is not merely a crowd. It is the people as a whole, but organized *in their own way*, the way of the people. It is outside of and contrary to all existing forms of the coercive

socioeconomic and political organization, which is suspended for the time of the festivity. (1984, p. 255)

Within the striated and liminal enclosed setting of the tattoo convention, a sense of bodily freedom is evident, as is the free and open display of bodies, both on the stage in the form of tattooed models and burlesque performers, and the bodies of the tattooed. In terms of the latter group, Bakhtin spoke of the status and centrality of the material bodily level and its associated bodily phenomena, what he dubbed the 'grotesque body', the 'body in the act of becoming. It is never finished, never completed; it is continually built, created, and builds and creates another body' (1984, p. 317). With regard to bodily transgression, this involves the fluids and products of the body, and more precisely the bodily 'elimination' of wastes and fluids, that which leads 'into the body's depths' because the 'grotesque image displays not only the outward but also the inner features of the body: blood, bowels, heart and other organs. The outward and inward features are often merged into one' (1984, p. 318). While not as graphically dramatic as Bakhtin's bodily litany, the tattoo convention does present bodily fluids and the exposure of the internal (albeit within the artists' hygienic control) as the needle punctures the skins of the many individuals who obtain tattoos, and is seen throughout the venue in the aftermath as the recipients wander the convention with their cling film wrapped designs which display the bodily fluids that ensue post-tattoo.

Fenske's derogation of the convention as an enclosed, exclusive and striated space is also useful with regards to perceiving the convention from a phenomenological and Heideggerian perspective. This is because the convention is a space in which tattooing becomes, for most of the attendees, the primary identifier, a visible and celebrated aspect of personal Dasein, of intrinsic Being. While Heidegger refers to the principle of 'falling' as a movement away from a state of authenticity – an absorption into the world of the 'They', the convention offers an alternative vision – a 'fall' into a tattooed world and a temporary state of 'inked authenticity' because the 'They' within this context is as equally (and frequently more so) tattooed. As Heidegger declares of the nature of authentic existence, it 'is not something which floats above falling everydayness; existentially, it is only a modified way in which such everydayness is seized upon' (1962, p. 224). As such, within the tattoo convention, the wearing of tattoos, from the level of the peripheral to the core, is a state that is 'seized upon' by attendees, it is an environment in which one's tattooed sense of being is naturalised because, as an attendee stated, the convention is a venue characterised by the 'accepting of differences'.

In the context of the tattoo convention, a Dasein's sense of Being-with-Others is reinforced, and any negative reactions that may be directed towards an individual's tattooed sense of 'Being' is negated, and can erase any sense

of anxiety associated with the overt revealing of tattoos, especially as reactions to them will be non-judgemental. As Heidegger states of the feeling of anxiety, in 'anxiety one feels "uncanny" ... 'uncanniness' also means 'not-being-at-home', but the 'others' within the tattoo convention reinforce a sense of bodily solidarity, a shared celebration of having tattoos and being tattooed. In this manner, while Heidegger maintained that the intelligibility of Being-in-the-world is expressed as a discourse that is communicated through language, through which 'we articulate significantly the intelligibility of Being-in-the-world' (1962, p. 204), such discourses are communicated in a semiotic fashion via tattooed skin within the convention to say no more than that tattoos are an important facet of that person's sense of 'Being'.

Therefore, it is little wonder that the tattoo convention, with its carnivalesque sights and sounds, its unabashed display of bodies, and its celebration of the art of tattooing is considered to be such a 'safe haven' and have such an important global presence and significance for those who follow the 'inked lifestyle'.

Tattoo Culture

Transformation, Being and Time

In defining the nature of contemporary tattooing, Hesselt van Dinter opines that a tattoo 'is a consciously applied decoration that, like any other artwork, is a product of the human spirit' (2005, p. 15). Such spirit is much in evidence as it is argued that there has never been a period in human history in which so many people bear tattoos, with some one in four people having tattoos in the United States (Friedman, 2015) and one in five adults bearing tattoos in the United Kingdom (Proud, 2015). Furthermore, of these 'inked' individuals, it is estimated that some twenty-two per cent of tattooed Americans and fourteen per cent in Britain regret getting tattooed (Jordan, 2015). What such statistics suggest is that relatively few people who acquire tattoos are sorry that they did so, and even for those who do express regret, the reactions that they have to their designs is not necessarily one of shame or distress based upon a desire to regain their unblemished skin (although some people obviously do), but rather to engage with new artists, acquire more expensive and, more importantly, higher quality work, and so 'upgrade' their refined and transformed sense of being. Therefore, as Fruh and Thomas state of this phenomenologically inspired nature of tattooing, they have the power to visually and symbolically fix 'a point through past, present, and future' (2012, p. 91). But, while the ingrained perception of tattoos is that they are permanent markings in the skin, Albert Parry reminds us that this view has always been a misconception, although the removal process has never been an easy option or a pain free experience – it's far from it.

THE UNBEARABLE DESIGNS OF BEING

Within *Tattoo: Secrets of a Strange Art*, Parry cites the case of James Scanlon, a man who was arrested by police on the charge of attempted suicide in

Pennsylvania in 1923 following the amputation of his left arm by a loco-
motive, the result of him laying it across the train track. When questioned,
Scanlon denied that he sought to commit suicide, explaining that he wanted to
lose his arm in order to be freed from the various tattoo images that adorned
it, and that he wished his arm to be cut off 'because he "got tired" looking
at the tattoos' (2006, p. 148). However, Parry points out that Scanlon could
have found a much less dramatic and injurious solution as methods of tattoo
removal are almost as old as the practice of tattooing itself. Indeed, one of the
first recorded instances of the performance of a tattoo removal procedure was
that of Aetius, a Greek physician who employed the technique of salabrasion
in 543 BCE, which consisted of scraping the tattooed skin with salt and gauze
(Burris and Kim, 2007). Later, as Parry notes, alternative traditional methods
included 'folk' remedies that ranged from the use of vinegar, stale urine, gar-
lic, pepper and lime and pigeon excrement, to the more direct (and success-
ful) practice of burning tattoo designs with a red-hot iron, replacing the ink
with a livid, but seemingly preferable, scar (especially if the tattooed subject
was a criminal or slave whose design acted as a stigmatising permanent sign).

 As tattooing flourished in the late nineteenth century and into the early
twentieth century, more chemically based methods were developed by derma-
tologists, who injected glycerole of papoid and tannic acid into tattoo designs
to dissolve them from within. Even tattoo artists began to develop removal
techniques, in which their needle work represented 'repeating the tattooing
process in the reverse'. (2006, p. 144) However, as Parry records, not all such
'dual practitioners' were successful in their experiments, as evidenced by
Sailor Joe Van Hart, whose 'white substance' succeeded in removing tattoo
designs, but was powerless to halt their visible return within the skin some
one year later. But, as the twentieth century progressed, an array of methods
and chemicals were brought to bear upon offending tattoo designs, such as,
monchloracetic acid, carbolic acid, sulphuric acid, zinc chloride, zonite, dry
ice, electrolysis, surgical scraping and surgical removal. However, in survey-
ing the range of removal procedures that contemporary industry offers, skin
care clinics still includes similar methods, from imiquimod removal creams
that may reduce the appearance of tattoo designs, – dermabrasion tattoo
removal, which removes skin layers over a design through the use of an abra-
sive device, salabrasion, which uses salt and water in concert with abrasive
technology, acids to peel and burn layers of the skin, and cryosurgery, in
which tattooed skin is frozen and the dead skin is removed through abrasion
techniques.

 With regard to the motivations for people to seek such extreme measures to
remove their tattoos in the 'classic era' of tattooing, Parry divided such indi-
viduals into two distinctive categories: military deserters and criminals who
sought to remove identifying tattoos that could lead to their arrest, and the

wider demographic of those whose had reached a certain age that made them 'ashamed of their youthful tattoo-marks' (2006, p. 148). This was especially the case in which tattoos acquired in youth took the form of offensive or sexually obscene images. In examining more contemporary attitudes to tattoo removal, researchers have posited reported reasons such as poor tattoo design choice and changes to one's sense of self through maturation (Wollina and Köstler, 2007). Similarly, Armstrong et al. stated reasons that included embarrassment, the lowering of body image self-perception, having to constantly hide tattoos because of careers, social stigma, negative comments from family and friends and having designs that were not the product of much consideration and time. As such,

[t]he purposes cited for the tattoos included impulsive decision making, 'to be part of a group', 'just wanted one', and 'for the heck of it'. While the tattoos were acquired for internal expectations of self-identity at an early age, tattoo removal also seemed to be internally motivated to dissociate from the past and to improve self-identity. (2008, p. 880)

As Grognard (1994) concurs, the urge to remove tattoos is habitually connected with progressive changes within the self, whereby tattoos can become psychologically damaging, personally embarrassing or serve as blocks to employment or career advancement. In terms of personal maturity, tattoos such as band logos and imagery and song lyrics, images and lettering that once evocatively spoke to a late teenage self, can be found to be personally irrelevant to the older self (indeed, affiliation with the music may long since have past). As such, while such images may serve an affective function that nostalgically evokes the past and its cultural passions, it may serve to erroneously demarcate the wearer as a 'fan' to observers. On the other hand, images of the past such as the names of ex-partners or extreme political symbols can become highly problematic in later life and to new relationships and professional and personal life chances as they represent outward signs of a no longer relevant identity. Alternatively, the very nature of a normalised tattoo culture that is inherently expressed within popular culture also produces motivations to seek tattoo removal. For instance, the popularity of distinctive tattoo genres and tattoo fashions cause problems once the trends have run their course. For example, older tattoo styles such as Tribal, Celtic armbands, Kanji symbols and lower-back designs (that garnered the unflattering designator of 'Tramp-Stamps') now represent dated and defunct genres that are considered to be deeply unfashionable, but which cannot be removed and discarded in the same manner as suddenly obsolete clothing styles can be. As such, these types of designs are now considered to be clichés that have little artistic value (although they may retain them for the wearer, of

course). Moreover, it is entirely feasible that the newer tattooing trends, from Roman Numerals, Arrows, Script Lettering, Bird Silhouettes and Skylines, will share the same artistic fate at some future point. Indeed, as a *Tattoodo* article entitled, 'Cliché Tattoos Like "This Too Shall Pass" and Many Others', suggests, this process has already begun in relation to the proliferation of Infinity Symbol tattoos, and life-affirming mottos and symbols such as 'This Too Shall Pass', 'Just Breathe', 'Always', 'Only God can judge me', and the delicate anchor wrapped around the words: 'I refuse to sink'.

While surgical and dermabrasive techniques are still available, the more commonly used contemporary method of tattoo removal is laser treatment. As Kent and Graber (2012) argue, the invention of the electric tattooing machine, in replacing the slow and limited hand-produced form of tattooing, ultimately made the art of tattooing more affordable and accessible to a greater number. However, similar revolutions in laser technology established a means by which the work of the tattoo machine could be effectively 'undone'. Utilising a synthetic ruby crystal, the first laser was created in 1960 and rapidly became adopted as a medical technology as it was discovered that lasers could be used to break down the chromophore part of a molecule, the section which gives the molecule its color. Consequently, from the 1960s new generations in laser technologies in the form of Q-Switched ruby laser and the QS Nd: YAG became the standard laser treatments for tattoo removal. In terms of how such technologies removed tattoo ink pigments, Kent and Graber explain that,

> [w]hen laser light reaches the skin, the tissue transmits, reflects, absorbs, or scatters the energy. Different chromophores in the skin, such as melanin, water, oxyhemoglobin, and exogenous pigment, each preferentially absorbs particular wavelengths of light. Laser light energy absorbed by a target chromophore is converted primarily to heat, destroying the chromophore itself and the surrounding cell. The heat created at the site of the chromophore may dissipate to surrounding structures, causing their destruction. (2012, p. 3)

However, while Q-Switched laser technologies have been the standard tattoo removal method for decades, newer systems such as Picosecond lasers have been developed which are proving to be even more effective because the shorter 'pulse durations produced by Picoseconds cause the target to heat and expand more rapidly than QS lasers, resulting in more substantial locally destructive forces' (2012, p. 9). And since the publication of Kent and Graber's work, Picosecond lasers have indeed become far more prevalent within tattoo removal. As Torbeck, Bankowski, Sarah Henize and Saedi (2016) illustrate within their technological and medical evaluation of Picosecond lasers, they have proven themselves to be capable of producing more effective tattoo pigment clearance than QS lasers and, most importantly, they require fewer laser treatment sessions to remove unwanted or offending tattoo designs.

Nevertheless, such advances in ever more sophisticated and effective and rapid laser removal technologies do not signify that tattoo removal is not an onerous (and painful) undertaking. As Picerno observes, tattoo removal, depending on the size of the design, an expensive 'pay-per-session' process that, ironically, works best with lower quality or amateur tattoos because 'badly executed tattoos are often easier to remove, as the ink has not penetrated too deeply into the dermis, while more accomplished work (and certain bright pigments) can require more treatments' (2011, p. 19). The financial costs of removal procedures are therefore dependent on the size and quality of the design and many designs will invariably require multiple session, meaning that treatments can range from hundreds to thousands of pounds, a cost in terms of money, but also time, that will invariably exceed that invested in the original tattoo experience. Moreover, tattoo removal is a periodic process as each treatment requires healing periods of some several weeks before the next can be undertaken, so the progression towards complete removal is a protracted one for major tattoo designs (although Picosecond lasers are reducing the number of sessions). On the one hand, then, removal techniques such as laser treatment may not be readily available to all of the social actors who may wish to remove designs, for example, in the United Kingdom tattoo laser treatment can be performed with funding by the National Health Service only if the tattoo designs are judged to be causing acute psychological distress to the wearer, which must be supported through medical evidence to qualify for funding (healthcentre.org.uk). But on the other hand, the desire to remove tattoo designs is not exclusively related to an urge to be without tattoos, but rather, it is motivated by a wish to ensure that tattoos continue to reflect a personal sense of identity, but one that is marked by changes in an individual's sense of being. At one level, this can be prosaic in that the individual's sense of the aesthetic has progressively developed, and is therefore motivated by the desire to remove poor quality work or ill-conceived concepts which are subsequently replaced with new designs that reflect current conceptions of 'Being'. This perception was evident within interviews with tattooed social actors, such as the previously mentioned mature student, Jason, whose tattoos acquired in his youth had lost their lustre and personal resonance. As he stated in relation to his decision to begin getting tattooed in his late teens,

> I always think that I would get tattoos again, certainly, I would get loads of tattoos, but I probably wouldn't get the same ones. So it's never a regret of having a tattoo … I'd love to have a fresh start, you can't rub them out, you know? So, it's not a regret of 'Oh, what was I thinking', it's more like 'I wish I had that space back'.

This sentiment was also expressed by one of the tattoo artists I interviewed – who, while taking pride in his own work and artistic progression, regarded

much of his own tattoo designs as being poor quality due to the young age at which he acquired them – that the aim was simply to be tattooed without any real conceptual, symbolic or artistic goal in mind. But of course, the lament of 'I wish I had that space back' can, if in possession of the requisite financial resources, be fulfilled through removal techniques, and this response suggests that the desire to remove tattoos is not simply one of later regret, or that tattoos stand as impediments to employment or acceptability within familial or other social groups.

For example, laser removal advertising is prevalent within leading tattoo magazines, frequently leading with the strapline 'erase and replace' (or sometimes something a little more suggestive, such as one advert within *Skin Deep* that reads: 'Would you like to get em off?'), illustrating the extent to which removal often does not signify an individual seeking to break away from tattoo culture, but rather affords the opportunity for social actors to remove existing designs in order to replace them with new ones that better reflect the social actor's contemporary sense of self, or replace poor quality work or misjudged design choices with better quality work from more gifted tattoo artists. While laser treatment was uncommon within the sample of tattooed people I interviewed, I did find instances of it, and it was to enhance the aesthetic appeal of later tattoos (in this case, a female respondent, it was done to remove a visible chest piece that was a poorer quality early tattoo), and not undertaken as a rejection of tattooing and as an expression of regret. And with the motivation to remove tattoos being linked to a desire for better quality work, there are alternatives to removal procedures that can 'erase and replace' in a far more direct manner, and at much less cost – the cover-up tattoo.

As with tattoo removal techniques, it is no surprise to note that the art of the cover-up is not a new practice, although it doesn't quite have the same historical lineage as dermasbrasion. As Parry reveals in his history of tattooing, the early twentieth century witnessed a tattooing-based alternative to undergoing the (potentially unsuccessful) ordeal of crude removal techniques to mask offending images, and that was in the form of what Parry calls the 'surcharge' – the tattooing of a new design upon the old. However, such an enterprise required skill on the part of the artist, in that the,

> [s]urchargers must know their designs and colors. They must know that birds of rich plumage and willow-trees of luxuriant growth are the best designs to cover other designs grown objectionable. They must remember that a black design will eventually show through a red surcharge. (2006, p. 149)

Within contemporary tattoo culture, the practice of cover-ups has been popularised within Reality TV shows such as the US show, *Tattoo Nightmares*, but more controversially, the British series, *Tattoo Fixers*. First broadcast

in 2015, *Tattoo Fixers* is premised upon its tagline: 'Three of the UK's best tattoo artists take on clients in their London pop-up parlour in an attempt to change some of Britain's worst tattoos into walking works of art'. The three artists, Jay Hutton, Alice Perrin (replacing Louisa Hopper in season 2) and Steven Porter/Sketch, meet a number of clients requesting a cover-up tattoo and competitively design and propose their tattoo idea to the client who chooses between the three, with the winning design then being shown getting tattooed over the original image. As such, each episode contains a number of clients and so showcases an array of tattooing work performed by each artist. In addition to the tattooing, the series features the clients telling their stories (sometimes accompanied with exaggerated acted sequences to recreate the circumstances of the original tattoo). However, unlike tattoo-based television shows such as *Miami Ink*, *Tattoo Fixers* is replete with tales of peer-influenced 'bet' tattoos, jokes, nicknames and crude sexualised (and often obscene) designs. As such, *Tattoo Fixers* centrally deals with tattoo regrets and the desire to undo tattoo work that no longer fits the person as their lives have changed. Moreover, in addition to possessing tattoos that are simply poor examples of the art (and there are many cases of 'scratcher' work – usually the result of friends obtaining a tattoo gun and inscribing crude 'doodles'), many clients feel that their designs are major life mistakes and need new designs that reflect their current more mature sense of being, especially when they have become parents and they bear sexual images that were the result of peer-influenced youthful irresponsibility (with dubiously themed tattoos acquired on riotous package holidays in Magaluf being a series leitmotif). Consequently, each client experiences a 'transformative' and emotional moment in which their offending (and often offensive) tattoos have been replaced with designs that are aesthetically effective and which better reflect tattooing as an art form. Accordingly, the cover-up negates the perception of permanence that has been immanent within the practice, and enables social actors to 'update' their bodily 'scrapbook' and visually communicate new perceptions of self.

However, while *Tattoo Fixers* has proven to be a success as a television series, it has faced adverse reactions from the professional tattooing industry, from the charges that much of the work produced by the onscreen artists does not showcase 'the best' of British tattoo art, to the seemingly unhygienic practices that ostensibly occur. Within a *GQ* feature on the show that stressed the negative reactions the series has garnered within the tattoo industry, Ailis Brennan (2016) states that the series has been charged with misrepresenting contemporary tattooing practice, with British artists such as Kevin Paul (who has tattooed Harry Styles and Ed Sheeran) arguing that *Tattoo Fixers* does not show the high skill level that is required to produce an effective and enduring cover-up, that they are a form of tattooing that should only be practiced

by highly experienced artists. Indeed, the ire of the British tattooing indus-
try is such that a hashtag entitled '#F***TattooFixers' not only was widely
spread through social media, but became emblazoned on a T-shirt range
that was widely featured by artists at various British tattoo conventions.
Unsurprisingly, this negative attitude was expressed within my interviews
with tattoo artists. At one level, this was based upon the skill factor raised by
critics, that some requests for cover-up designs are not straightforward, and
not always fully necessary. As one artist stated of her experience with cover-
up tattoo requests,

> I think with cover-ups, people just want to put something completely different
> on top and it just doesn't work out as well. And sometimes what they've got
> they think it's a lot worse than what it is and you can actually do something
> mint with it.

Alternatively, other artists felt that tonal style of *Tattoo Fixers* worked
towards resurrecting the negative perceptions of tattooing and stereotyped
motivations of people to be tattooed – that getting tattoos are spontaneous and
irresponsible bodily acts that are casually undertaken with no foresight to the
future and little regard for artistic merit: that, to evoke the words of Grognard,
tattoos are not graffiti for the soul, but just crass graffiti on the body. This
criticism stemmed from the view that the series exclusively focuses upon the
sensational, grotesque and the outrageously humorous, with little to no focus
on people who seek cover-ups simply due to older work that has naturally
become outdated in relation to their identity or poorer quality work that is
personally unartistic and irrelevant rather than being lurid and offensively
embarrassing. As one artist stated in this vein of the series,

> [i]t's not showing tattooing in the right light ... For the general public to engage,
> it's got to have that novelty factor ... picking the worst ones or the funny ones.
> The focus is on the bad tattoo as there is little attention given to the cover-up.

Nonetheless, regardless of the critical nature of TV productions such as
Tattoo Fixers, it does mitigate against taking an overly romantic view of
tattooing as a complete art world as people *do* make bad design choices.
Many people have and *do* obtain tattoos in a causal and maverick fashion
as a permanent souvenir when under the influence of alcohol or particularly
influential peers on a particularly boisterous holiday. Individuals *do* split up
from partners whose names are etched upon their skin as once romantic dec-
larations of love, but which prove problematic when new relationships are
formed, and people *do* get tattoos of offensive sexualised imagery or extreme
political symbols which may haunt them in later life. So, while many inked
indiscretions may always keep their 'joke' status and act as symbols of a past

self, some can cause acute psychological damage (reflecting the reluctance artists expressed in tattooing faces – designs that can have radically damaging social effects). In this sense, tattooing itself can be seen as a journey, and one in which the recognition of the artistry that can be achieved through tattooing is only gradually recognised. For instance, in evaluating his extensive tattoo collection, an interviewee, Jonathan, clearly divided his tattoos into two distinctive groups – those he obtained from the age of eighteen into his early twenties, which were motivated simply to have tattoos, and those from his mid-twenties, which were imbued with distinctive symbolic personal values. As he explained, this shift in perception occurred: 'When I got older, when I got more wise to tattoos, when I came into my own style, my own reasons for getting them', and some early designs were accordingly covered-up with distinctively personalised and aesthetically richer designs.

Therefore, while tattoos are designed to rest permanently within the skin, this is changeable, and increasingly culturally perceptible. For example, just as celebrity culture has played a significant role in the popularising of tattoos, celebrities have also increasingly communicated their inked mistakes and dealt with them through laser removal and cover-ups, with celebrities removing ex-partners names, such as, Johnny Depp, Angelina Jolie, Eva Longoria, Heidi Klum, Kaley Cuoco and the celebrity tattoo artist, Kat Von D. Alternatively, a number of prominent celebrities have had tattoos removed that they acquired years earlier and which have outlived their personalised symbolism, as has been the case with Drew Barrymore, Mark Walhberg, Kelly Osbourne, Pamela Anderson and Pharrell Williams. And so, for the tattooed general public and inked celebrities alike, tattoos are not necessarily forever, and outmoded designs can be removed or be obscured and revitalised with new body art.

TATTOOS: EXISTENTIAL ARMOUR

In Grognard's view, the wish to remove tattoos is tied to changing personal conditions and statuses, but the removal process can still have a symbolic value even if the image has been erased. Hence, even if the removal process leaves traces in the form of scarring, this can have a symbolic value and does not serve as 'a humiliating mark at all. On the contrary ... [it] provides a lasting souvenir, so that the tattoo is never really negated' (1994, p. 129). In this sense, even poor artistic work or symbols of a life that is no longer pertinent, can still retain a positive 'anchoring' effect, a memorial scar or mark that signifies a moment in life never to be forgotten. And this is even more pronounced with the cover-up design, because, as Fenske points out, when a new tattoo design is inscribed over another 'the memory of the first tattoo remains

in the form of the subsequent tattoo – both shaping the newer image as well as lurking in its shadows' (2007b, p. 154). So, the tattoo remains a symbolically transformative experience; it is a process that activates memories, even if the tattoo is removed or covered with an alternative image, it still can speak to the person's altered sense of self and identity.

In evaluating the status and function of tattoos, Atkinson argues that they can represent 'a signifier of a new life trajectory, a fresh beginning for the person' (2003a), that tattoos (although not always, as *Tattoo Fixers* graphically illustrates) can have a profound symbolic value and communicative function, either to the wider world, or simply to the person who wears the design. It is in this sense, then, that tattoos arguably resonates with a phenomenological worldview. As Peter Sloterdijk within his first volume of *Bubbles*, states, the contemporary world is one of multiple messages that consists of a panoply of mediums such as media, electronically transmitted messages, multiple channels and a myriad of languages that are all united in the drive to produce an 'intimate ability to communicate' (2011, p. 41). Yet, this is precisely the nature of the tattoo at the micro-social, individual level. At one level, the 'confessional' tattoo-themed television series such as *Miami Ink*, and its various tattoo-themed offshoots, have potentially made the tattoo into a symbolic cliché – that all designs *must* have a deep personal meaning and significance, but tattoo literature and many of social actors I interviewed, point to the fact that the artistic potential and dominance of custom-designed art has enabled individuals to symbolically express themselves. Such expressions can range from profound personal transformations (such as the mature design student whose ornate full sleeve obtained at the age of twenty-six to visually represent and mark the age that he came out as a gay man) or can be no more symbolically philosophical than the expression through ink of a personal fandom of the music of Biffy Clyro.

The phenomenological perspective, as Berger and Luckmann point out, is predicated upon the view that social actors can gain access to another social actor's subjectivity through 'the human production of signs' (1991, p. 50). As discussed within chapter 4, a number of instances of this process being consciously literalised were cited, with an especial focus on those who selected tattoos that reflected not only their personalised interests, but the essence of their university education and their ultimate employment trajectory within the creative industries. Such a self-perception, and motivation for being tattooed, reflects Merleau-Ponty's appraisal of the nature of phenomenology as a body of thought that is concerned with essences, but more fundamentally, the essence of perception, or 'the study of the *appearance* of being to consciousness' (2014, p. 62). As Falkenstern (2012) argues in relation to the phenomenology of Merleau-Ponty, tattoos, even if the subject of later regret or a jaded view of their aesthetics, can act as visual symbols of self, as inscribed

'mementos' of an individual's past. However, the primacy of appearance and consciousness was a factor that was expressed within interviews with social actors. For example, Louis, a Fashion student, (stated in relation to his eleven tattoos) that the significance of being tattooed is that 'you get to show your expressive side'. The importance of this perception is that of the ability to communicate intrinsic aspects of the self visually. This was articulated in great detail by Tom, who wears a self-designed lower arm sleeve that keenly evokes his film and theatrical-based education with its fusion of script, a vintage sound recorder, film reel, clapperboard and stage lights. As a Film and Television Production undergraduate, Tom stated that the design was such because, 'I wanted something that reflects what I do quite a lot in my day-to-day life, and it pretty much is my life'. The idea of essence, consciousness and appearance is endemic to Tom's design as it is a visual communicator of his personality and future aspiration, and a design that he enjoys revealing as often as possible because of the tattoo's ability to reveal his sense of self in lieu of any verbal articulation, but rather, in a semiotic form. As he explained,

[i]t's good for people who don't really necessarily have to speak to me can just look at that and go: 'He does something to do with film, or he likes film, or he's a creative person'. And I think that's the good thing about tattoos, like, you can tell a lot about a person with just what they've got on their skin. And I think that's the beauty of them. That they are a piece of art and I think a lot of people should be more open to getting them. Not everyone's up for them and not the biggest a fan of them, but I think they're just such a great way of expressing, because it's alright me talking to someone saying 'Oh, I love film, I love this', but to actually say that, they're just words, but to actually put ink to skin knowing that it's going to be there for life is a big statement to do.

For Tom, then (as for many of the tattooed social actors I interviewed), tattoos possess this symbolic ability to communicate a key aspect of a personal essence, to enunciate visually fundamental aspects of their sense of Being/Dasein and to express their Being-in-the-World and Being-one's-Self. Moreover, Tom's view that deciding to express one's sense of self in this manner is 'a big statement to do' stresses the ways in which tattooing remains a significant bodily act, regardless of how 'normalized' tattooing purportedly is. In this sense, tattooing is now commonly seen within popular culture, and especially within celebrity culture, and in high-profile areas such as advertising. For example, while Johnny Depp's extensive tattoo collection is routinely obscured within his film work, his designs are prominently featured within his advertising for the Dior fragrance, Sauvage; Ruby Rose's tattoos are key visual cues within her Urban Decay, Ralph Lauren and Maybelline brand endorsement images, and Cara Delevingne's designs are present in Chanel, TAG Heuer and DKNY campaigns. Furthermore, David Beckham's extensive

tattoos have now become a primary component of his public persona, and are fully exhibited within his advertising work for H&M, Belstaff, Breitling and Haig Club whiskey. More potently, however, his bodily inscriptions are at the heart of in his 2016 film for UNICEF, which features his tattoos 'coming to life' in a series of animations that graphically communicate a powerful message about the ways in which violence towards children affects them throughout the entirety of their lives. What is more, these examples stand within the myriad of communications, from celebrity magazines to celebrity-based websites and social media platforms that now routinely and visually convey a rich array of celebrity tattoo work, from the extensive designs of Justin Bieber, Adam Levine, Rihanna or Angelina Jolie, to the minimalist designs of Kendall and Kylie Jenner, Bella Thorne, Selena Gomez, Maisie Williams, Ariana Grande and Jennifer Lawrence.

In the view of McComb (2015), the increasing visibility of tattoos within mainstream fashion and celebrity has played a major role within the contemporary mainstreaming of tattooing, a factor that divided opinions within the sample I interviewed. On the one hand, some respondents felt that celebrities bearing tattoos, especially those from pop music, fashion, or Reality TV, are sanitising tattooing and reducing it to a fashion trend and potentially undermining its history and status as an alternative bodily practice. This view was particularly acute with regard to fans copying celebrity tattoo designs and affecting the perception of the tattoo as an expression of the personal self. But on the other hand, whilst cautious of celebrity-created 'fad' designs (e.g. Cheryl Cole's much-copied hand design) other respondents viewed the preponderance of tattooed celebrities as the creation of distinctive and influential tattoo 'role models', whose visibility has played an important part in the greater widespread acceptance of tattooing, overcoming barriers to employment and decisively moving social and cultural perceptions of tattooing away from any residual 'deviant' past associations.

As a result, celebrity, fashion, sports, and Reality TV have contributed towards giving tattooing a level of cultural representation that is unprecedented within the history of tattooing (for instance the television network, tru TV, the broadcaster of *Ink Master*, even advertises itself with the tagline: 'Where tattoos live'). Therefore, tattoos may well have lost their 'outsider' quality and now represent, in Heideggerian terms, a badge of inauthenticity and the stamp of the cultural 'They'. In Watts' view, even the 'rebellious' tattoos of the past invariably reflected the dictates of the peer-group or gang, negating them as signs of otherness, and this may now be more relevant than ever, as Watts states,

[i]n falling one drifts along with the fads and trends of the crowd, oblivious that one's own being is an issue. Caught up in the mindless busy-ness, lulled by

feeling that everyone else is doing the same, Dasein becomes blind to all its possibilities, and tranquilizes itself with that which is merely 'actual'. (2011, pp. 56–57)

In tattooing circles, this perception has been iterated by the ironic tattoo artist, Lyle Tuttle. While Tuttle is famous for tattooing Janis Joplin, he has recently stated that tattooing now represents 'a trend and a fad, and trends and fads end', and offers the following advice to those considering getting a tattoo to express their individuality: 'Don't get one, and stay unique' (Xavier, 2016, tattoodo.com). As such, given the seemingly ubiquitous expression of the self through tattooing, the path to authenticity may well now be tattoo-free skin.

Yet, while the cultural visibility of tattoos, and the varied array of people who now sport them, may have proliferated – from the Baristas in Starbucks, the models on the fashion runway and in the pages of *Vogue*, to the celebrity-status enjoyed by many tattoo artists – the act of tattooing is not an insignificant one. At a fundamental level, whether a person gets the inside of their lower lip tattooed simply because Kendall Jenner has a tattoo in that particular body part, receives an ill-considered and crudely designed tattoo as a holiday drinking-game forfeit, or obtains a deeply personal custom piece that has been produced by the finest artist within that genre, the act of receiving a tattoo is transformative. At the physical level, from lesser to greater degrees, every tattoo unites its wearer in pain, the bodily factor that represents the 'necessary evil' of obtaining tattoos (Rimmer, 2016), complemented by the residual pain and discomfort of the healing process and the final outcome: an image that is inscribed *within* the skin. Consequently, a tattoo changes one's sense of being as it is an addition to the body that becomes a part of the body. In some instances this may be minor – a small image that is seen only by the wearer, or sometimes even almost forgotten by the wearer if located on a part of the body that is not routinely observed, but in many cases tattoos are significant additions to the body, and the ink is consciously interwoven with personalised symbolism and semiotic relevance: that tattoo designs 'speak' of the wearer's sense of self. Within the qualitative interviews, this ranged from a love of the tattoo process to intricate and well-considered custom designs that reflect personal and professional aspirations.

This was a key rationale for the respondent group that I principally selected: young adults bound for professional/creative industries and so very much tattoo culture's next generation, a generation that is cognizant of the artistic potential of tattooing, and the beneficiaries (in the main) of a generation of artists who see themselves as artists and practitioners of a craft. Certainly, such an ethos was reflected by Carl, a mature Journalism student in relation to his thirteen tattoo designs. In speaking of his tattoos, acquired over nearly a decade, even though the designs were varied in terms of subject

and style, they each possessed a symbolic status. At one level, some of Carl's tattoos were simple and irreverent, such as the peace symbol tattooed on the side of his head, DIY-style by a friend at a party, or the self-drawn image of A-Team star, Mr. T, tattooed onto his posterior (complete with a 'Crazy Fool!' logo), or the initials of each of his two siblings tattooed on each collarbone. However, these simple designs were mixed with more artistic images that keenly reflected his sense of self, such as the large tattoo of the science fiction character, the Predator from Carl's favourite film, (and the first image in what will ultimately become a full sleeve dedicated to characters from his favourite films), and the image of a microphone on his upper back, a design that signifies the period in his life in which he performed as an MC at music festivals. But, Carl's most significant tattoo is a tribute piece devoted to David Bowie, tattooed onto his calf in the wake of Bowie's death in January 2016 to commemorate the degree to which he was not simply a lifelong fan of the singer, but obtained a strong sense of spiritual and personal inspiration from Bowie. In this regard, Carl did not consider any of his tattoos to be merely random designs because all of them, from the 'amateur/scratcher' head design to the aesthetically ornate and artistically accomplished Bowie portrait, have some form of personal meaning. Moreover, his tattoos resonated with his sense of being, as he stated in relation to his designs: 'Tattoos are sort of like armour' and act as an 'extra layer of protection against the outside world'.

A noteworthy aspect of Carl's tattoos was the way in which his fidelity to a particular artist meant that his body reflected that artist's skill progression from the design of a microphone to the geometric David Bowie portrait (a progression often commented upon by his artist), and this insight indicates the major differences between Sanders' ethnographic investigation into tattooing in the late 1980s and similar studies undertaken of its contemporary expression. For instance, the process of the artistic 'drift' into tattooing is now much less marked as tattooing is increasingly seen as an aspirational profession, and one in which the artistic backgrounds of those seeking to be tattooists that was evidenced within the 'Tattoo Renaissance' has now arguably become the norm. In this sense, tattooing reflects a key aspect of Becker's art work configuration – that of the trust placed in an artist with a reputation, with a name. As Becker explains, the 'reputation of the artist and the work reinforce one another: we value more a work done by an artist we respect, just as we respect more an artist whose work we have admired' (2008, p. 23). Reputation is a key factor within tattooing, as it enables artists to attract clients from beyond the geographical area in which they work on a daily basis, a factor that stems from traditional word-of-mouth recommendations and studio-based portfolios (but which can also include portfolio features within tattoo magazines) to the increasingly core use and importance of social media mediums such as Instagram. However, while this exposure of tattooing work

and styles have become an important factor in attracting clients, it also can serve to empower the clients themselves as they can utilise similar platforms to positively extoll and display work that they admire, or broadcast examples of poor examples of the craft, and so warn away would-be clients. As such, within the era of social media, reputation is vital, especially as the proliferation of tattoo studios means that there is no shortage of artists to work with.

Tattoo culture, then, manifestly has many parallels with Becker's conception of the art world, but it has developed to such an extent that it now arguably constitutes an art world in its own right. While the classic key tattoo dynamic was the dyadic relationship between the client and the artist (and at its most potent, it still is), this core has progressively developed into multiple strata. For instance, the old-school tattoo shops are now tattoo studios, 'models of sanitation [where the] needles gleam, the working areas are spotless' (Steward, 1990, p. 181) and Reality TV has taken the viewer behind the studio doors to see the artistry and witness that tattooing can indeed be art, that the tattooist can translate the vision of the client into an inscribed image that speaks of themselves and speaks symbolically to the world (and is unique to that person). At a wider level, the tattoo convention has proliferated into a series of global fan events that artfully walk a fine line between sustaining the mystery of tattooing and consciously evoking its past 'outsider' and circus origins. As such, while the heart of the tattoo convention is built around the visible expression of the craft of tattooing, and the opportunity to be tattooed, the auxiliary spectacles of the burlesque performances, knife-throwing acts, alternative fashion shows, tarot readings, tattoo competitions and the uninhibited displays of heavily tattooed bodies vividly and vibrantly keeps the spirit of the 'sideshow' and the Circus Era alive. As such, the tattoo convention showcases tattoo artist and a tattooed lifestyle talent within 'liminal', but family-friendly and inclusive environments. Hence, while, as Swarmi et al. (2015) argue, there remains a residual perception that tattooing has retained its associations with otherness and deviance in the view that tattoos potentially act as outward signifiers of aggressive behaviours, such an assessment is difficult to sustain or defend given the complex nature of tattooing, its multifaceted social and cultural diffusion, and its diverse manifestation as a distinctive art world.

Therefore, while one respondent rejected the idea that there is a tattoo culture, I respectfully disagree. From Ötzi to Ruby Rose and the tattooed social actors, tattoo artists, and tattoo convention attendees I interviewed, tattoos can and do possess and express a semiotic and communicative function. At one level, this may simply signify that an individual holds a maverick attitude to their body (one of my respondents did state that on one occasion he told his tattoo artist that he would figure out what he would be having tattooed while on route to the studio – he just really felt like having a tattoo that day),

but invariably it represents something much more significant. Of course, this meaningfulness might fade, or the style might become an artistic cliché, but if removal is not opted for (and this still invariably leaves its mark and memory) the tattoo alters 'Being'. As Mifflin states of the communicative nature of tattoos,

> [w]ritten on the skin – the very membrane that separates the self from the world – they're diary entries and public announcements, conversations pieces and countercultural totems, valentines to lovers, memorials to the dead, reminders to the self. They're scars and symptoms, mistakes and corrections. (2013, p. 147)

Tattoos, then, represent the Cartesian dualism of mind and body in a unified form, the 'union of the soul and the body' (Merleau-Ponty, 2014, p. 98) in an inscribed image that is engraved within the body. However, the status of tattoos is one of flux and attitudinal shifts. For example, in encapsulating the various 'eras' of tattooing, Proud (2015) acerbically notes that tattooing has progressively acquired respectability throughout the decades, from the adoption of the art by royalty in the late nineteenth century, its 'working class turn' throughout much of the twentieth century, until the 1990s when it began to visibly cross class and gender lines and became a more marked feature on university students and assorted middle-class professionals until its current popularity within what Alex Proud dubs the modern 'tattoo craze'. But, like all obsessions and fads, its current popularity may recede. As Steward observes, 'There have been throughout history great swings of the pendulum between restrictiveness and permissiveness in society' (1990, p. 180), and tattooing has swung with it. Consequently, it may well be the case that the current mainstream status of tattooing may well fade, a factor that Proud is convinced will happen, but not due to any social censure or a return to the perception of tattoos representing signifiers of deviance or otherness, but by dint of ageing bodies. As he forecasts,

> I'm confident that the tattooing craze has some years to run. But I'm equally bullish in predicting its end date. In 2025, people who were 25 in the year 2000 will be 50. They will have teenage children. And these teenagers will be disgusted by dad's paunch with its stretched Celtic motifs and mortified mum's bingo wings with their faded flowers. They'll roll their eyes and wonder what the hell their parents were thinking. They will rebel by leaving their skin unadorned. (2015, Telegraph.co.uk)

Tattooing is (in the UK and US, at least) undoubtedly at a cultural zenith (with even Disney now featuring tattooed characters, as illustrated by their 2016 animated feature, Moana), but how long it remains at this peak of cultural acceptance and social visibility is unknown (unless we accept the date of 2025 as the downturn point, we'll just have to see). But for some of the

tattooed people I interviewed, this will be no problem, indeed this is a desired outcome as they yearn for tattooing to return to its subcultural roots, and for pop stars and fashion models to leave tattoos to the heavy metal musicians and their cultish fans: that tattoos return to how Steward described it in its classic era, as a world that 'is dim and mysterious to most people' (1990, p. 81). But, it arguably still is, and always will be. More people have tattoos than in previous decades, but statistically far more people do not have them, and will never have them. Of course, they may now see the tattooing process within the increasing number of Reality TV shows that are focused upon the art, culture and practice of tattooing and tattoo artists, but that is very different from the experiential process of having a tattoo. This is why phenomenological ideas have been argued to be so relevant in understanding contemporary tattoo culture. This is because phenomenology is concerned with the self and reflection, subjectivity and symbolic processes, consciousness and sensation, meaning, bodily experience, Being in relation to time, and the essence of things, and tattoos, whether they be ill-conceived in terms of idea, design or taste, or are exquisite bodily works of art, are designed to stay within the body, and even removal or the cover-up design represents changes in subjectivity and being in relation to bodily essence and time.

As an experience, there are arguably fewer more phenomenal moments than entering into the environment that is the tattoo studio. It is a world that can induce the simultaneous sensation combination of anticipation, excitement and sometimes intimidation. It is a creative space that dramatically and potently hits the senses when its doors are opened in a heady and utterly unique sensory fusion of the distinctive disinfectant smell and, more evocatively, the whirring sound of tattoo machines that are injecting ink into a human's skin to form an image that speaks, if not to the world, then most assuredly to the self. Because, regardless of the extent to which tattooing has become fashionable, one thing remains unchanged: when you leave the tattoo studio, the essence of who you were has changed, even if this is just at the level of your external skin.

Bibliography

Adams, Josh. (2009) Marked Difference: Tattooing and its Association with Deviance in the United States. *Deviant Behavior*, Vol. 30, pp. 266–292.

Armstrong, Myrna. L. (1991) Career-oriented Women with Tattoos. *Journal of Nursing Scholarship*, Vol. 23, No. 4, pp. 215–220.

Armstrong, Myrna. L. Owen, Donna. C. Roberts, Alden. E. Koch, Jerome. R. (2002) College Students and Tattoos: Influence of Image, Identity, Family, and Friends. *Journal of Psychosocial Nursing*, Vol. 40, No. 10, pp. 21–29.

Armstrong, Myrna. L. (2008) Motivation for Contemporary Tattoo Removal: A Shift in Identity. *Arch Dermatol*, Vol. 144, No. 7, pp. 879–884.

Armstrong, Myrna. L. Pace Murphy, Kathleen. (1997) Tattooing: Another Adolescent Risk Behaviour Warranting Health Education. *Applied Nursing Research*, Vol. 10, No. 4, pp. 181–189.

Awofeso, Niyi. (2002) Jaggers in the Pokey: Understanding Tattooing in Prisons and Reacting Rationally to it. *Australian Health Review*, Vol. 25, pp. 162–169.

Alayon, Erick. (2004) *The Art and Science of Modern Tattooing.* Marston Gate: Amazon.co.uk.

Armstrong, M. L. McConnell, C. (1994) Tattooing in Adolescents, More Common Than You Think: The Phenomenon and Risks. *Journal of School Nursing*, Vol. 10, pp. 22–29.

Atkinson, Michael. (2003a) *Tattooed: The Sociogenesis of a Body Art.* Toronto: University of Toronto Press.

Atkinson, Michael. (2003b) The Civilizing of Resistance: Straightedge Tattooing. *Deviant Behaviour*, Vol. 24, pp. 197–220.

Ayer, David. (2016) Suicide Squad.

Bailkin, Jordanna. (2005) Making Faces: Tattooed Women and Colonial Regimes. *History Workshop Journal*, Vol. 59, pp. 33–56.

Bakhtin, Mikhail. (1984) *Rabelais and his World.* Bloomington: Indiana University Press.

Baldaev, Danzig. Vasiliev, Sergei. Plutser-Sarno, Alexei. (2009) *Russian Criminal Tattoo Encyclopaedia.* London: Fuel.

Belliotti, Raymond. Angelo. (2010) The Existential Void of Roger Sterling. In Carveth, Rod. South, James. B. (eds) *Mad Men and Philosophy.* Hoboken, New Jersey: John Wiley & Sons, pp. 66–79.

Barthes, Roland. (1993) *Mythologies.* London: Vintage.

Becker, Howard. S. (2008) *Art Worlds.* Berkeley: University of California Press.

Beckham, David. (2000) *Beckham: My World.* London Hodder and Stoughton.

Benson, Susan. (2000) Inscriptions of the Self: Reflections on Tattooing and Piercing in Contemporry Euro-America. In Caplan, Jane. (ed) *Written on the Body.* London: Reaktion Books, pp. 234–254.

Berger, Peter. Luckmann, Thomas. (1991) *The Social Construction of Reality.* London: Penguin.

Besson, Luc. (2017) *Valerian and the City of a Thousand Planets.* EuropaCorp.

Bjerrisgaard, Sofie. M. Kjeldgaard, Dannie. Bengtsson, Anders. (2013) Consumer–brand Assemblages in Advertising Practices: An Analysis of Skin, Identity and Tattoos in Ads. *Consumption, Markets and Culture*, Vol. 16, No. 3, pp. 223–239.

Biressi, Anita. Nunn, Heather. (2005) *Reality TV: Realism and Revelation.* London: Wallflower.

Bolton, Doug. (2015) People All Over the World are Getting Semicolon Tattoos to Draw Attention to Mental Health. *Independent*, Friday, 3 July, pp. 1–8. http://www.independent.co.uk/life-style/health-and-families/people-all-over-the-world-are-getting-semicolon-tattoos-to-draw-attention-to-mental-health-10365313.html (Accessed 11/07/2016).

Botz-Bornstein, Thorsten. (2012) Female Tattoos and Graffiti. In Arp, Robert. (ed) *Tattoos: Philosophy For Everyone: I Ink, Therefore I Am.* Oxford: John Wiley and Sons, pp. 53–63.

Bourdieu, Pierre. (1984) *Distinction: A Social Critique of the Judgement of Taste.* London: Routledge & Kegan Paul.

Bradbury, Ray. (1972) *The Illustrated Man.* London: Corgi Books.

Brake, Mike. (1980) *The Sociology of Youth Culture and Youth Subcultures: Sex and Drugs and Rock 'n' Roll?* London: Routledge and Kegan Paul.

Braunberger, Christine. (2000) Revolting Bodies: The Monster Beauty of Tattooed Women. *NWSA Journal*, Vol. 12, No. 2, pp. 1–23.

Brennan, Ailis. (2016) Why Do Tattoo Artists Hate E4's Tattoo Fixers? *GQ*, Tuesday, 29 March. http://www.gq-magazine.co.uk/article/tattoo-fixers-why-do-tattoo-artists-hate-e4 (Accessed 13/12/2016).

Brewer, John. D. (2000) *Ethnography.* Buckingham and Philadelphia: Open University Press.

Brooks, Bob. (1981) Tattoo. Joseph E. Levine Productions.

Broome, Karl. (2006) Tattooing Starts at Home: Tattooing, Affectivity, and Sociality. *Fashion Theory*, Vol. 10, No. 3, pp. 333–350.

Brown, Nacho. (2015a) Magazine Cover Models: Sexy or Sexist? *Total Tattoo*, September, pp. 78–80.

Brown, Nacho. (2015b) The Memory Remains. *Skin Deep*, November, pp. 78–81.

Buckland, A.W. (1888) On Tattooing. *The Journal of the Anthropological Institute of Great Britain and Ireland*, Vol. 17, pp. 318–328.

Burdett, John. (2006) *Bangkok Tattoo*. London: Corgi Books.

Burger, Peter. (2007) The Tattooist. Daydream Productions.

Burris, Katy. Kim, Karen. (2007) Tattoo Removal. *Clinics in Dermatology*, Vol. 25, pp. 388–392.

Callinicos, Alex. (1990) *Against Postmodernism: A Marxist Critique*. Cambridge: Polity.

Camphausen, Rufus. C. (1997) *Return of the Tribal: A Celebration of Body Adornment*. Rochester: Park Street Press.

Caplan, Jane. (ed) (2000) *Written on the Body*. London: Reaktion Books.

Carmen, Rachael. A. Guitar, Amanda. E. Dillon, Haley. M. (2012) Ultimate Answers to Proximate Questions: The Evolutionary Motivations Behind Tattoos and Body Piercings in Popular Culture. *Review of General Psychology*, Vol. 16, No. 2, pp. 134–143.

Cashmore, Ellis. (2002) *Beckham*. Cambridge: Polity.

Cashmore, Ellis. (2006) *Celebrity/Culture*. London and New York: Routledge.

Chatterson Handy, Willowdean. (2008) *Tattooing in the Marquesas*. Mineola and New York: Dover Publications.

Church Gibson, Pamela. (2012) *Fashion and Celebrity Culture*. London and New York: Berg.

Ciment, Jill. (2005) *The Tattoo Artist*. New York: Vintage Books.

Chin, Bertha. Hills, Matt. (2010) Restricted Confessions@: Blogging, Subcultural Celebrity and the Management of Producer-fan Proximity. In Redmond, Sean. (ed) *The Star and Celebrity Confessional*. London and New York: Routledge, pp. 142–161.

Craik, Jennifer. (1994) *The Face of Fashion: Cultural Studies in Fashion*. London: Routledge.

Cronenberg, David. (2007) *Eastern Promises*. Focus Features.

Cummings, Dolan. Clark, Bernard. Mapplebeck, Victoria, Dunkley, Christopher. Barnfield, Graham. (2002) *Reality TV: How Real Is Real?* London: Hodder & Stoughton.

Curl, James Stevens. (1980) *A Celebration of Death*. London: Constable.

Gilles. Deleuze. Guattari, Félix. (2000) *A Thousand Plateaus*. London and New York: Continuum.

DeMello, Margo. (2000) *A Cultural History of the Modern Tattoo Community*. Durham and London: Duke University Press.

DeMello, Margo. (2014a) *Body Studies: An Introduction*. London and New York: Routledge.

DeMello, Margo. (2014b) *Inked: Tattoo and Body Art Around the World*. Santa Barbara: ABC-CLIO.

DeMello, Margo. (1993) The Convict Body: Tattooing Among Male American Prisoners. *Anthropology Today*, Vol. 9, No. 6, pp. 10–13.

Derrida, Jacques. (1997) *Of Grammatology*. Baltimore and London: The Johns Hopkins University Press.

Descartes, René. (1997) *Key Philosophical Writings*. Hertfordshire: Wordsworth Editions Limited.

Deter-Wolf, Aron. Robitaille, Benoît. Krutak, Lars, Galliot, Sébastien. (2015) The World's Oldest Tattoos. *Journal of Archaeological Science: Reports*, Vol. 5, pp. 19–24.

Dickson, Lynda. Dukes, Richard. Smith, Hilary. Strapko, Noel. (2014) Stigma of Ink: Tattoo Attitudes Among College Students. *The Social Sciences Journal*, Vol. 51, pp. 268–276.

Duffett, Mark. (2014) *Understanding Fandom: An Introduction to the Study of Media Fan Culture*. New York: Bloomsbury.

Durkheim, Émile. (1984) *The Division of Labour in Society*. Basingstoke: MacMillan.

Eagleton, Terry. (1989) *Literary Theory: An Introduction*. Oxford: Basil Blackwell.

Eco, Umberto. (1976) *A Theory of Semiotics*. London: Indiana University Press.

Ellis, Juniper. (2012) How to Read a Tattoo and Other Perilous Quests. In Arp, Robert. (ed) *Tattoos: Philosophy for Everyone: I Ink, Therefore I Am*. Oxford: John Wiley and Sons, pp. 14–26.

Emmons, Betsy. Billings, Andrew. C. (2015) To Airbrush or Not?: Theoretical and Practical Applications of Athletes, Tattoos, and the Media. *Journal of Sports Media*, Vol. 10, No. 2, pp. 65–88.

Falkenstern, Rachel. C. (2012) Illusions of Permanence: Tattoos and the Temporary Self. In Arp, Robert. (ed) *Tattoos: Philosophy For Everyone: I Ink, Therefore I Am*. Oxford: John Wiley and Sons, pp. 96–108.

Favazza, Armando. R. (1996) *Bodies Under Siege: Self-Mutilation and Body Modification in Culture and Psychiatry*. Baltimore and London: The Johns Hopkins University Press..

Ferguson, Harvie. (2006) *Phenomenological Sociology: Experience & Insight in Modern Society*. London: SAGE.

Ferrier, Morwenna. (2014) Needles and Spin: Inside the World of the US's Top Tattooist. *The Guardian*, Friday, September. https://www.theguardian.com/fashion/2014/sep/26/tattoos-dr-woo-fashion-la. (Accessed 22/07/2016).

Fenske, Mindy. (2007a) Movement and Resistance: (Tattooed) Bodies and Performance. *Communication and Critical/Cultural Studies*, Vol. 4, No. 1, pp. 51–73.

Fenske, Mindy. (2007b) *Tattoos in American Visual Culture*. Basingstoke: Palgrave Macmillan.

Fetterman, David. M. (1989) *Ethnography*. London: Sage Publications.

Fisher, Jill. A. (2002) Tattooing the Body, Marking Culture. *Body & Society*, Vol. 8, No. 4, pp. 91–107.

Fiske, John. (1990) *Introduction to Communication Studies*. London: Routledge.

Freud, Sigmund. (1991) *Introductory Lectures on Psychoanalysis*. London: Penguin Books.

Friedman, Anna. Felicity. (2015) *The World Atlas of Tattoo*. London: Quintessence.

Fruh, Kyle. Thomas, Emily. (2012) Tattoo You: Personal Identity in Ink. In Arp, Robert. (ed) *Tattoos: Philosophy For Everyone: I Ink, Therefore I Am*. Oxford: John Wiley and Sons, pp. 83–95.

Gitlin, Todd. (2003) *The Whole World Is Watching: Mass Media in the making and UnMaking of the New Left.* Berkeley, Los Angeles and London: University of California Press.

Godden, Nicholas. (2015) Lewis Hamilton Opens up about His Tattoos as He Poses for Front Cover of Men's Health: They All Have Meaning … I'm Strong in My Faith, so I Wanted Some Religious Images. *Mail Online,* 1 April. http://www.dailymail.co.uk/sport/formulaone/article-3021404/Lewis-Hamilton-opens-tattoos-poses-cover-Men-s-Health-meaning-m-strong-faith-wanted-religious-images.html#ixzz4GSAyWaeG (Accessed 05/08/2016).

Goffman, Erving. (1991) *Asylums.* London: Penguin Books.

Goffman, Erving. (1959) *The Presentation of Self in Everyday Life.* Middlesex: Penguin Books.

Goldhill, Olivia. (2014) Inking Mad: The Cult of Celebrity Tattoos. *The Telegraph,* 7 July. http://www.telegraph.co.uk/news/celebritynews/10947005/Inking-mad-the-cult-of-celebrity-tattoos.html (Accessed 22/07/2016).

Grognard, Catherine. (1994) *The Tattoo: Graffiti for the Soul.* London: Sunburst Books.

Hale, Matthew. (2014) Cosplay: Intertextuality, Public Texts, and the Body Fantastic. *Western Folklore,* Vol. 73, No. 1, pp. 5–37.

Hall, Sarah. (2004) *The Electric Michelangelo.* London: Faber and Faber.

Halnon, Karen. Bettez. (2004) Inside Shock Music Carnival: Spectacle as Contested Terrain. *Critical Sociology,* Vol. 30, No. 3, pp. 743–779.

Hambly, Wilfred. Dyson. (2009) *The History of Tattooing.* Mineola and New York: Dover Publications, Inc.

Hammersley, Martyn. (1990) *Reading Ethnographic Research.* London and New York: Longman.

Hardy, Lal. (2014) *The Mammoth Book of New Tattoo Art.* London: Constable & Robinson.

Harkins, Christopher. A. (2006) Tattoos and Copyright Infringement: Celebrities, Marketers, and Businesses Beware of the Ink. *Lewis & Clark Law Review,* Vol. 10, No. 2, pp. 313–332.

Heywood, Wendy. Kent, Patrick. Smith, Anthony, M.A., Simpson, Judy. M., Pitts, Marian. K., Richters, Juliet. Shelley, Julia. M. (2012) Who Gets Tattoos?: Demographic and Behavioural Correlates of Ever being Tattooed in a Representative Sample of Men and Women. *AEP,* Vol. 22, No. 1, pp. 51–56.

Hebdige, Dick. (1979) *Subculture: The Meaning of Style.* London and New York: Methuen.

Heidegger, Martin. (1977) *Basic Writings.* London: Harper and Rows.

Heidegger, Martin. (1962) *Being and Time.* Oxford: Blackwell.

Heidegger, Martin. (2016) *Mindfulness.* London: Bloomsbury.

Hellard, M.E., Aitken. C.K., Hocking. J.S. (2007) Tattooing in Prisons–not Such a Pretty Picture. *American Journal of Infection Control,* Vol. 35, No. 7, pp. 477–80.

Hemingson, Vince. (2009) *Tattoo Design Directory.* London: A&C Black.

Henry, Michel. (2015) *Incarnation: A Philosophy of Flesh.* Evanston: Northwestern University Press.

Hesselt van Dinter, Maarten. (2005) *The World of Tattoo: An Illustrated History*. Amsterdam: KIT.

Hewitt, Kim. (1997) *Mutilating the Body: Identity in Blood and Ink*. Bowling Green: Bowling Green University Popular Press.

Hill, Annette. (2005) *Reality TV: Audiences and Popular Factual Television*. London and New York: Routledge.

Hills, Matt. (2002) *Fan Cultures*. London and New York: Routledge.

Hine, Christine. (2000) *Virtual Ethnography*. London: SAGE.

Hodkinson, Paul. (2002) *Goth: Identity, Style and Subculture*. Oxford and New York: Berg.

Holmes, Dominique. (2013) *The Painted Lady: The Art of Tattooing the Female Body*. London and New York: Ryland Peters & Small.

Holmes, Su. (2004) 'All you've got to worry about is the task, having a cup of tea, and doing a bit of sunbathing': Approaching Celebrity in *Big Brother*. In Holmes, Su. Jermyn, Deborah. (eds) *Understanding Reality Television*. London and New York: Routledge, pp. 111–136.

Husserl, Edmund. (1969) *Ideas: General Introduction to Pure Phenomenology*. London: George Allen & Unwin.

Irving, John. (2006) *Until I Find You*. London: Black Swan.

Irwin, Katherine. (2007) Saints and Sinners: Elite tattoo Collectors and Tattooists as Positive and Negative Deviants. *Sociological Spectrum*, Vol. 19, No. 16, pp. 27–57.

Jenkins, Henry (1992) *Textual Poachers*. New York: Routledge.

Jones, Owen. (2012) *Chavs: The Demonization of the Working Class*. London and New York: Verso.

Jordan, William. (2015) Myth busted: people do NOT regret getting tattoos in later life. YouGov UK. https://yougov.co.uk/news/2015/07/14/myth-busted-people-do-not-regret-their-tattoos/ (Accessed 15/12/2016).

Junishiro, Tanizaki. (1991) *Seven Japanese Tales*. New York: Vintage Books.

Kang, Miliann. and Jones, Katherine. (2007) Why do people get tattoos? *Contexts*, Vol. 6, No. 1, pp. 42–47.

Kellner, Douglas. (1992) Popular Culture and the Construction of Postmodern Identities. In, Lash, Scott. Friedman, Jonathan. (eds) *Modernity and Identity*. Oxford: Blackwell. pp 141–178.

Kent, Kathryn. M. Graber, Emmy. M. (2012) Laser Tattoo Removal: A Review. *Dermatological Surgery*, Vol. 38, pp. 1–13.

Kenny, Steven. (2017) Soul Music. *Skin Deep*, April, pp. 24–28.

Kerpen, Dave. (2011) *Likeable Social Media*. New York: McGraw Hill.

King, Keith. A. Vidourek, Rebecca. A. (2013) Getting inked: Tattoo and risky behavioural involvement among university students. *The Social Science Journal*, Vol. 50, pp. 540–546.

Kitamura, Takahiro. Kitamura, Katie. M. (2001) *Bushido: Legacies of the Japanese Tattoo*. Atglen, PA: Schiffer Publishing.

Klanten, Robert. Schulze, Floyd. E. (eds) (2012) *Forever: The New Tattoo*. Berlin: Die Gestalten Verlag.

Kozinets, Robert. V. (2015) *Netnography: Redefined*. London: SAGE.

Kosut, Mary. (2006) An Ironic Fad: The Commodification and Consumption of Tattoos. *The Journal of Popular Culture*, Vol. 39, No. 6, pp. 1035–1048.

Kosut, Mary. (2014) The Artification of Tattoo: Transformations within a Cultural Field. *Cultural Sociology*, Vol. 8, No. 2, pp. 142–158.

Larsen, Katherine. Zubernis, Lynn. (2012) *Fandom At The Crossroads: Celebration, Shame and Fan/Producer Relationships.* Newcastle upon Tyne: Cambridge Scholars.

Larsson, Stieg. (2008) *The Girl with the Dragon Tattoo.* London: Maclehose Press.

Lash, Scott. (1990) *Sociology of Postmodernism.* London: Routledge.

Lawrence, Cooper. (2009) *The Cult of Celebrity.* Connecticut: skirt!

Lodder, Matt. (2013) George Burchett: The Man, the Myth, the Legend. *Total Tattoo*, February, pp. 66–69.

Lodder, Matt. (2015) "Things of the sea': iconographic continuities between tattooing and handicrafts in Georgian-era maritime culture. *Sculpture Journal*, Vol. 24. No. 2, pp. 195–210.

Lombroso, Cesare. (2006) (translated by Gibson, Mary. Hahn Rafter, Nicole) *Criminal Man.* Durham and London: Duke University Press.

Lyotard, Jean-Francois. (1986) *The Postmodern Condition.* Manchester: Manchester University Press.

Lynne, Lee. Wendy. (2012) Never Merely 'There': Tattooing as a Practice of Writing and a Telling of Stories. In Arp, Robert. (ed) *Tattoos: Philosophy For Everyone: I Ink, Therefore I Am.* Oxford: John Wiley and Sons, pp. 151–164.

McComb, David. (2015) *100 Years of Tattoos.* London: Laurence King.

McLaughlin, Eugene. Muncie, John. (2013) *The SAGE Dictionary of Criminology.* Los Angeles and London: SAGE.

MacCormack, Patricia. (2006) The Great Ephemeral Tattooed Skin. *Body & Society*, Vol. 12, No. 2, pp. 57–82.

MacNaughton, Alex. (2011) *London Tattoos.* Munich: Prestel.

Maltby, John. et al. (2005) Intense-personal Celebrity Worship and Body Image: Evidence of a Link among Female Adolescents. *British Journal of Health Psychology*, Vol. 10, No. 1, pp. 17–32.

Maltby, J. Giles, David. (2008) Toward the Measurement and Profiling of Celebrity Worship. In Meloy, J. Reid. Sheridan, Lorraine. Hoffman, Jens. (eds) *Stalking, Threatening and Attacking Public Figures: A Psychological and Behavioural Analysis.* Oxford: Oxford University Press, pp. 271–285.

Manuel, Laura. Retzlaff, Paul. D. (2002) Psychopathology and Tattooing Among Prisoners. *International Journal of Offender Therapy and Comparative Criminology*, Vol. 46, No. 5, pp. 522–531.

Mars, Lola. (2015) *Inked.* Chichester: Summersdale Publishers.

Mascia-Lees, Frances. Sharpe, Patricia. E. (1992) The Marked and the Un(re) Marked: Tattoo and Gender in Theory and Narrative. In Mascia-Lees, Frances. Sharpe, Patricia. E. (eds) *Tattoo, Torture, Mutilation, and Adornment.* Albany: State University of New York Press, pp. 145–169.

Mayers, Lester. B. Chiffriller, Sheila. H. (2008) Body Art (Body Piercing and Tattooing) among Undergraduate University Students: 'Then and Now'. *Journal of Adolescent Health*, Vol. 42, pp. 201–203.

Melville, Herman. (2003) *Moby Dick.* London: Penguin.

Mercer, Nigel. Davies, D.W. (1991) Tattoos: Marked for life. *British Medical Journal*, Vol. 303, p. 380.

Merleau-Ponty, Maurice. (2014) *Phenomenology of Perception*. London and New York: Routledge.

Mifflin, Margot. (2013) *Bodies of Subversion: A Secret History of Women and Tattoo*. Brooklyn: powerHouse Books.

Miori, Daniel. (2012) To Ink, or Not to Ink: Tattoos and Bioethics. In Arp, Robert. (ed) *Tattoos: Philosophy For Everyone: I Ink, Therefore I Am*. Oxford: John Wiley and Sons, pp.193–205.

Modesti, Sonja. (2008) Home Sweet Home: Tattoo Parlors as Postmodern Spaces of Agency. *Western Journal of Communication*, Vol. 72, No. 3, pp. 197–212.

Mohamed Nasir, Kamaludeen. (2016) Antipodal Tattooing: Muslim Youth in Chinese Gangs. *Deviant Behaviour*, Vol. 37, No. 8, pp. 952–961.

Mohamed Nasir, Kamaludeen. (2015) *Globalized Muslim Youth in the Asia Pacific: Popular Culture in Singapore*. New York: Palgrave Macmillan.

Nally, Claire. (2009) Grrrly Hurly Burly: Neo-burlesque and the Performance of Gender. *Textual Practice*, Vol. 23, No. 4, pp. 621–643.

Nelson, Jennifer. (2012) *Airbrushed Nation: The Lure and Loathing of Women's Magazines*. Seal Press.

Nolan, Christopher. (2000) Memento. I Remember Productions.

O'Donnell, Kathleen A. (1999) Good Girls Gone Bad: The Consumption of Fetish Fashion and the Sexual Empowerment of Women. *Advances in Consumer Research*, Vol. 26, pp. 184–189.

Orend, Angela. Gagné, Patricia. (2009) Corporate Logo Tattoos and the Commodification of the Body. *Journal of Contemporary Ethnography*, Vol. 38, pp. 493–517.

Papacharissi, Zizi. (2015) Toward New Journalism(s). *Journalism Studies*, Vol. 16, No. 1, pp. 27–40.

Pappas, Erin. (2014) Between Barbarism and Civilization: Librarians, Tattoos, and Social Imaginaries. In Pagowsky, Nicole. Rigby, Miriam. (eds) *The Librarian Stereotype: Deconstructing Perceptions and Presentations of Information Work*. Chicago: Association of College & Research Libraries, pp. 185–212.

Parry, Albert. (2006) *Tattoo: Secrets of a Strange Art*. Mineola: Dover Publications.

Pavia, Lucy. (2016) How Ruby Rose Is Changing the Face Of Beauty. *InStyle UK*, Friday 6 May. http://www.instyle.co.uk/celebrity/news/why-oitnb-star-ruby-rose-is-a-very-modern-girl-crush (Accessed 21/06/2016).

Pearson, Keith. Ansell. Mullarkey, John. (eds) (2002) *Henri Bergson: Key Writings*. London: Bloomsbury.

Peirson-Smith, Anne. (2013) Fashioning the Fantastical Self: An Examination of the Cosplay Dress-Up Phenomenon in Southeast Asia. *Fashion Theory*, Vol. 17, No. 1, pp. 77–111.

Picerno, Doralba. (2011) *Tattoos: Ancient Traditions, Secret Symbols and Modern Trends*. London: Arcturus.

Pierrat, Jérôme. (2014) The Russian Tattooing. In. Anne and Julien. (eds) *Tattoo*. Paris: Actes Sud, pp. 50–53.

Pitts, Victoria. (2003) *In The Flesh: The Cultural Politics of Body Modification*. Basingstoke: Palgrave Macmillan.

Pringle, Hamish. (2004) *Celebrity Sells.* Chichester: Wiley.

Proud, Alex. (2015) We're Not Going to Reach 'peak tattoo' Until 2025. *The Telegraph,* 20 April. http://www.telegraph.co.uk/men/fashion-and-style/11545649/ Were-not-going-to-reach-peak-tattoo-until-2025.html (Accessed 05/12/2016).

Rahmna, Osmud. Wing-Sun, Liu. Hei-man Cheung, Brittany. (2012) "Cosplay": Imaginative Self and Performing Identity. *Fashion Theory,* Vol. 16, No. 3, pp. 317–341.

Rakovic, Rocky. (2012) I Ink Therefore I Foreword. In Arp, Robert. (ed) *Tattoos: Philosophy For Everyone: I Ink, Therefore I Am.* Oxford: John Wiley and Sons, pp. x–xiii.

Redmond, Sean. (2014) *Celebrity and the Media.* Basingstoke: Palgrave Macmillan.

Rimmer, Beccy. (2016) A Necessary Evil. Skin Deep, November, pp. 72–78

Ringrose, Jessica. (2010) Beyond Discourse? Using Deleuze and Guattari's schizo-analysis to Explore Affective Assemblages, Heterosexually Striated Space, and Lines of Flight Online and at School. *Educational Philosophy and Theory,* Vol. 43, No. 6, pp. 598–618.

Rochell, Hannah. MacDonnell, Chloe. (2016) The Cool Girl's Guide to Tattoos. *Instyle* (British Edition), July, p. 24.

Rojek, Chris. (2001) *Celebrity.* London: Reaktion.

Rojek, Chris. (2007) *Cultural Studies.* Cambridge: Polity.

Roth, Veronica. (2011) *Divergent.* London: HarperCollins.

Said, Edward. W. (1995) *Orientalism: Western Conceptions of the Orient.* London: Penguin Books.

Saltz, Ina. (2006) Body Type: Intimate Images Etched in Flesh. New York: Harry N. Abrams, Inc.

Sanders, Clinton. R. (2009) Colorful Writing: Conducting and Living with a Tattoo Ethnography. In Puddephatt, Anthony. J. Shaffir, William. Kleinknecht, Steven. W. (eds) *Ethnographies Revisited: Constructing Theory in the Field.* London and New York: Routledge, pp. 63–77.

Sanders, Clinton. R. (2008) *Customizing The Body: The Art and Culture of Tattooing.* Philadelphia: Temple University Press.

Sartre, Jean-Paul. (2003) *Being and Nothingness.* London and New York: Routledge.

de Saussure, Ferdinand. (2008) *Course in General Linguistics.* Illinois: Open Court.

Scheinfeld, Noah. (2007) Tattoos and Religion. *Clinics in Dermatology,* Vol. 25, pp. 362–366.

Schiffmacher, Henk. (ed) (2005) *1000 Tattoos.* Hong Kong and London: Taschen.

Schrader, Abby. M. (2000) Branding the Other/Tattooing the Self: Bodily Inscription among Convicts in Russia and the Soviet Union. In. Caplan, Jane. (ed) *Written on the Body.* London: Reaktion Books, pp. 174–192.

Schreier, Jake. (2015) *Paper Towns. Fox 2000 Pictures.*

Schwentke, Robert. (2002) *Tattoo. StudioCanal.*

Shilling, Chris. (2008) *Changing Bodies: Habit, Crisis and Creativity.* Los Angeles and London: SAGE.

Scutt, Ronald. Gotch, Christopher. (1974) *Skin Deep: The Mystery of Tattooing.* London: Peter Davies.

Selby Price, Carol. Price, Robert. M. (1999) *Mystic Rhythms: The Philosophical Vision of Rush.* New Jersey: Wildside Press.

Sennett, Richard. (2008) *The Craftsman.* London: Penguin.

Sia, Huan. Jian. Levy, Michael. (2015) What Have You Heard About Tattooing in Prison? The Clandestine Role of Hearing Aids in the Risk of Bloodborne Virus Transmission. *Healthcare Infection,* Vol. 20, pp. 36–37.

Siebler, Kay. (2015) What's so Feminist about Garters Ad Bustiers? Neo-burlesque as Post-feminist Sexual Liberation. *Journal of Gender Studies,* Vol. 24, No. 5, pp. 561–573.

Sharkey, Linda. (2016) Ruby Rose: Urban Decay Announces Gender Fluid Model and Actress as the New Face of Its Latest Campaign, *Independent,* Wednesday, 2 March, pp. 1–7. http://www.independent.co.uk/life-style/fashion/news/ruby-rose-urban-decay-announces-gender-fluid-model-and-actress-as-its-new-face-A6907796.html (Accessed 03/03/2016).

Sheehan, Thomas. (2015) *Making Sense of Heidegger: A Paradigm Shift.* London and New York: Rowman & Littlefield.

Siorat, Cyril. (2006) The Art of Pain. *Fashion Theory,* Vol. 10, No. 3, pp. 367–380.

Sloterdijk, Peter. (2011) *Bubbles: Spheres 1.* Los Angeles: Semiotext(e).

Smart, Barry. (2005) *The Sport Star: Modern Sport and the Cultural Economy of Sporting Celebrity.* London: SAGE.

Smith, Philip. (2001) *Cultural Theory: An Introduction.* Oxford: Blackwell.

Steele, Valerie. (1996) *Fetish: Fashion, Sex & Power.* Oxford and New York: Oxford University Press.

Stein, Abby. (2011) The Tattooed Therapist: Exposure, Disclosure, Transference. *Psychoanalysis, Culture & Society,* Vol. 16, No. 2, pp. 113–131.

Steward, Samuel. M. (1990) *Bad Boys and Tough Tattoos: A Social History of the Tattoo with Gangs, Sailors, and Street-Corner Punks, 1950–1965.* London and New York: Harrington Park Press.

Stirn, Aglaja. Hinz, Andreas. Brähler, Elmar. (2006) Prevalence of Tattooing and Body Piercing in Germany and Perception of Health, Mental Disorders, and Sensation Seeking Among Tattooed and Body-pierced Individuals. *Journal of Psychosomatic Research,* Vol. 60, pp. 531–534.

Sturtevant, William. C. In Fellowes, C.H. (1971) *The Tattoo Book.* Princeton: The Pyne Press.

Sullivan, Nikki. (2001) *Tattooed Bodies: Subjectivity, Textuality, Ethics, and Pleasure.* London: Praeger.

Sullivan, Nikki. (2009) The Somatechnics of Bodily Inscription: Tattooing. *Studies in Gender and Sexuality,* Vol. 10, pp. 129–141.

Swami, Viren. Gaughan, Helen. Tran, Ulrich. S. Kuhlmann, Tim. Stieger, Stefan, Voracek, Martin. (2015) Are Tattooed Adults Really More Aggressive and Rebellious Than Those Without Tattoos? *Body Image,* Vol. 15, pp. 149–152.

Swami, Viren. (2011) Marked for Life? A Prospective Study of Tattoos on Appearance Anxiety and Dissatisfaction, Perceptions of Uniqueness, and Self-esteem. *Body Image,* Vol. 8, pp. 237–244.

Sweetman, Paul. (1999) Anchoring the (postmodern) self? Body Modification, Fashion, and Identity. *Body and Society*, Vol. 5, No. 2, pp. 51–76.

Taliaferro, Charles. Odden, Mark. (2012) Tattoos and the Tattooing Arts in Perspective. In Arp, Robert. (ed) *Tattoos: Philosophy For Everyone: I Ink, Therefore I Am*. Oxford: John Wiley and Sons, pp. 3–13.

Taylor, Ian. Walton, Paul. Young, Jock. (1973) *The New Criminology*. London and Boston: Routledge.

Teitel, Emma. (2015) Go ahead. 'Go gay' for Ruby Rose. *MacLean's*, June 21, pp. 1–1. http://www.macleans.ca/culture/television/go-ahead-go-gay-for-ruby-rose/ (Accessed 02/08/2016).

Thornton, Sarah. (1995) *Club Cultures: Music, Media and Subcultural Capital*. Cambridge: Polity.

Tiggemann, Marika. Golder, Fleur. (2006) Tattooing: An Expression of Uniqueness in the Appearance Domain. *Body Image*, Vol. 3, pp. 309–315.

Tiggemann, Marika. Hopkins, Louise. A. (2011) Tattoos and Piercings: Bodily Expressions of Uniqueness? *Body Image*, Vol. 8, pp. 245–250.

Tighe, Hopkins. (1877) The Art and Mystery of Tattooing. *The Leisure Hour*, January, pp. 774–780.

Thompson, Beverly. Yeun. (2015) *Covered In Ink: Tattoos, Women, and the Politics of the Body*. New York and London: New York University Press.

Thorne, Russ. (2012) *Tattoo Art: Inspiration, Style & Technique from Great Contemporary Tattoo Artists*. London: Flame Tree Publishing.

Titilayo, Abiona. C. et al. (2010) Body Art Practices Among Inmates: Implications for Transmission of Bloodline Infections. *American Journal of Infection Control*, Vol. 38, pp. 121–129.

Torbeck, Richard. Bankowski, Richard. Henize, Sarah. Saedi, Nazanin. (2016) Lasers in Tattoo and Pigmentation Control: Role of the PicoSure® Laser System. *Medical Devices*, Vol. 9, pp. 63–67.

Travellin' Mick. (2016) Tattoos Banned in Japan. *Total Tattoo*, May, pp. 71–75

Turner, Graeme. (2006) The Mass Production of Celebrity 'Celetoids', Reality TV and the 'demotic turn'. *International Journal of Cultural Studies*, Vol. 9, No. 2, pp. 153–16.

Turner, Graeme. (2014) *Understanding Celebrity* (Second Edition). London: SAGE.

Turner, Bryan. S. (1991) Recent Developments in the Theory of the Body. In Featherstone, Mike. Hepworth, Mike. Turner, Bryan. S. (eds) *The Body: Social Process and Cultural Theory*. London: SAGE Publications, pp. 1–36.

Utanga, John. Mangos, Therese. (2006) The Lost Connections: Tattoo Revival in the Cook Islands. *Fashion Theory*, Vol. 10, No. 3, pp. 315–332.

Vail, D. Angus. (1999) Tattoos are Like Potato Chips ... You Can't Have Just One: The Process of Becoming and Being a Collector. *Deviant Behaviour*, Vol. 20, No. 3, pp. 253–273.

Vale, Vivian. Juno, Andrea. (2010) *Modern Primitives: An Investigation of Contemporary Adornment and Ritual*. San Francisco: Re/Search.

Van Krieken, Robert. (2012) *Celebrity Society*. London and New York: Routledge.

Van Vechten, Carl. (1987) *The Tattooed Countess*. Iowa: University of Iowa Press.

Vassileva, Snejina. Hristakieva, Evgeniya. (2007) Medical Applications of Tattooing. *Clinics in Dermatology*, Vol. 25, pp. 367–374.

Vidan, Katie. (2015) Janis Joplin: The First Tattooed Celebrity. *Tattoodo*, 30 December. https://www.tattoodo.com/a/2015/12/janis-joplin-the-first-tattooed-celebrity/ (Accessed 04/08/2016).

Von D, Kat. (2009) *High Voltage Tattoo*. New York: Collins Design.

Watts, Michael. (2011) *The Philosophy of Heidegger*. Durham: Acumen.

Weinstein, Deena. (2000) *Heavy Metal: The Music and its Culture*. Boston: Da Capo Press.

Welton, Donn. (1977) Structure and Genesis in Husserl's Phenomenology. In Elliston, Frederick. McCormick, Peter. (eds) *Husserl: Expositions and Appraisals*. Notre Dame and London: University of Notre Dame Press, pp. 54–69.

White, Rob. Haines, Fiona. (2008) *Crime & Criminology*. Sydney: Oxford University Press.

Willinge, Amy. Touyz, Stephen. Charles, Margaret. (2006) How Do Body-dissatisfied and Body-satisfied Males and Females Judge the Size of Thin Female Celebrities? *International Journal of Eating Disorders*, Vol. 39, No. 7, pp. 576–582.

Wilson, Jacki. (2007) *The Happy Stripper: Pleasures and Politics of New Burlesque*. London: I.B. Tauris.

Wohlrab, Silke. Stahl, Jutta. Kappeler, Peter M. (2007) Modifying the Body: Motivations for Getting Tattooed and Pierced. *Body Image*, Vol. 4, pp. 87–95.

Wollina, Uwe. Köstler, Erich. (2007). Tattoos: Surgical Removal. *Clinics in Dermatology*, Vol. 25, pp. 393–397.

Woodstock, Louise. (2014) Tattoo Therapy: Storying the Self on Reality TV in Neoliberal Times. *The Journal of Popular Culture*, Vol. 47, No. 4, pp. 780–799.

Wroblewski, Chris. (2004) *Skin Shows: The Tattoo Bible*. Hong Kong: Collins & Brown.

Xavier. (2016) Tattoo Legend Lyle Tuttle Says, 'Don't Get One, Stay Unique'. *Tattoodo*, 11 January. https://www.tattoodo.com/a/2016/01/tattoo-legend-lyle-tuttle-says-don-t-get-one-stay-unique/ (Accessed 19/12/2016).

Index

DATE DU